GIL COHEN
AVIATION ARTIST

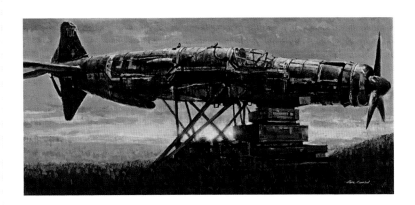

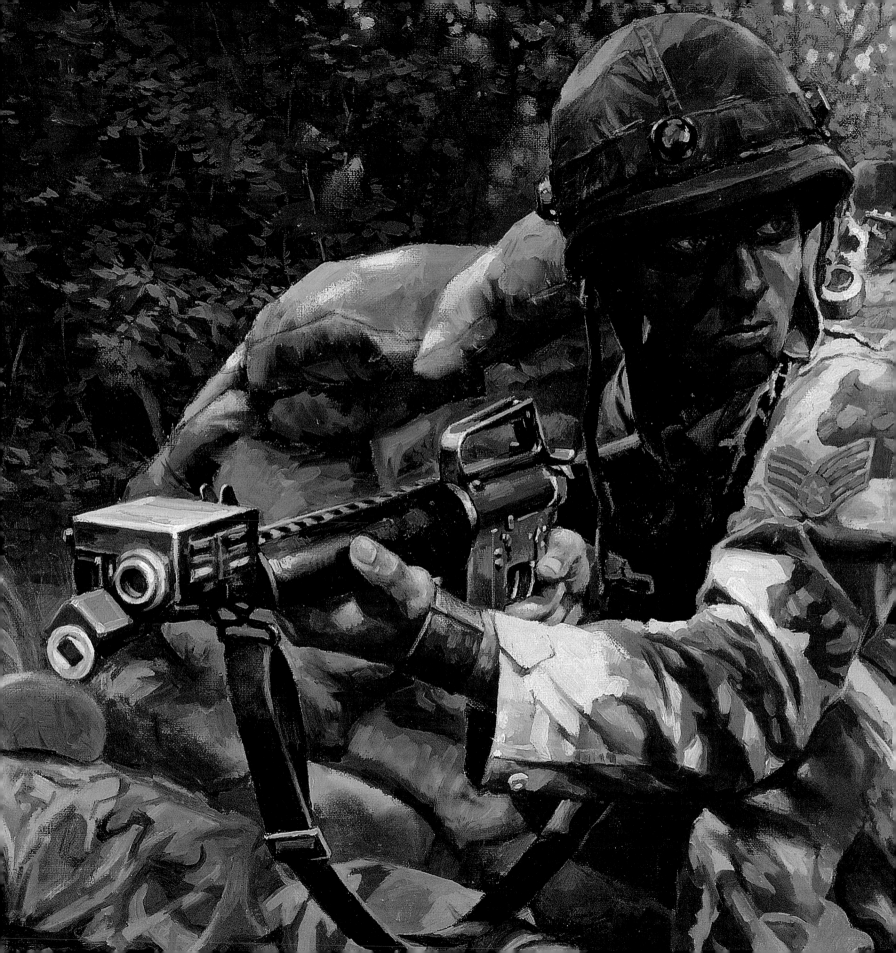

GIL COHEN
AVIATION ARTIST

Written by Gil Cohen

with photography by Dan Patterson

Foreword by Colonel Donald J.M. Blakeslee, USAF (ret)

A Boston Mills Press Book

First printing

Published by Boston Mills Press, 2009
132 Main Street, Erin, Ontario N0B 1T0
Tel: 519-833-2407 Fax: 519-833-2195

In the United States:
Distributed by Firefly Books (U.S.) Inc.
P.O. Box 1338, Ellicott Station
Buffalo, New York 14205

In Canada:
Distributed by Firefly Books Ltd.
66 Leek Crescent
Richmond Hill, Ontario, Canada L4B 1H1

Publisher Cataloging-in-Publication Data (U.S.)

Cohen, Gil.
Gil Cohen : aviation artist / Gil Cohen ;
foreword by Colonel Donald Blakeslee ; with additional text by Dan Patterson.
[144] p. : col. ill., col. photos. ; cm.
Includes bibliographical references.
Summary: The works of Gil Cohen both as illustrator and aviation artist.
ISBN-13: 978-1-55046-512-9 ISBN-10: 1-55046-512-0
1. Cohen, Gil — Biography. 2. Artists — United States — Biography. 3. Airplanes, Military in art.
4. War in art. I. Patterson, Dan, 1953– . II. Blakeslee, Donald. III. Title.
759.13 dc22 ND237.C6546 A4 2009

Library and Archives Canada Cataloguing in Publication

Cohen, Gil
Gil Cohen : aviation artist / Gil Cohen ;
foreword by Donald Blakeslee ; with additional text by Dan Patterson.

Includes bibliographical references.
ISBN-13: 978-1-55046-512-9 ISBN-10: 1-55046-512-0

1. Cohen, Gil. 2. Airplanes, Military, in art. 3. Aeronautics in art.
4. War in art. 5. Artists — United States — Biography.
I. Patterson, Dan, 1953– II. Title.

ND237.C5783A4 2009 759.13 C2009-902141-2

The publisher acknowledges for their financial support of our publishing program
by the Government of Canada through the Book Publishing Industry Development Program (BPIDP).

Design by Dan Patterson
Printed in China

HALF TITLE PAGE: *Valhalla*
TITLE PAGE: *MAC Security Patrol,* detail.
TABLE OF CONTENTS: *Return to the Bump,* detail.

*To all of the people who have inspired me
along my life's journey.*

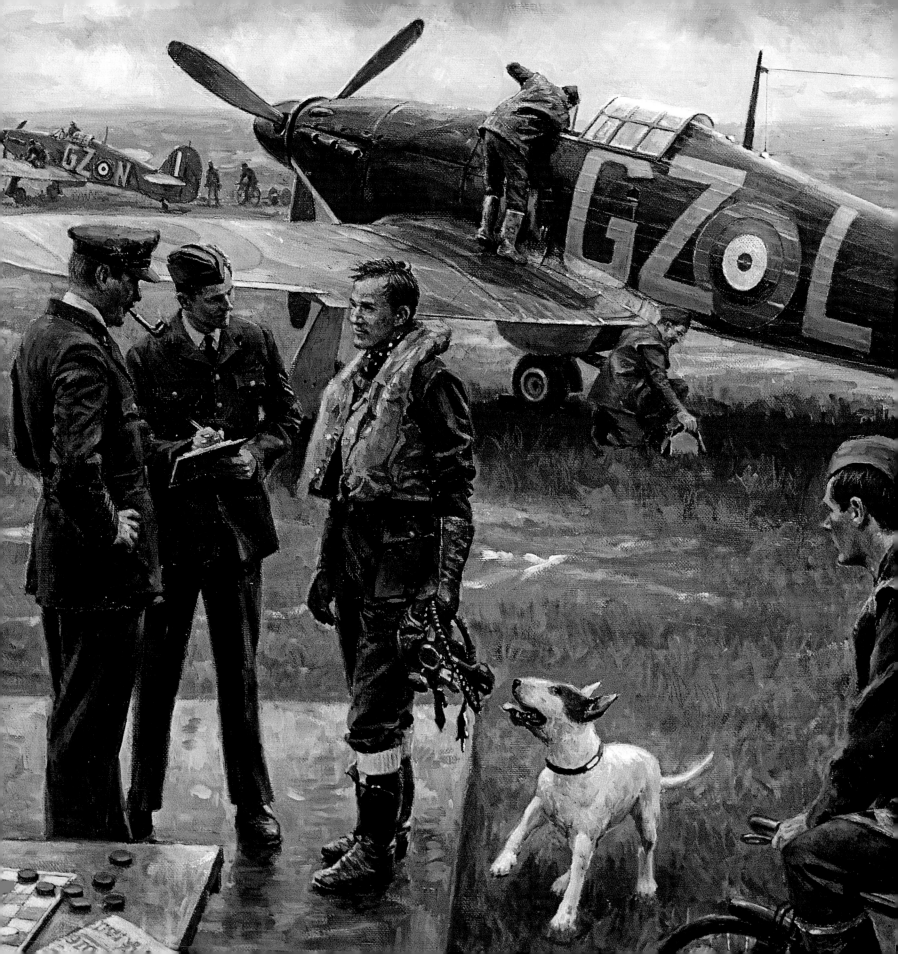

CONTENTS

Foreword

I first met Gil in early 1993 in Tampa, Florida, for the signing and launch of his *The Mighty Eighth/Russian Shuttle* print.

Over many months, during Gil's research stage for the painting, we had several telephone conversations during which I recalled my memories of that long, difficult mission in the summer of 1944.

When I first saw the *Russian Shuttle* print, I was immediately impressed by the incredible depth of Gil's talent. His attention to detail and accuracy was astonishing. The descriptions I had shared with him were now suddenly alive on canvas. The memories of those days, so long ago, came flooding back.

Many years later, Gil once again contacted me requesting my input for a new project depicting the Eagle Squadron's participation during the Dieppe Operation in August of 1942.

The result was the painting entitled *Fourth Mission of the Day*. When I first saw the painting, I recalled how exhausted I was after that fourth mission. Once again, Gil got it exactly right.

In the fall of 1944, I left the base at Debden, England, and returned to the United States for the first time in over four years. During my entire service with the Fourth Fighter Group, my regular Crew Chief was Staff Sergeant Harry East. I considered him to be the finest Crew Chief in the Eighth Air Force.

I left the base in such haste, I regretfully did not take the opportunity to thank S/Sgt. East for his months of hard work and dedication, not only to me personally, but to the Fourth Fighter Group as a whole.

The oversight haunted me for years. Decades later, I found out that Harry East had passed away in the mid-1980s. I realized at this point, it was now impossible for me to thank him personally.

My regrets were finally satisfied in 2003 when Gil produced a wonderful pencil drawing based on a wartime photograph depicting S/Sgt. East and me after my return to Debden, following the Shuttle Mission to Russia. The drawing was commissioned by my good friend Mark Copeland of Lakeville, Minnesota.

When I first saw this amazing sketch, it prompted my desire to locate the family of Sgt. East. It was my good fortune to find them alive and well, living in Central Michigan. I finally had the opportunity to explain how important Harry East's contributions were to my success as a fighter pilot and Group Commander.

It was one of the most satisfying moments of my life. A very special copy of the drawing now hangs in the home of the East family. This was all a direct result of the drawing made by my special friend Gil Cohen.

It is my privilege and honor to write the foreword for this fine book.

Colonel Donald J. M. Blakeslee
United States Air Force (Retired)
Author's note: Don Blakeslee passed away in September 2008.

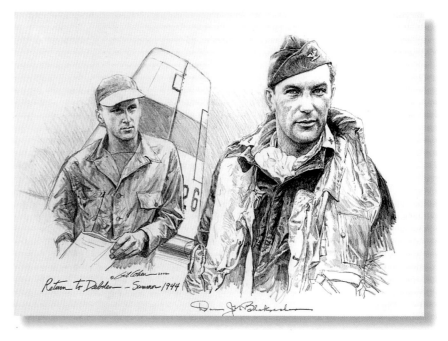

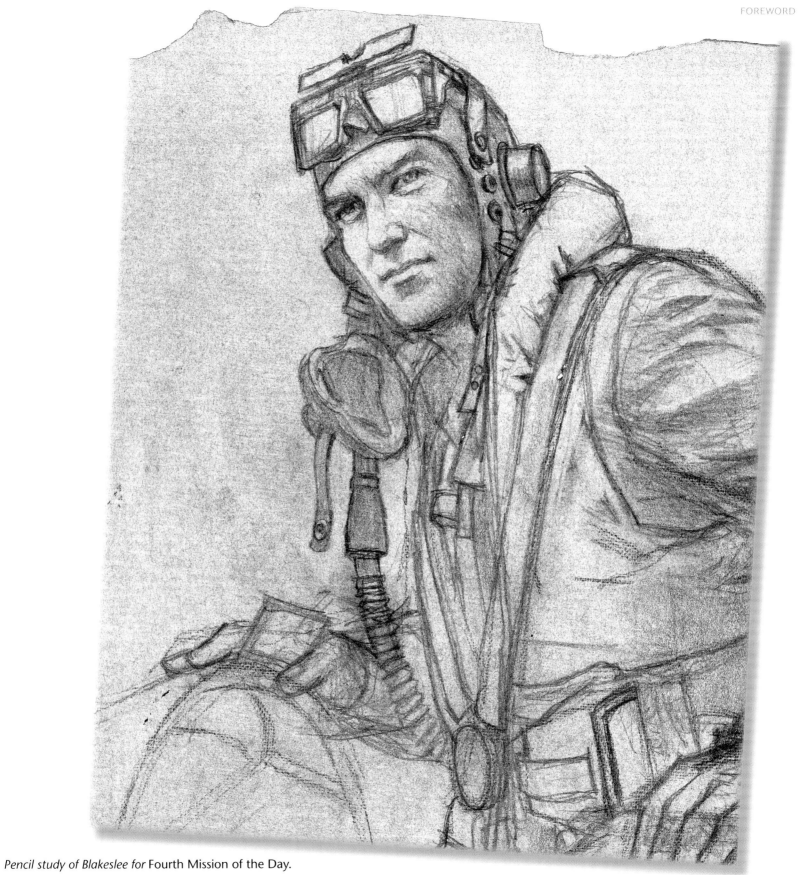

Pencil study of Blakeslee for Fourth Mission of the Day.

Introduction

After a long career spanning five decades as an artist and illustrator, I am often asked about the process that I go through to create a painting. With that in mind, in addition to offering a gallery of finished paintings, I thought that it would be appropriate to devote a portion of this book to the creative process: the metamorphosis that begins with the nucleus of an idea, followed by sometimes painful trial-and-error compositional sketching, and finally the completed painting.

I can honestly say that after all this time, creating art does not get any easier. I don't think of this as a negative aspect of the process. I believe that if the process gets too easy, a glib, hackneyed feeling can creep into the finished art. I once heard it said that, in terms of creativity, the journey is more important than the destination. In other words, the act of thinking, sketching and painting — all that an artist must go through to create a painting — is a learning sequence that is more important than the final result.

The type of artwork that I do can best be described as narrative art. It is representational in style and its content suggests some kind of scenario or the telling of a story. If the painting has been commissioned, the client will most likely have a subject matter and concept in mind. At other times, the idea is self-generated — a vision that originates within myself alone.

The paintings and drawings shown on these pages are reproduced as faithfully as current state-of-the-art book printing will allow, but tonal and color shifts are bound to occur. In cases where I have committed technical errors (and I have), I decided not to "correct" them by modern wonders such as Photoshop or any other means.

What I wish to convey in this book are my thoughts on picture-making and how I attempt to arrive at the most effective composition, including the use of tone, lighting and color in order to produce a work that captures the emotion of a specific moment in time.

Pencil study of co-pilot for the painting Almost Home.

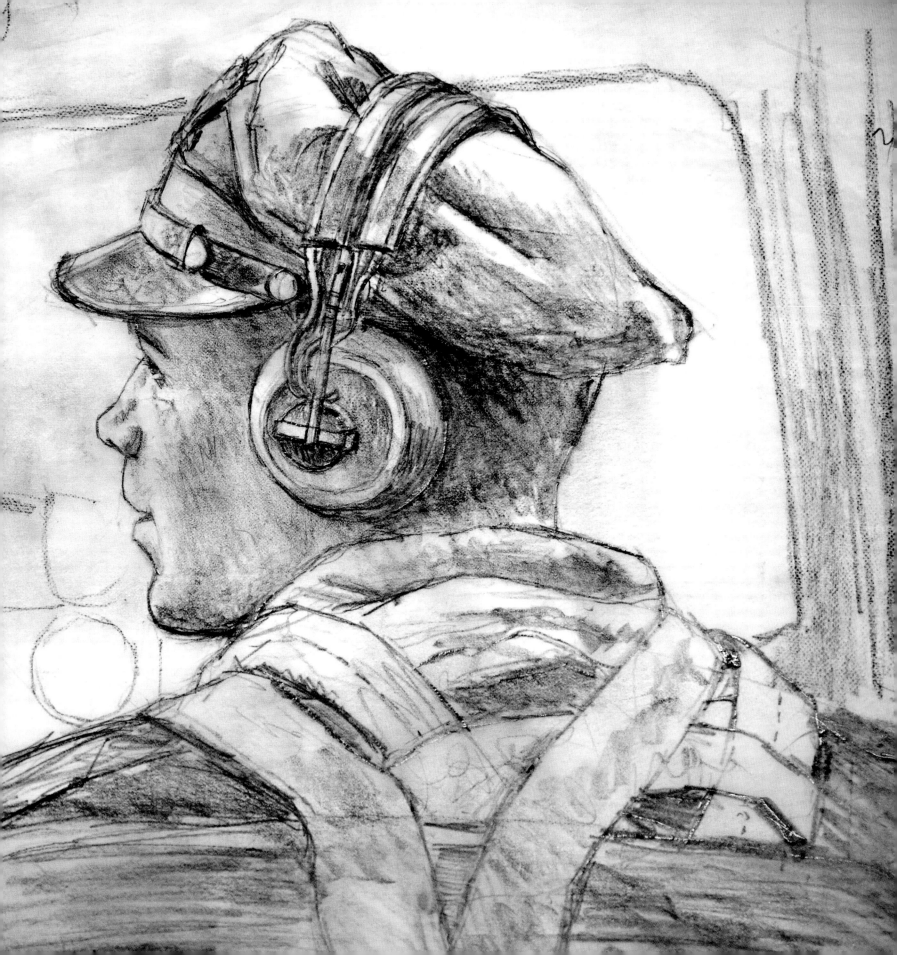

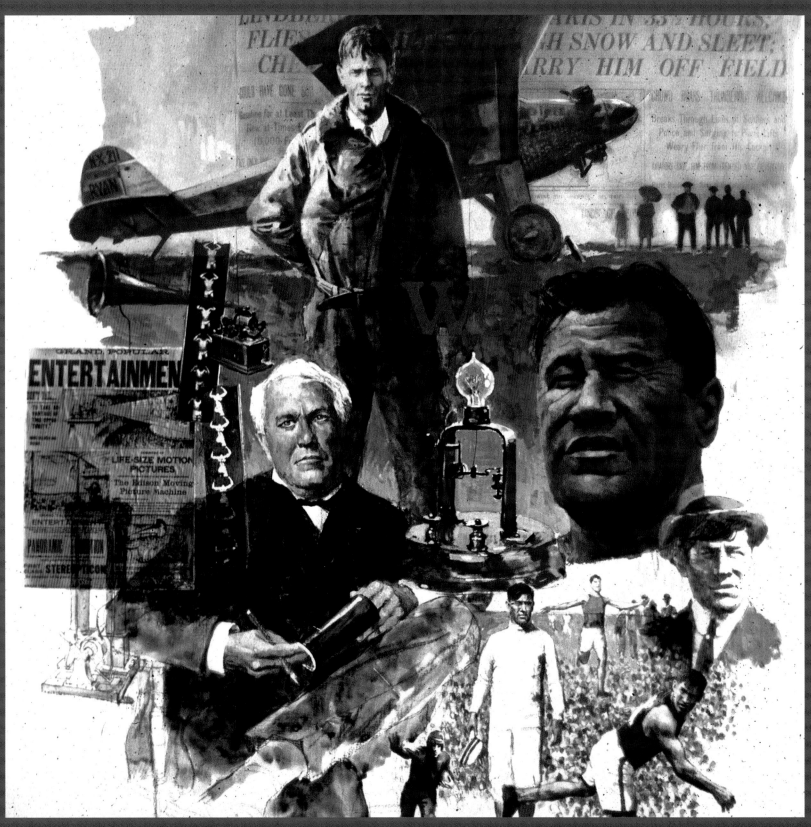

Promotional illustration for Warner–Lambert Pharmaceutical Corporation, acrylic on canvas with collage elements, 1975.
This piece significantly altered the course of my career.

Moments in a Lifetime of Illustration and Aviation Art

I will always be appreciative of my environment as a youngster growing up on South Street in downtown Philadelphia, Pennsylvania, in the 1930s and '40s. My Russian immigrants grandparents, along with my father, owned and operated a hardware store on this bustling street of newsstands, movie theaters, pawn shops, barbershops, grocery stores, clothing merchants, shoe-shine parlors, restaurants, pharmacies, meat markets and bakeries. I lived with my parents and siblings on the third floor above the store.

My exposure to these surroundings and to the many varied ethnic and racial groups helped me form a reserve of stored information that would later come to the fore in my depictions of the human form — its individually distinctive movements, attitudes and ensuing energy patterns. I am told that I picked up a pencil and started drawing at the age of two and a half. By the time I entered kindergarten, I had already been drawing for a couple of years. I did not realize that my drawing ability was anything out of the ordinary until I became aware that the other children could not draw as I did. My early drawings consisted of cars, fire engines, airplanes, images from movies I had seen, and, above all, people.

I have my Aunt Alice to thank for taking me to see many movies when I was too young to go by myself. Even at this early age, I was fascinated with movies — how they were made, how the cinematographer framed a composition, and how the play of light and shadow affected the emotional feeling of a scene. My early exposure to movies influenced greatly my approach to picture-making later in life.

Long before television and computer games, the movies and radio were the prime sources of entertainment. In the 1940s, there were many movie theaters within walking distance of my house in center-city Philadelphia. In those days, going to the movies was a special event. The "first-run" theaters on Market and Chestnut streets, especially, were immense baroque palaces. Even the neighborhood theaters had curtains covering the screens, and when the movie started, the curtains would part with a fanfare soundtrack and the appropriate logo would appear on the screen announcing a Warner Brothers, MGM, 20th Century Fox, Paramount or other Hollywood studio production. War movies abounded: *Air Force, Sahara, Thirty Seconds Over Tokyo, Wake Island* — a plethora of romanticized action movies in which the "goodies" and the "baddies" were not hard to tell apart. I flew vicariously with John Garfield and the crew of the *Mary Ann*; I slithered through the Japanese nets into Tokyo Harbor with Cary Grant; I served under Brian Donlevy defending Wake Island; fought in the jungles of Burma with Errol Flynn; and with Humphrey Bogart, I crossed the Sahara in a Grant tank, fighting the Afrika Korps along the way.

Sometime in 1942, my Aunt Alice took my older brother and me to the Army War Show in Franklin Field at the University of Pennsylvania, where we saw GIs marching in formation, and dis-

Self portrait, age 17.

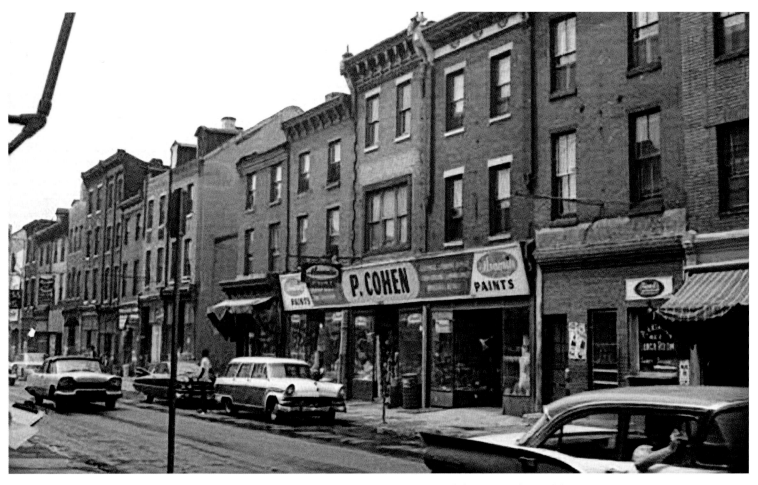

*Although this photo was taken in the 1960s, it still suggests some of the atmosphere of the '30s and '40s.
I lived with my family above Cohen's Hardware Store until late 1946.* (City of Philadelphia photo)

plays of tanks and flame-throwers, a German JU-88 bomber shot down during the British Blitz, and the wreck of a Japanese VAL dive-bomber that had been blown out of the skies over Pearl Harbor. All of this fascinated me, and the visual and tactile stimulation left indelible impressions in my mind. The next day, I scribbled many sketches of the events of the previous evening.

The wartime atmosphere was all encompassing, whether you were attending school, at home listening to the radio, watching a movie in a theater, listening to popular music or simply walking down the street. There were ongoing scrap drives, rationing, war bond drives and school special-kit projects to be sent to the servicemen. Nearly every citizen was involved in the war effort in some way.

In sixth grade, my teacher, Mr. Brown, brought in a newspaper headline that shocked me when he read it aloud to the class. The headline read, "Sixty U.S. Bombers Shot Down Over Schweinfurt, Germany." I knew that there were ten crewmen to each bomber. I realized for the first time what a heavy price there was to pay for this war in loss of human life.

To escape the oppressively hot summers of the early 1940s, my mother, siblings and I spent the summer months in Atlantic City, New Jersey. This was decades before the era of seaboard gambling casinos, and wartime Atlantic City was a fascinating town. I recall strolling the boardwalk and watching dozens of GIs in their summer khakis executing close-order drill. Many of the finest hotels had

been turned over to Uncle Sam to house soldiers on R&R or those awaiting shipment overseas. One of the most spacious of these hotels had been converted into a hospital for wounded airmen. Looking up at the balconies of England General Hospital, I could see GIs fitted out in plaster casts, sitting in wheelchairs. Another unforgettable sight, beyond the distant horizon, was a plume of ugly black smoke, indicating that a torpedo from a German U-boat had hit a ship. Within a couple days, evidence of that hit arrived as pools of black oil and pieces of wood washed ashore with other debris. For a more positive experience, I could look up and see Wildcat, Hellcat or Corsair fighter planes rushing past, sometimes flying as low as 25 feet above the water's surface!

I had an uncle who took a great interest in my artistic talents and made up his mind, in spite of my protests, that I would appear on the stage in one of the musical revues that were a regular feature at Steel Pier, a well-known entertainment attraction jutting out over a quarter mile from the Jersey shore. Steel Pier boasted three theaters, which showed movies and featured live performances, often famous comedians and musical acts. Toward the end of the pier was a ballroom where the most prominent big bands of the era performed — Benny Goodman, Glenn Miller, Tommy and Jimmy Dorsey, Harry James. At the far end of the pier, one could be entertained by the Steel Pier Water Circus, featuring a diving horse. And then there was "Daddy Dave's Kiddies' Revue."

My uncle must have confused my drawing talent with an aptitude for the performing arts. After my audition, "Daddy Dave" (I cannot

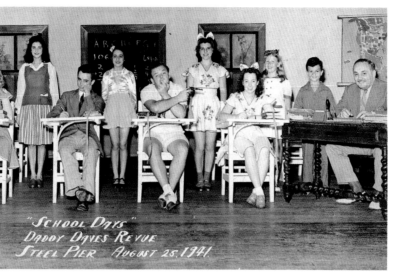

Daddy Dave's Revue, August 1941.
I am standing to the left of Daddy Dave (seated at desk).

remember his real name) decided that I would "perform" the week before Labor Day. The theme of the show that week was to be School Days. I rehearsed backstage for weeks, sketching famous cartoon characters of the period on a huge sketchpad secured to a wooden easel. Finally, it was time for the big show! When the curtain parted, the stage revealed a set resembling a school classroom. Sitting at a desk stage left was the "teacher," Daddy Dave, who was the show's emcee. The back of the set revealed a classroom wall with fake windows, a blackboard, an alphabet display and a map. Ten "students," all singers, tap dancers or comics, sat in desk chairs facing the audience. They reportedly ranged in age from about thirteen through seventeen, though I would swear that the class comic was at least thirty! The show consisted of Daddy Dave introducing each performer, who would then perform his or her tap dance or popular song. Eventually, he introduced me: "And now, I bring you eight-year-old Buddy [my middle name] Cohen, our class artist, who will entertain you with his drawing talent." Daddy Dave suddenly became my sworn enemy! I was TEN, not eight! He was capitalizing on the fact that I was rather small and looked younger than ten. After my introduction, the easel with its large sketchpad was placed center stage. Using a fat crayon, I would sketch famous cartoon characters such as Mickey Mouse, Pluto and Porky Pig. The whole idea was that I would execute each drawing in such a way that the audience would not know the identity of the character until the last strokes of the crayon, allowing Daddy Dave to tease the audience with clues as I sketched. After several days of performing three shows a day, my initial nervousness turned into boredom. At one matinee performance, while I was sketching a cartoon character,

Daddy Dave provided the usual hints to the audience: "I think he loves spinach, is in the Navy and smokes a pipe." Because he was speaking from stage right, he could not view my sketchpad. When I finished, Daddy Dave pronounced, "It's Popeye!" The audience broke out in laughter. Perplexed, Daddy Dave got up from his desk to examine the sketchpad, which featured Donald Duck. He recovered his embarrassment, for a moment, applauded and said, "Let's give a round of applause to Buddy. He had me fooled, too!" But when the curtain came down, he took me aside and whispered, "Listen, kid, don't you ever pull that on me again!" That was the end of my career in showbiz.

In high school, my artist hero was the famous adventure-strip cartoonist Milton Caniff, the creator of *Terry & the Pirates* and later *Steve Canyon*. I slavishly and unashamedly imitated his style using my own plots and characters. One day Caniff came to my high school to give a talk about his work. I brought in my own work to show him, hoping to get a critique from the master. Caniff viewed my creations thoughtfully. I asked him if there was anything he might suggest that would improve my work. He paused for a moment and he said that the only thing that he would suggest was "change the style of your signature." At that time I even boxed in my signature, just as my hero Milton Caniff did.

As a teenager living in Philadelphia, a town with so many professional sports teams, I was a fan of the Phillies, A's, Eagles and Warriors. There used to be a Saturday morning radio talk show in Philly devoted to major league sports. Host Tom Moorehead was a well-known local radio personality, and his guests included stars of baseball, football and basketball, depending on the sporting season. The broadcast's live studio audience consisted of enthusiastic teenage boys. When it was announced that Detroit Tigers pitching ace Hal Newhouser would be next week's guest, my childhood friend Jerry encouraged me to make a drawing of Newhouser. This drawing would be our entree to meeting the star pitcher (and perhaps made

Jerry my first agent). Because of my artwork, we were invited to meet Newhouser privately backstage, where he gave us an autographed photo. During that baseball season, I drew portraits of other stars, including Joe DiMaggio, Jackie Robinson, Harry Walker and Ted Williams. When I heard that the Pittsburgh Pirates were coming to town to play the Phillies and that their star first-baseman Hank Greenberg was going to be a guest on the broadcast, I quickly drew Greenberg's portrait. Jerry and I arrived at the broadcast studio with the drawing, only to be very disappointed. Greenberg didn't show. In his stead was a young rookie Pirates slugger named Ralph Kiner. As it turned out, Kiner was so impressed with the drawing that he arranged for us to meet Hank in the Connie Mack Stadium's visiting clubhouse the following day. In addition to meeting both Kiner and Greenberg, we were given complimentary box seat tickets to Connie Mack Stadium for all the Pirates' games for the rest of the season — a kid's dream come true!

In 1950 I embarked on four years of study at the Philadelphia Museum School of Art (now the University of the Arts), majoring in illustration. I don't think it is an overstatement to assert that the art school experience was an epiphany for me. My previous understanding of art came mostly from popular culture. Now, the wondrous worlds of Michelangelo, Da Vinci, Vermeer, Rembrandt, Homer, Van Gogh and Picasso were revealed to me. I learned that drawing involved much more than copying surface detail. Before a painting depicts a warhorse, a nude or an airplane, it is fundamentally an abstraction, whether the artist intends it to be or not. I discovered that color is more than the "local" color of an object. The color of the object depicted is influenced by other colors around that object. I was fortunate to have great teachers, such as Karl Sherman, Henry C. Pitz, Albert Gold and Gertrude Schell. My developing artistic vision was influence greatly by the work of Winslow Homer, John Singer Sargent, Thomas Eakens and other nineteenth-century American masters, as well as Dutch and Flemish painters such as Van Dyke, Franz Hals and, above all, Johannes Vermeer. And then there were the great illustrators, such as N.C.

I painted this Korean War scene during my first year of art school, in 1951.

(Above) This painting depicting the Mexican Revolution of 1912 was done in 1952, during my sophomore year at art school. As you might guess, it was inspired by the Marlon Brando film Viva Zapata!

(Top) Southwest Native Americans, art school assignment, 1952.

Wyeth, Dean Cornwell, Al Parker, Norman Rockwell and, for his incredible draftsmanship, Robert Fawcett. I was also fortunate to be mentored by Isa Barnett, a superb artist whose work appeared in the *Saturday Evening Post*, *Argosy* and *True* magazines. I would occasionally travel to Isa's Germantown studio, where he would give me the most thorough critiques of my work that I had yet encountered. By the time I graduated from the Museum School of Art, I had started what would become lifelong friendships with several fellow students and instructors.

In the days before the Internet, email and personal websites, ambitious young illustrators would phone or write to make appointments to see art directors of ad agencies, publishing companies and other institutions in order to show their portfolios, in hopes of getting assignments. It didn't take long before I realized that New York City was the place where I would have the best chance of starting my career. I gathered my art samples together and headed for the city. After several days of calling on potential clients and striking out, I finally hit pay dirt, an assignment to illustrate an article about the Nez Perce Indian tribe for an action-adventure magazine publisher on 42nd Street. However, while I was working feverishly to meet my deadline, I received a draft notice from Uncle Sam. A week later, I delivered the finished painting, and the very next morning I reported for induction into the U.S. Army. I would spend the next two years in the service of my country.

After basic training at Camp Pickett, Virginia, I was sent to Fort Monmouth, New Jersey, to learn still photography, then was shipped to Fort Lewis, Washington, for the next seven months. Eventually, I was shipped to West Germany, to the 513th Military Intelligence Unit in Oberursel. When I reported for duty there, I was told that they

My sketchbook went with me when I entered the Army. Occasionally, during a "take ten" cigarette break or back in the barracks, I would sketch my buddies using a pen or felt-tipped marker.

PVT. HEFFERNAN 12 APRIL 54

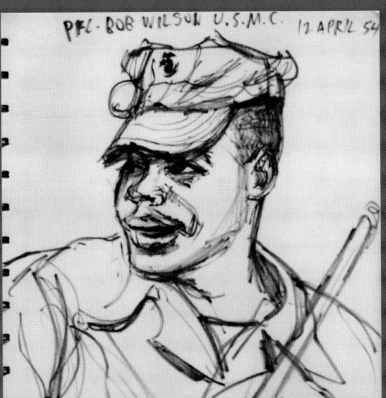

PFC. BOB WILSON U.S.M.C. 12 APRIL 54

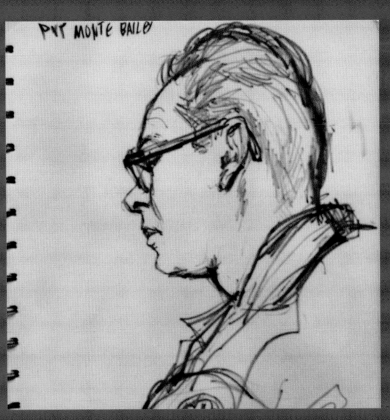

PVT MONTE BAILEY

did not need photographers. I told them of my art background as a civilian and was informed that my talents would be very useful for intelligence-gathering purposes. During WWII, Oberursel had been the initial interrogation center for American and British flyers shot down. To the Germans, it had been known as Auswertestelle West. The Allies called it Dulag Luft. Among its many famous WWII "guests" were Hub Zemke and Gabby Gabreski. After the German surrender, high-ranking Nazis such as Hermann Goering were interrogated here. I was stationed at Camp King (the postwar American name for the center) for close to a year, where my work consisted of producing drawings of new Soviet tanks and other military equipment, based on information smuggled out of East Germany by spies.

After my Army discharge I restarted my career, receiving most of my illustration assignments from New York publishers of male-oriented magazines such as *Stag, Men, Male, Adventure* and *Saga*, plus the up-market magazines *True* and *Argosy*. The antecedents of these 1950s publications were the pulp magazines of the ´20s, ´30s and ´40s.

As I look back, the 1950s were a fantastic time for a young illustrator to start a career, but I was often called upon to meet impossible deadlines such as depicting complex battle scenes with dozens of detailed figures in two or three days. In a way, it was a continuation of my art school education. My drawing facility improved rapidly. There was not much time to contemplate how you were going to approach your assignment. Decisions were necessarily arrived at quickly in order to meet close deadlines. My biggest client was Magazine Management Company, publishers of many of the men's adventure magazines. The person whom I was most in contact with was the art director, Larry Graber. Larry was not the hard-boiled art director

Illustration for the James Bond novel Thunderball, Argosy *magazine, 1961.*

that one might expect to find at a publisher in this type of genre. He was nurturing and understood my responsibilities as an illustrator. When he asked for changes or corrections in my art, his demeanor was never demanding or forceful. Larry fortified my self-confidence. I am very appreciative of all that I learned from him.

The other division of Magazine Management was Marvel Comics Group. Super-heroes spawned from the Marvel Group include Spider Man, the Incredible Hulk, Captain America and Plastic Man. The founder of Magazine Management was a tough, enterprising man named Martin Goodman. He was ingenious in his choice of talented editors and writers. Writers Mario Puzo, Bruce Jay Friedman, Mickey Spillane and Rona Barrett were among those contributors who went on to great fame. The Marvel Comics editor and great draftsman Stan Lee created many of the superheroes we know today.

In 1961 I received an assignment from *Argosy* to illustrate a serialized novel for that magazine. The novel, entitled *Thunderball*, was written by a British author named Ian Fleming and featured a hero named James Bond. At that time, I had heard of neither Fleming nor Bond, but both soon had their profiles increased when a reporter asked President John F. Kennedy what kind of books he read for escapist entertainment: "Ian Fleming novels about a super spy, James Bond." Today, James Bond is known the world over. I believe I might have been the first American artist to illustrate a James Bond novel.

In 1970 I began illustrating paperback book covers for a Pinnacle Books series called *The Executioner*, created by Don Pendleton. In 1980 the series was bought out by Gold Eagle Books, a division of Harlequin Publications of Toronto, Canada. Charles Kadin, the art director at

Magazine illustrations produced in the 1960s. All were done in gouache medium except bottom right, which was executed in Negro pencil.

(Lower left) Duotone illustration of Bud Mahurin being interrogated and tortured. Decades later I would meet this brave and wonderful man.

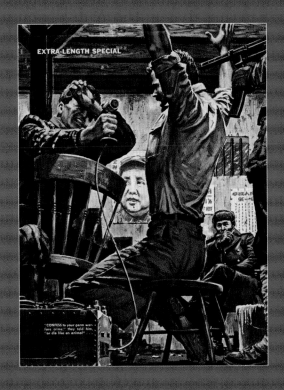

Gold Eagle, asked me to continue illustrating *The Executioner* covers for them. The name of the series was changed to *Mack Bolan*, and I proceeded to paint *Mack Bolan* covers at the rate of one a month, plus covers for the series spinoffs Phoenix Force and Able Team, until 1987 — a total of 17 years! I also illustrated romance novel covers, children's books, mystery novels, epic gothic novels, movie posters and print advertising campaigns.

Some of my most interesting assignments were for the National Park Service. One prodigious project was for Appomattox Court House Battlefield Park. It consisted of 75 watercolor paintings of the South's surrender to Northern troops in April 1865, depicting the common foot soldier's point of view from both sides, to be presented as an audio-video documentary in the theater of the Appomattox Visitor's Center. I went on to do similar work for Gettysburg, Manassas, Petersburg

Self portrait, 1971.

and Chickamauga National Military Parks and many other NPS sites.

In 1966 I received a phone call from Albert Gold, chairman of the Illustration Department at my alma mater, at that time known as the Philadelphia College of Art. He asked that I join their faculty.

I enthusiastically agreed and spent the next 20 years as a part-time instructor teaching illustration, drawing and figure anatomy, eventually chairing the Illustration Course of the Continuing Studies Program. Teaching was one of the most rewarding experiences of my life. For the first time, I had to put into words the act of producing a visual creation. I learned much about myself through imparting such information to my students. As I communicated, I also learned. I recall that the great jazz drummer Chico Hamilton once said, "One who dares teach should never stop learning."

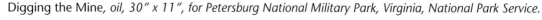

Digging the Mine, oil, 30" x 11", for Petersburg National Military Park, Virginia, National Park Service.

 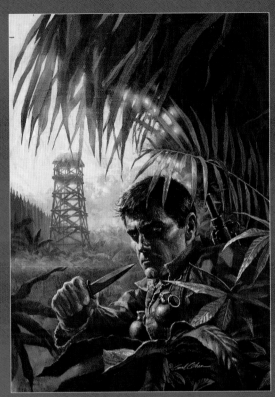

Three covers for the Mack Bolan *action-adventure book series. The cover on the left shows Bolan seated in the back of an obscure First World War Lloyd CII, shooting down a modern Soviet MIG 21 fighter with a surface-to-air missile! At center, Bolan lies in wait in the Vietnam jungle. At right, Bolan and a Russian scientist battle the enemy in Siberia.*

Confederate Assault on Fort Stedman – March 25, 1865, *oil, 30" x 11 for Petersburg National Military Park, Virginia, National Park Service.*

Book Covers

Wrap-around (front cover, spine and back cover) for the 1978 Pinnacle Books novel The Woman from Sicily.
The original pastel rendering measured 32" x 25". For all of these cover assignments, a specific format was provided by the art director.
I had to create a pictorial composition that integrated the placement of the type with the illustration.

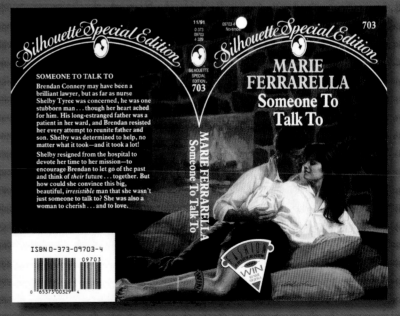

(Above left) Cover art for The Complete Edgar Allen Poe, *1983, Running Press edition.*

(Above right) *A 1970s gothic romance cover done in acrylic.*

(Right) *Wraparound cover art for the Harlequin-Silhouette romance* Someone To Talk To, *oil, 30" x 24".*

Drawings and
Paintings from Life

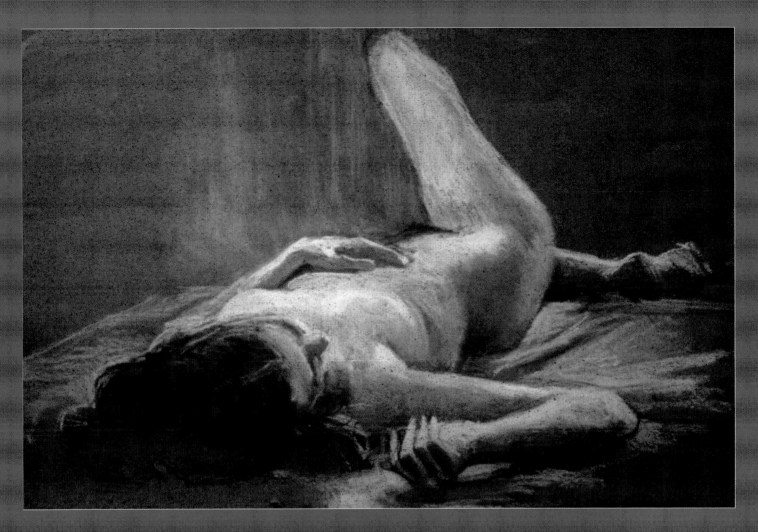

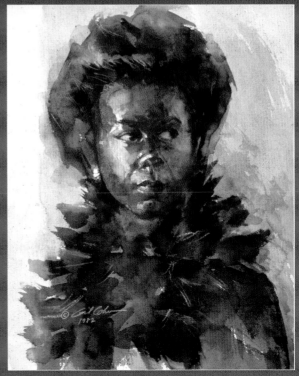

(Far Left) Head study in pencil, 1981.

(Left) Donna, oil on linen, 25" x 40", 2002.
From the collection of Nancy Hall.

(Above) Supine nude, pastel on toned paper, 25" x 19".

(Right) Gloria — Black on Black,
watercolor on cold-pressed Arches paper, 20" x 25", 1982.

In the early 1980s, I joined the Society of Illustrators of New York and later became a member and contributor to the Air Force Art Program. This program was begun decades earlier when the Air Force Historical Branch, recognizing that photography alone was inadequate in depicting the Air Force's mission, contacted the Society of Illustrators and proposed that the two organizations work together in the following way: the Air Force would invite SI artists to travel to various U.S. and overseas Air Force bases and operations as their guests, all expenses paid. In return, the artwork that the artists produced would be donated to the Air Force for their permanent collection. The artist is not told what he or she is to produce with regard to subject, quantity, size or medium. During my many years as a contributor to that program, I was sent to locations around the world, some of them in war-torn regions such as Somalia and Bosnia. Artist Keith Ferris oversaw the Air Force Art Program and eventually appointed me as chair of that program.

Also in the 1980s, I joined the American Society of Aviation Artists (ASAA), an organization dedicated to promoting higher standards and excellence in the field of aviation and space art. Its founders were five of the top names of that genre: Keith Ferris, Jo Katula, Bob McCall, R.G. Smith and Ren Wicks. ASAA has sometimes worked in concert with the British Guild of Aviation Artists to mount joint exhibits at the RAF Museum in Hendon, England, and at the U.S. Air Force Museum in Dayton, Ohio.

One of my clients in the mid-1970s was the pharmaceutical giant Warner-Lambert, headquartered in Morris Plains, New Jersey. As I was finishing an assignment for them, my agent, Phil Veloric, who usually picked up and delivered my work, informed me that he was not well and asked if I would deliver the painting personally. There

Hindy and Bob Westervelt at a signature reception, Virginia Bader Fine Art Gallery, 1991.

were three elements in the montage painting: the inventor Thomas Edison, the athlete Jim Thorpe and the aviator Charles Lindbergh (see page 12). At his Warner-Lambert office, art director Bob Westervelt stared at the image of Lindbergh and his plane, *The Spirit of St. Louis*, before saying, almost to himself, "Do you like airplanes?" "Yes, I do," I replied. "So do I," he said. He then went on to state that someday he would like to retire from the rat race, move to New England and publish aviation art. This chance encounter would, years later, have a profound effect on the direction of my career.

As any professional illustrator knows, nothing is permanent. Eventually, clients come and go, including Warner–Lambert. One day, thirteen years after I executed my last assignment for that company, I received a phone call from someone from the past. It was Bob Westervelt. He went on to explain that he had left Warner–Lambert and was now living in Spofford, New Hampshire, and publishing aviation art prints under the company name Aeroprint. He asked if I had any aviation paintings that he might publish. All I had was an old painting (circa 1970) of Messerschmitt Bf-110s on an airfield. This image became my first aviation art print. Aeroprint would publish nearly all of my aviation paintings until Bob Westervelt's death in the late 1990s. After Bob's passing, my wife, Alice, and I made the decision to self-publish my work under the publishing banner Knightsbridge Press.

I can now look back on well over half a century as a professional freelance artist. Over the years, I've traveled around the country and overseas in pursuit of reference material for my paintings — I even wrestled a real live panther! — and I feel blessed that I have been able to pursue the life that I chose, using my art to inform, entertain and, hopefully, inspire.

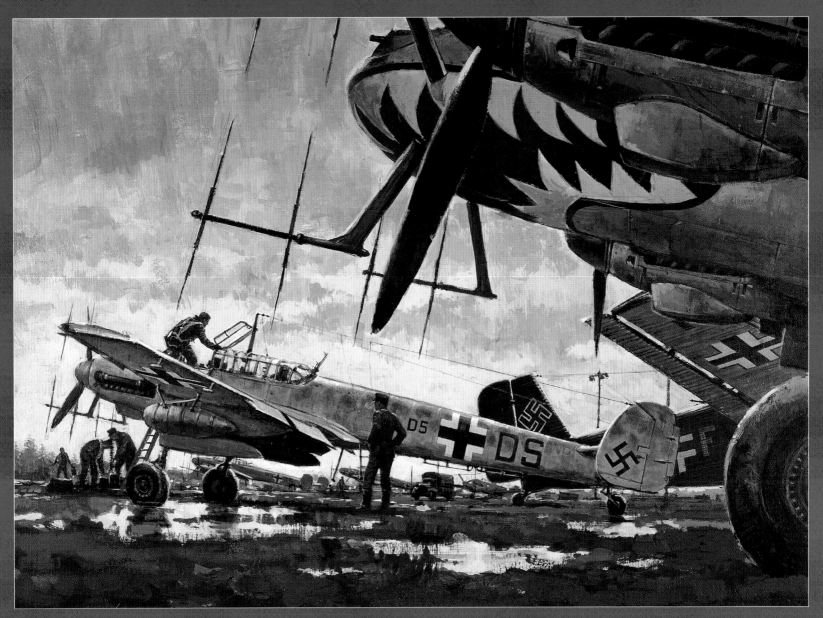

Nightfighters, *acrylic on gesso panel, 36" x 26", 1970.*

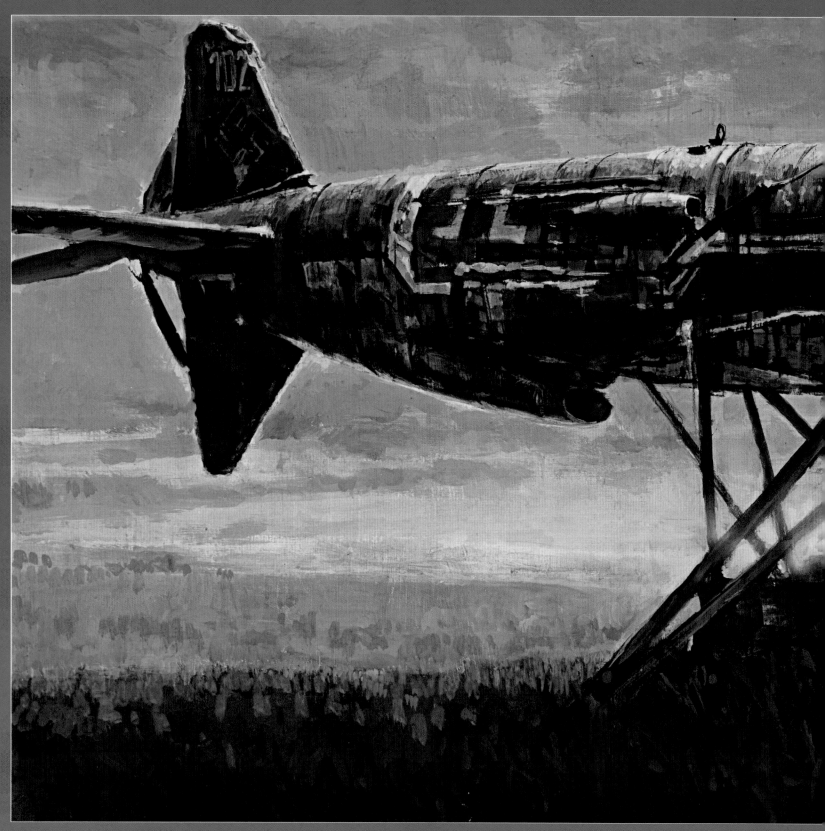

Valhalla, *acrylic on gesso panel, 50" x 25", 1971. Valhalla was painted many years before I established myself as an aviation artist.*
It was, however, a harbinger of things to come.

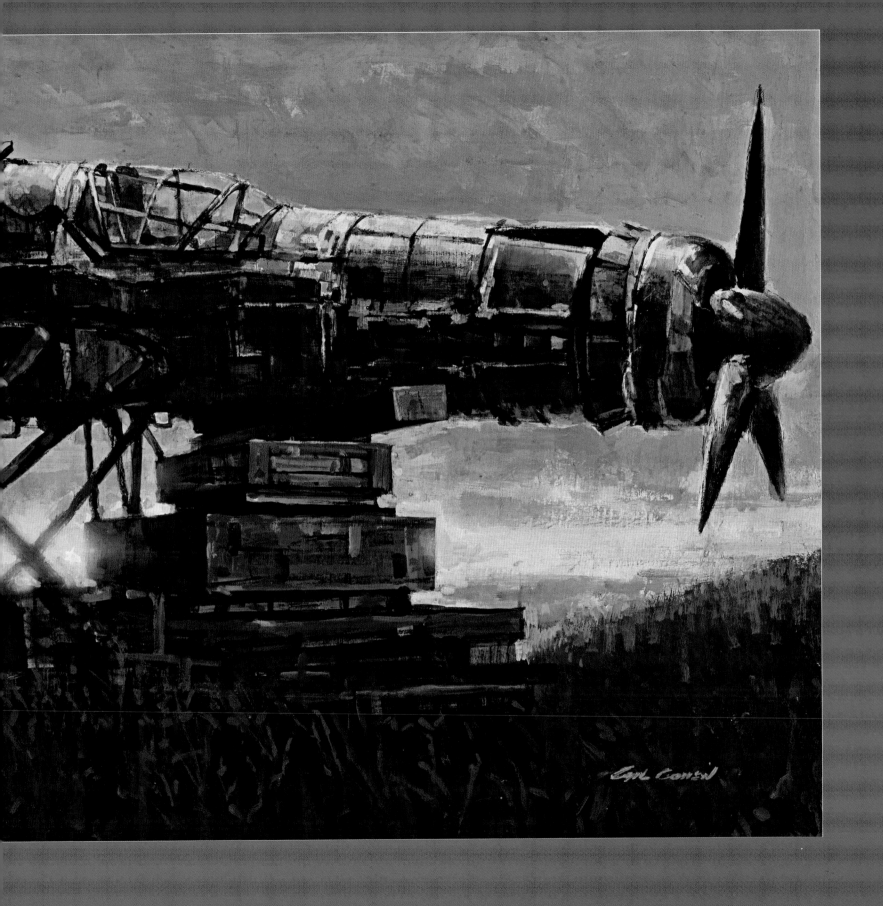

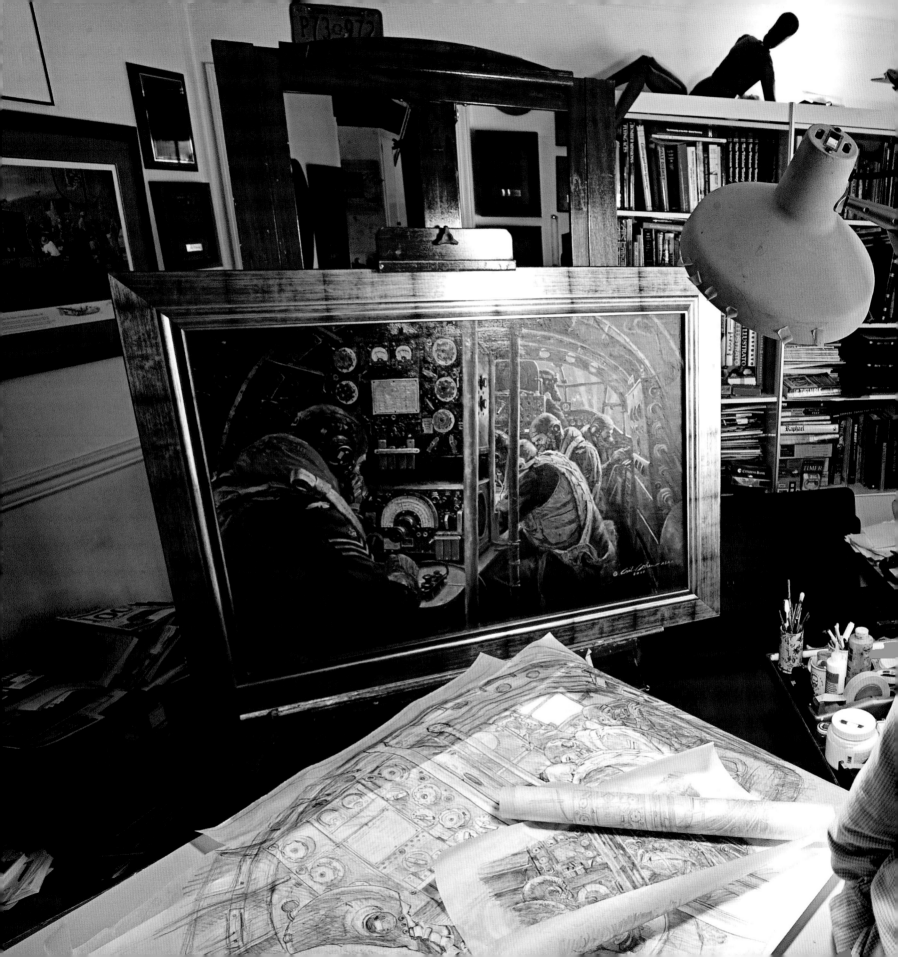

A Portrait of the Artist

My friend and colleague Gil Cohen asked me a few years ago to consider the project of putting the book together about his lifetime of art. I immediately agreed to the project as long as I could come to Gil's home and studio to make a photographic portrait of him. I wanted to create an image of Gil which is environmental; a photograph that is about his working space as well as it is about Gil.

The intervening years had us discussing the project at length. The format of the book you are now holding represents many forms and variations in content, sizes and number of pages. The over-riding goal was to create a book about art . . . in which aviation happens to be the primary subject.

In addition to being a consummate professional who has solved illustrative issues for nearly 50 years, he also has the innate ability to teach about art, and painting and perhaps most importantly the mysteries of translating the human figure onto a canvas or a piece of paper. There are many artists who are masters of their craft, but who cannot express how or why they have chosen that cer-

tain point of view, the choice of the colors on their palette, or what the implications are for further interpretation of the "moment in time" they have selected.

Gil Cohen's studio is a wonderful place to visit; a classic artist's lair, and an aviation artist at that. Reference materials on the bookshelves, the ceiling strung with World War II aircraft recognition models, leather flight jackets and helmets lay over chairs. There is also the fascinating "stuff" that artists must have to do their work; tubes of paint, X-acto knives, pads of paper, pencils, markers, brushes, rags that are filled with color, sketches taped to the wall and just about any surface.

This image of Gil only required a bit of selective editing of the space, there was an old sock in a box of other stuff that had to go. I wanted you to see how endlessly fascinating artists studios can be. There is also the fact that Gil is comfortable in this space and the image that you see of him to the left, is the Gil Cohen that I know; my dear friend and colleague.

Dan Patterson
19 April, 2009

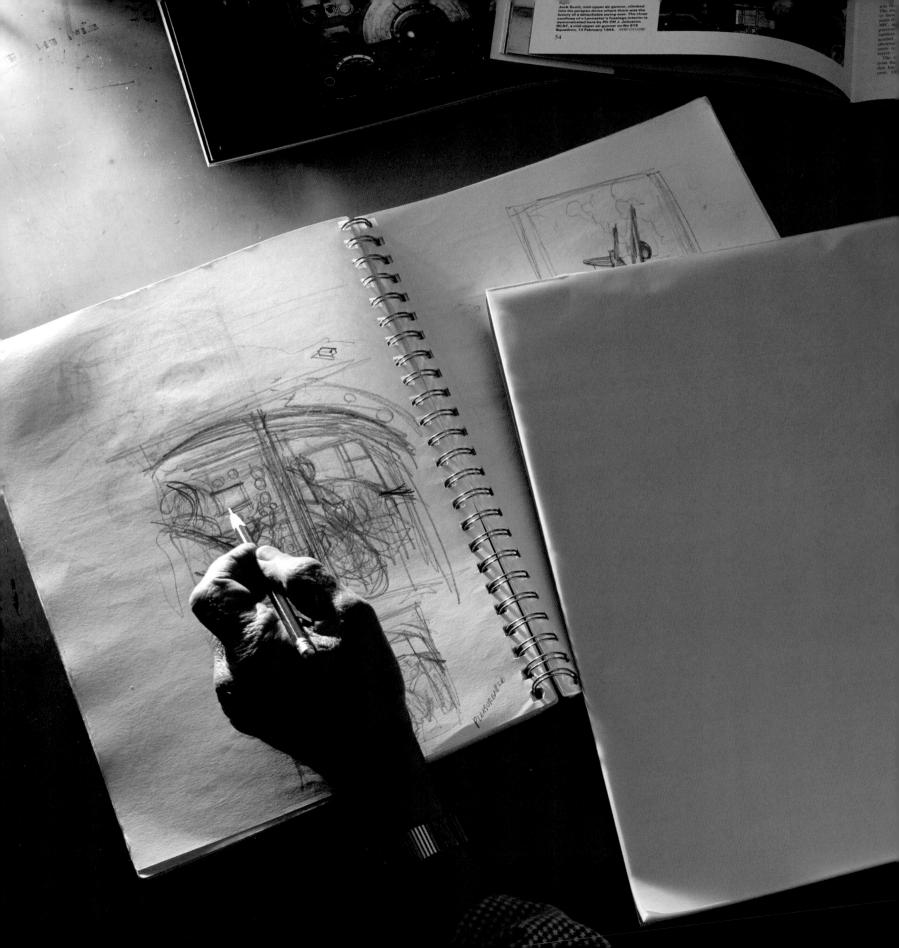

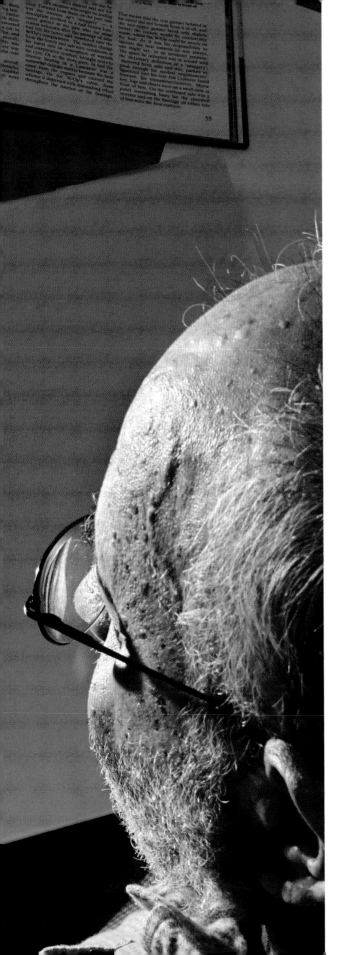

Putting It All Together

Several years ago, while doing research for a National Park Service assignment depicting the Civil War Battle of Chickamauga, I came upon an example of artwork showing a Confederate infantry charge. In the painting, we see soldiers with fixed bayonets charging almost directly toward the viewer. Exploding canister fire can be seen all around, with men being hit left and right — a deadly tumult. In the foreground, a soldier is seen falling, his hat hitting the ground. One cannot help but peer inside the hatband, where the hat manufacturer's label can be clearly seen!

All too often, we observe similar examples of so-called "historical painting." When viewing aviation art, how many times have we seen every rivet and panel line on an aircraft as depicted from a distance of 300 feet? We are able to read the plane's nickname on its nose, from the same distance, and equipment, clothing and other accoutrements, from the foreground to the background, are presented with equal emphasis. To me, this is a misuse of research. The true historian-artist will gather as much information about the subject that he or she can obtain, but in the end will discard all but what is needed to convey the mood and ambience of the moment depicted. Art is about creating a feeling, an emotion, not about creating a pictorial catalog of the artist's knowledge and research. The horror of death and destruction in the aforementioned Civil War painting is broken because of the plethora of distracting details that have nothing to do with the emotional content of the painting.

(Left and far left)
Sketching compositional
ideas for my painting
We Guide to Strike.

(Following pages)
World War II spotter
models suspended from
my studio ceiling.

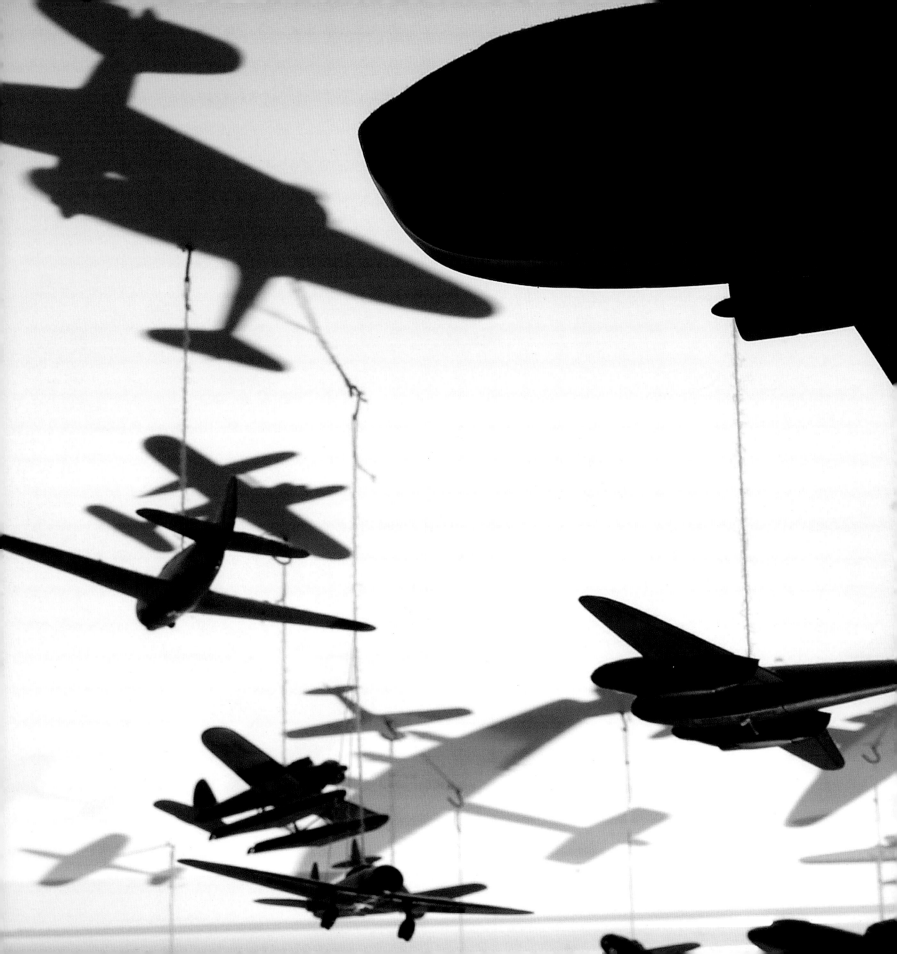

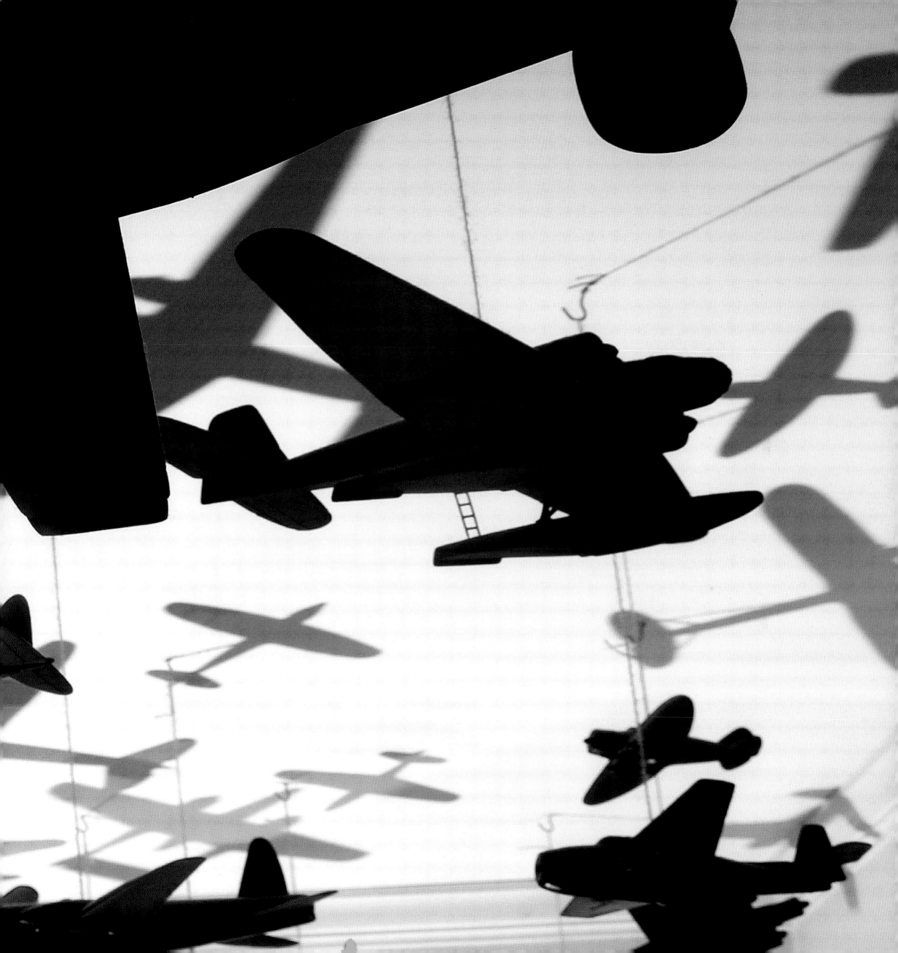

Research often consists of inter–views with veterans, historians and knowledgeable enthusiasts, as well as library research and visits to appropriate websites. I have learned over the years to double-check any assertions made by any one source. Even an eyewitness can be wrong — not because of any deliber-ate deceit, but because one's memory can alter how one per-ceives an event that may have happened over half a century ago. An Eighth Air Force veteran once told me that my painting *Mission Regensburg* was "wrong" because I depicted a B-17 bombardier sitting on a low chair at his station in the nose. He explained that he believed the bombardier would lie prone on the air-craft deck while aiming his bombsight at the target. I asked the veteran what his M.O.S. (job) had been during WWII. He had installed the Norden bombsights on the planes prior to missions, and he had never seen bombardier chairs during his installations. Then I figured it out: some-one had to remove the bombardier seats prior to him installing the bombsights, then reinstall them afterwards. That is why he had never seen one.

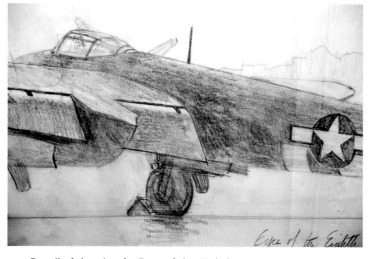

Detail of drawing for Eyes of the Eighth *painting.*

With my research at hand, I start making small thumbnail sketches — very rough, almost abstract in nature — mea-suring no more than a few inches wide. I may try dozens of these sketches. Ques-tions that I ask myself include: What is happening in this scene and what is the most effective point of view from which to depict it? Should the figures dominate the other elements? (In my work, they of-ten do.) Should the view be a worm's eye, down very low to the ground, or a bird's eye, from high above? What about the all-important light — back light, full front or side light? Is it a sunny day or dark and overcast? Bright colors or muted? What are the figures doing? How are they re-lating one to the other? This process of sketching and re-sketching can take sev-eral days until something begins to gel.

(Right) A large working drawing of We Guide to Strike, *along with smaller preliminary studies.*

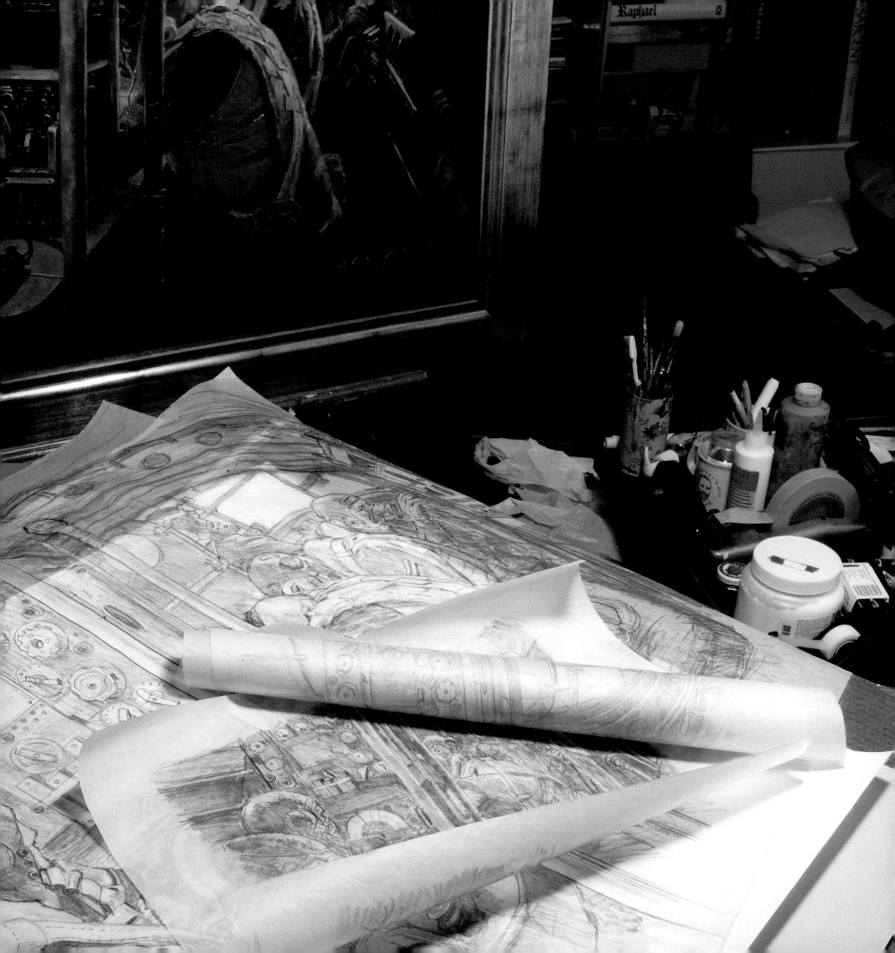

At this point I enlarge the last sketch to about ten inches wide, further refining my compositional ideas and adding some detail to the sketch. I may find it necessary to seek out actual objects that will be featured in the finished painting. There really is no substitute for direct observation, viewing the true item in three dimensions, walking around it, touching it and sketching it. Even the most accurate scale model replication cannot take the place of the real thing. Photography is a great means for obtaining reference. However, we should not spend so much time snapping photos that our only memory of going on location is of what we saw through the viewfinder of our camera. That said, I do take many reference photos after a thorough eyeballing and/or sketching of the researched object.

Drawing the Human Figure

The people in my preliminary sketches are usually drawn from imagination. After a lifetime of figure-drawing and years of teaching drawing and figure anatomy at the Philadelphia College of Art, it is relatively easy for me to draw figures from my imagination. When it comes time for the finished painting, however, I prefer to pose people who approximately fit the description of the figures I have in mind. No matter how adept at figure-drawing one may be, figures created from one's imagination have a tendency to look alike. In fact, I believe we draw ourselves in some unconscious way. But no two people gesture, walk, turn, bend or do things alike.

When someone poses for me, I first give them an idea of what is happening in the scene I am depicting — not only the facts of the situation, but also the emotional aspects. In effect, I try to convey motivation to the character that they are portraying. You could call this can a painter's version of "method acting." I do not necessarily follow my preliminary sketch. Sometimes a good model will have another idea. I am always open to my models' suggestions. They may have a better pose than what I sketched originally. As long as it is consistent with my original concept, I am open to what may be a

more natural pose. Again to borrow from stage and film, even the "supporting cast" (background figures) must have purpose. I do not paint figures for the sake of filling a canvas. The figures may be active or passive, but they must contribute to the overall emotional or narrative theme of the painting through their placement in the composition, their body language and expression. Most people pay attention to the emotions conveyed by facial expressions, but the hands are almost as important in revealing expression and character. However difficult they may be to portray, any artist who paints figures must master the drawing of hands. They are essential to the telling of the story.

When it comes to painting or drawing the figure, there is no better way than to paint directly from life. The full three-dimensionality of the figure and all the subtleties of form and color can be more clearly discerned by direct observation. However, while a photograph is only a flat two-dimensional facsimile of the real thing, I find it necessary to take photographs for several reasons. I can shoot innumerable variations of poses and, later, back in the studio, select those that work best. Also, the storytelling nature of my paintings can sometimes be enhanced by spontaneous gestures and expressions captured in a fraction of a second by the camera. Still, it's a good idea to carry a sketchbook when you travel. For instance, waiting at an airport terminal for hours can be much less boring if you occupy some of that time making quick studies of other people waiting for their flights.

Like many artists, I still attend drawing sessions at which a model will pose for a three-hour session. There is no instruction during these sessions. The model simply holds various poses for periods of thirty seconds up to five minutes. There is no time to lovingly render faces, eye color or any other details at such sessions. The object is to capture on paper the essential sweep and gesture of the pose. I have found that drawing rapidly changing poses in this manner has greatly increased my overall drawing facility.

The Working Drawings

After gathering all of my research, including historical descriptions, interviews, books, plus photographs and/or sketches of models, equipment and backgrounds, I reach the final stage of preparation for the finished painting. At this point, I decide on the dimensions of the final painting. It is usually based on the amount of detail to be painted. This would take into consideration the number of figures, objects in the foreground and background material. Typically the canvas will measure anywhere from 36 to 88 inches horizontally. It seems as though the older I become, the worse my eyes get and, alas, I find myself producing larger paintings.

Once the painting's size is determined, I project or grid-off the preliminary sketch and enlarge it to the finished size. A pencil drawing on tracing paper is then executed. At this stage, I can now focus my attention more carefully on details of textures, clothing, equipment and background elements. I precisely plot out my perspective and establish the picture plane.

Finally, I transfer this drawing to the canvas by tracing it down, using a sharp 9H pencil. A sheet of graphite paper is sandwiched between the working drawing and the canvas to facilitate the transfer.

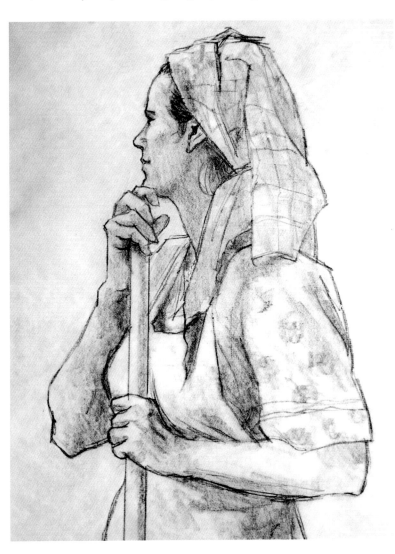

The Finished Painting

After transferring the drawing onto the canvas, my next step is underpainting, applying acrylic paint, highly diluted with water and medium to retain transparency. This is loosely and vigorously brushed onto the white gessoed surface of the canvas. After completing the underpainting, I can begin to get a feeling of the color and tone of the finished painting. The underpainting usually takes about a day to complete. I am now ready to plunge into the final oil painting.

I often like to start the finished painting with a key element suggesting the overall color and tonality of the painting. As with the underpainting, I paint with broad, loose strokes. Depending upon the composition, I'll usually start by painting in the sky. I sometimes paint in the background elements next, working my way toward the foreground, gradually increasing the brightness and contrast. At other times, I will proceed immediately to the area of greatest contrast or deepest tones, usually somewhere in the foreground.

The following section focuses on three paintings, showing their progressive stages.

Detail study for Staying Power — Berlin Airlift, 1948–49.

41

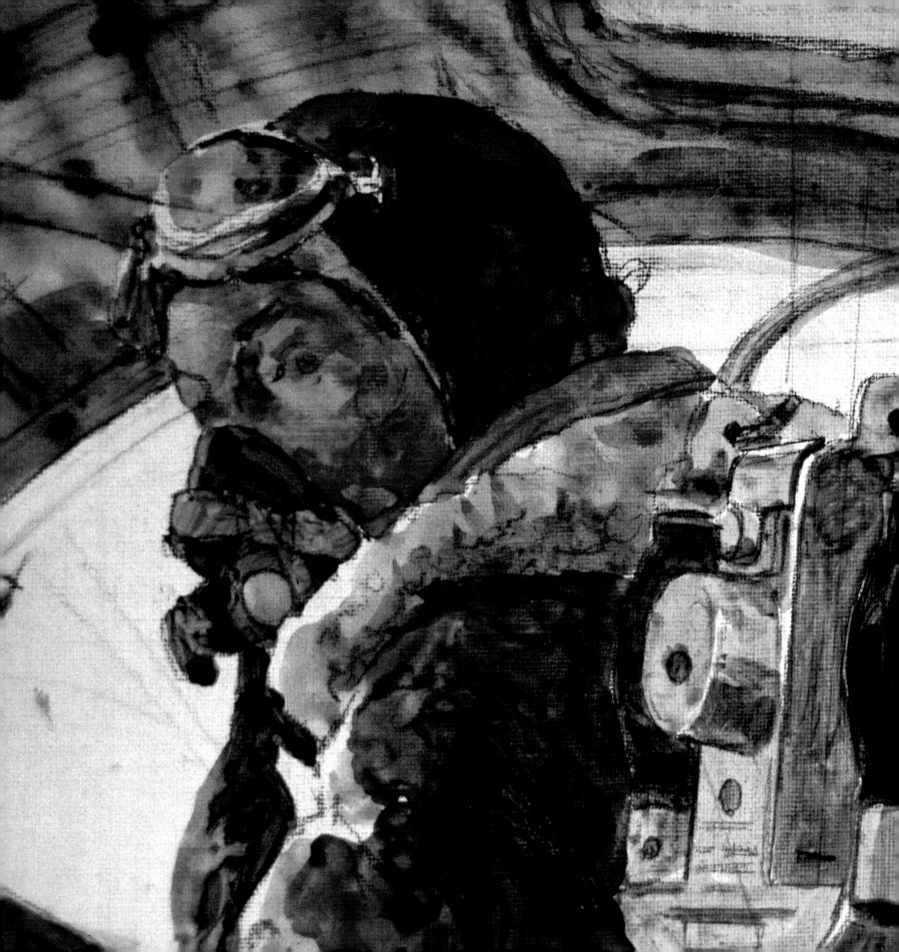

Mission Regensburg

The idea for a painting depicting a bomber crew inside a B-17 during a sortie had been germinating in my head for years. After completing the painting *After the Mission*, I felt it was time to put the idea on canvas.

I chose to put the viewer inside the nose compartment of *Just-A-Snappin*, the lead bomber of the 100th Bomb Group on the August 17, 1943, Regensburg Mission, showing bombardier Lt. Jim Douglass and, directly in front of the viewer, navigator Lt. Harry Crosby. In effect, this was an effort to make viewers feel as if they are a part of the scene rather than merely viewing the painting from a distance.

As part of my research for this painting, I studied and photo-graphed the famous Boeing B-17F *Memphis Belle* at Mud Island in Memphis, Tennessee. Even though the *Memphis Belle* lacked many of the fittings, gauges and hardware it would have had sixty or so years ago, its basic anatomy and layout, such as the position of windows, were similar to *Just-A-Snappin*. I also studied

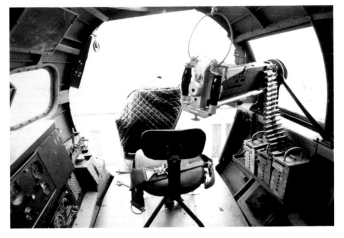

(Above) I took this reference photo of the interior nose section of the B-17F Memphis Belle *in Memphis, Tennessee, with a wide-angle lens.*

(Left) Mission Regensburg *underpainting detail. Acrylic washes were applied over the white gessoed canvas.*

another fortress, *Shoo-Shoo-Baby*, housed at the Air Force Museum in Dayton, Ohio. The interior of this plane was fully equipped and in immaculate condition, though it was a later G model with a different interior configuration and somewhat more advanced instrumentation and hardware (cheek and chin guns, etc.). It was quite the operation to photograph my friend Dave Berry wearing high-altitude clothing, oxygen mask, parachute harness and other gear on the bombardier's seat in that cramped nose compartment in August!

In addition to my hands-on study of actual B-17s, I consulted loads of reference materials — books, technical documents, aircraft construction diagrams. I also contacted Harry H. Crosby, the most decorated navigator in the Eighth Air Force, who told me more about the navigator and bombardier's jobs, particularly during the crucial time over the target.

One of the problems I encountered was showing the correct pieces of equipment, weapons and instruments in the nose compartment. The technology was changing rapidly at that time. I had to establish which instruments were most likely to have been in use in August 1943 and where they would have been located. No two B-17 interiors were alike. Instruments such as oxygen regulators, radio switch boxes, ammunition boxes and electric rheostat heaters for flight suits were often positioned specifically for individual crews.

While I was pondering all of this, I received a package containing several 8 x 10 factory photographs of B-17F nose interiors. These photos, taken during early to mid-1943, helped clarify some of my questions. One valuable source supplied me with actual equipment from that time period. My studio became a mini historical museum, with ammunition belts, navigators' instruments, flight helmets, switches, etc. For a time, I even had an entire .50-caliber aerial machine gun.

I chose as my point of view a position about a foot or so behind the bulkhead that separates the nose compartment from the rest of

the plane. By eliminating the bulkhead, I was able to create a clear view looking forward, with the navigator seated directly in front of viewer and the bombardier seated in his position at the bombsight in the nose. I felt that this view would best show the somewhat claustrophobic atmosphere yet convey the drama of the moment — that moment just after the bombardier has released his salvo of bombs on the Messerschmitt factory in the city of Regensburg and has given the thumbs-up sign to Lt. Crosby, who then records the time of the bomb release in his log before charting a course for North Africa.

Before arriving at this setting, I had tried sketching out other ideas. For instance, having the two men manning and firing their machine guns. I quickly rejected this idea, as it reminded me of countless war books that I had seen and other art I had done in the past. I wanted to depict these men simply doing their basic jobs with quiet heroism amid the tumult of deadly flak bursts just outside the plane's windows.

Once I decide how the scene should be depicted and from what viewpoint, I start to refine my composition and to craft a more careful drawing. This drawing was enlarged and transferred to Belgian linen. Only at this stage could I finally begin the actual painting.

It is difficult to estimate the time involved in producing Mission Regensburg. The initial inspiration came many years earlier while visiting the former home of the 100th Bomb Group at Thorpe Abbotts, located on farmland in England's East Anglia region. Later, it took close to a year from the time I started my research until I began to put paint to canvas. Once begun, the painting itself took another two months to complete.

Through *Mission Regensburg*, as well as through my other historical paintings, I have attempted to draw the viewer into the scene. I have used composition, light and atmosphere to achieve a mood and an emotional impact, to provide the viewer with a more personal experience.

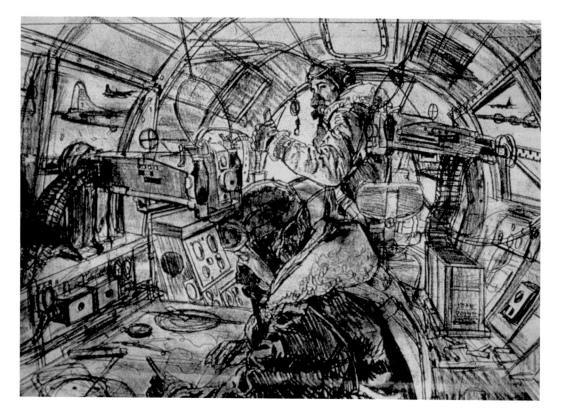

(Left) Early compositional study for Mission Regensburg. *Note various changes in finished painting.*

(Right) This close-up at near actual size features an inset showing the progression from underpainting to overpainting in oil, specifically the shearling texture on the navigator's collar.

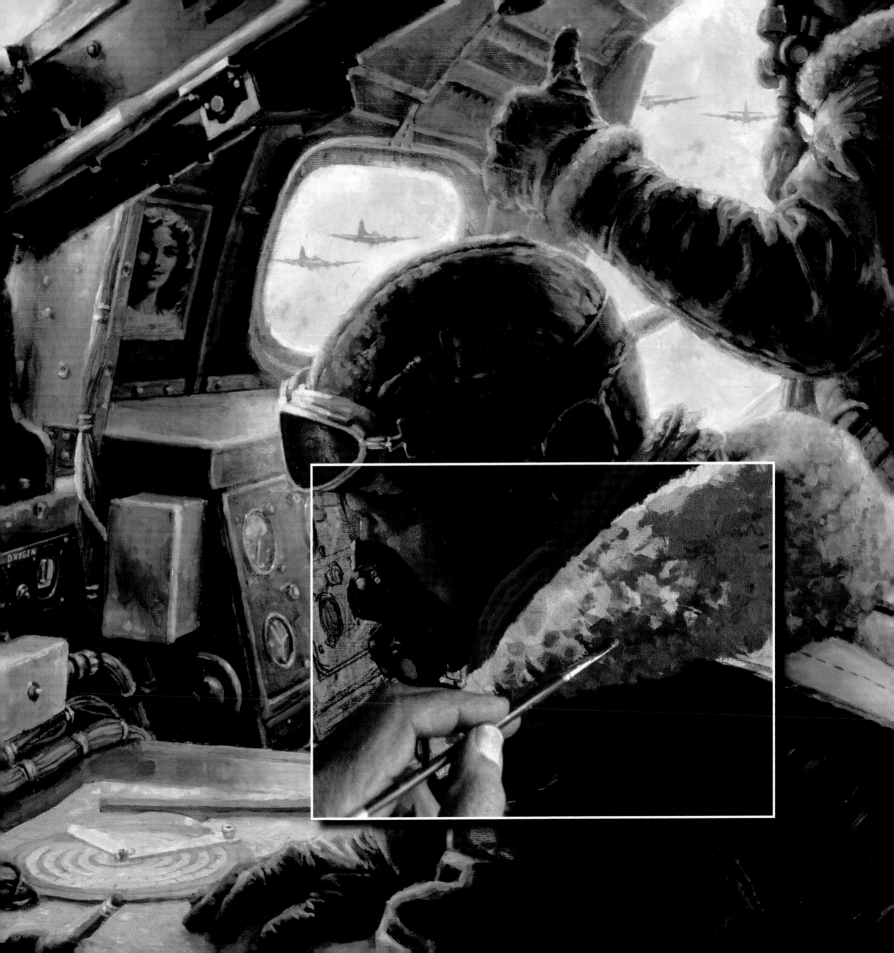

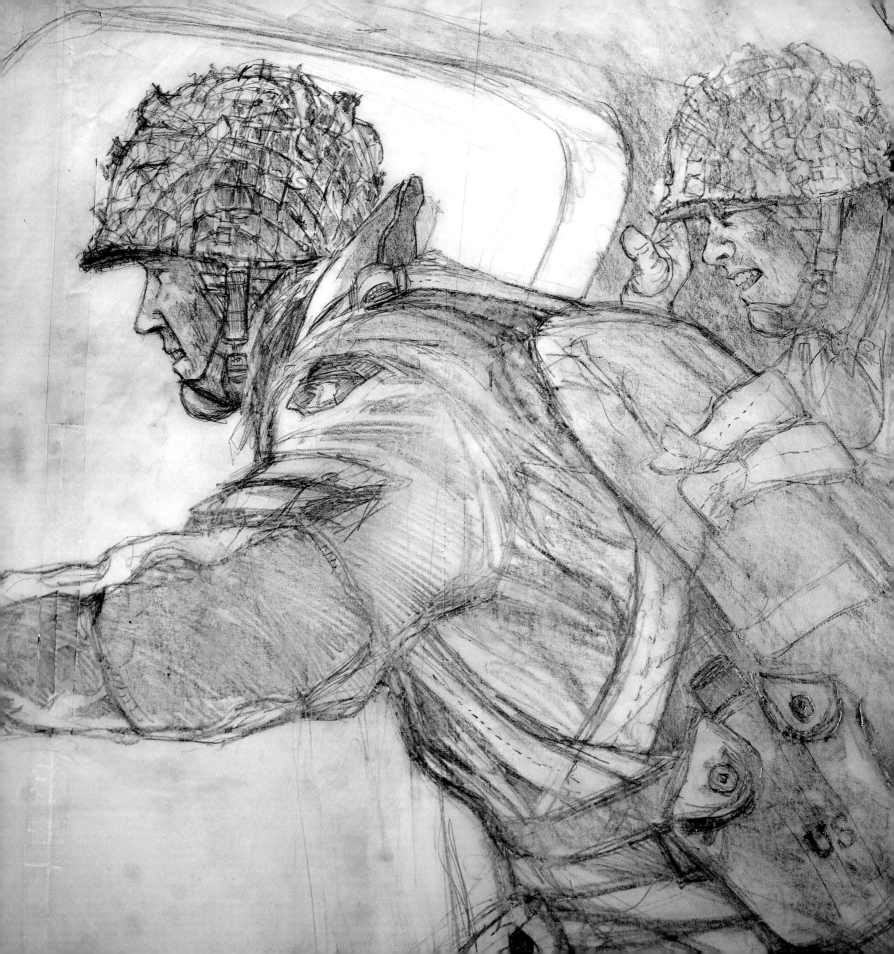

Night of Nights

The late historian Stephen E. Ambrose's epic work *Band of Brothers*, chronicling the lives of the men of E Company, 506 Parachute Infantry Regiment, 101st Airborne Division, was a huge bestseller when it was pub–lished in 1992. Nine years later, it became an HBO television miniseries, with Steven Spielberg and Tom Hanks as its executive producers. The production went on to win twenty Emmy Awards, a Golden Globe and numerous additional awards, both domestic and foreign. Subsequent DVD sales worldwide exceeded all expectations.

This enthusiasm for the true stories of wartime veterans is shared by Bryan and Adam Makos, two enterprising brothers who, with the help of friend Joe Gohrs and the active support of their family, formed Valor Studios, publishers of *Valor* magazine. Based in Montoursville, Pennsylvania, Valor Studios' mission is "to honor veterans by telling their stories on canvas and in print." As part of their ongoing commissions, I was asked to produce a painting dramatizing Easy Company's parachute drop into Normandy the night before the beach landings.

In June 1944 General Eisenhower, Supreme Commander of Allied Expeditionary Forces, along with American and British commanders, embarked on Operation Overlord, a multi-pronged invasion of the

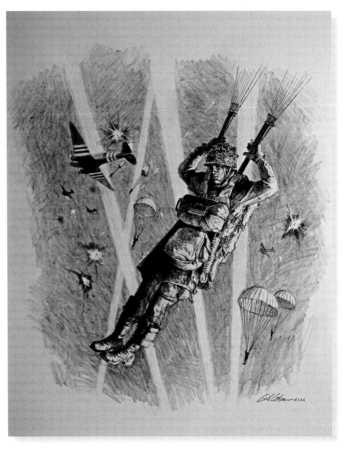

(Above) Pencil drawing of descending paratrooper.
(Left) Detail, pencil study of lead paratrooper.

coast of Nazi-occupied France. British and Canadian forces were to land along the eastern end of Normandy toward Caen, and the Americans to land along the western end toward the Carentan Peninsula. The beach landings were set for 0630.

Approximately six hours before the landings, the British 6th Airborne Division were to land gliders and pathfinder paratroops in the vicinity of Ranville and the Orne Canal, east of the British and Canadian landings. Meanwhile, the American 82nd and 101st Airborne Divisions were to drop their pathfinders on the western flank of the American beachhead, signaling drop zones (DZs) with lights and radar beacons. An hour later, the main force of 800 C-47s were to drop paratroopers onto the DZs. The American paratroopers' objectives were to secure the western flank of the Cotentin Peninsula and cut off German reinforcements heading toward the American beachhead.

There is a well-known wartime saying, "Battle strategy and tactics can be thoroughly planned — until the first shot is fired." Many of the paratroopers became lost due to massive anti-aircraft fire, ground fog, incorrectly marked DZs and because the Germans had flooded many of the landing zones. In spite of these impediments, the Allied strategy worked. German reinforcements never made it to the invasion beaches, in part,

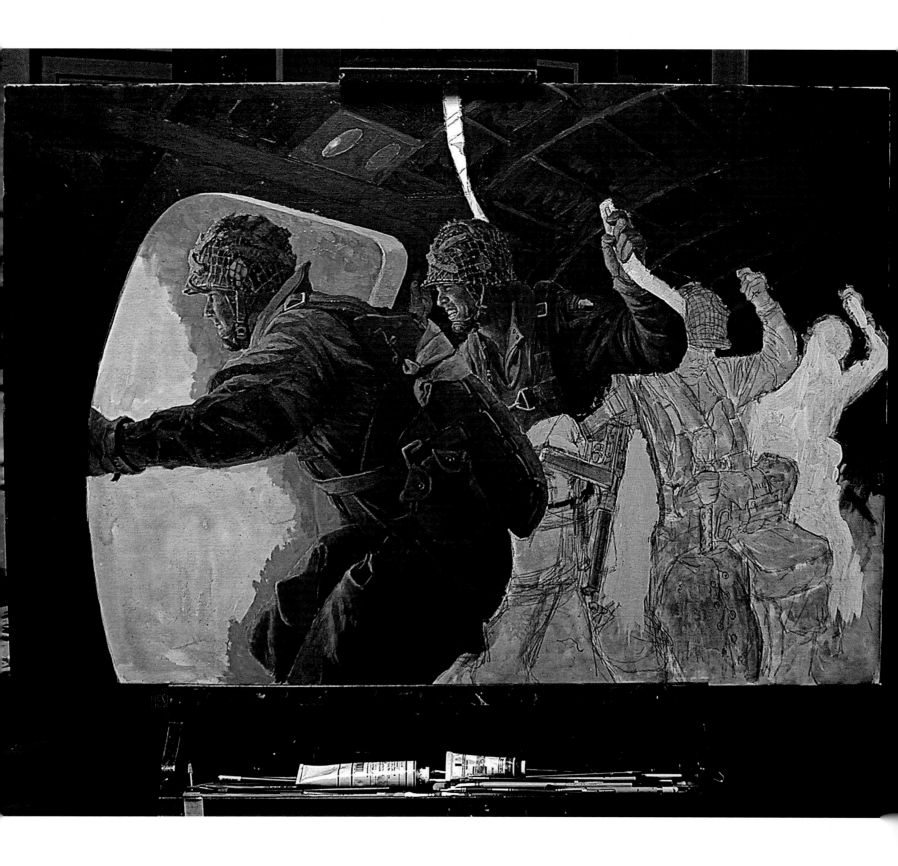

because of the massive confusion that took place that night among the German forces. Some of the German commanders believed that there was a much greater force of airborne divisions than there really were. Other German commanders held back reinforcements, still thinking that the main invasion force would be landing farther up the coast to the east at the Pas de Calais.

To depict this significant moment in history, the beginning of the liberation of Europe from Nazi oppression, I chose as my point-of-view the interior of a C-47, adjacent to the jump door, a view that might be seen by the jumpmaster or crew chief. The men are hooked up, with the lead man in the stick, standing at the open door, bracing his hands against the sides of the doorway. The second man grimaces from the blast of air coming in as well as the bright flashes of anti-aircraft explosions. The plane shakes violently from those explosions and from the zigzag pattern the pilot must fly to avoid being hit. The jarring motion throws the paratroopers off balance. Some fall onto the deck. Others are thrown against the plane's bulkhead. At that instant, the green jump light goes on. Within seconds, the entire stick of men will hit the silk. Most will make it to the soil of France, but some will not.

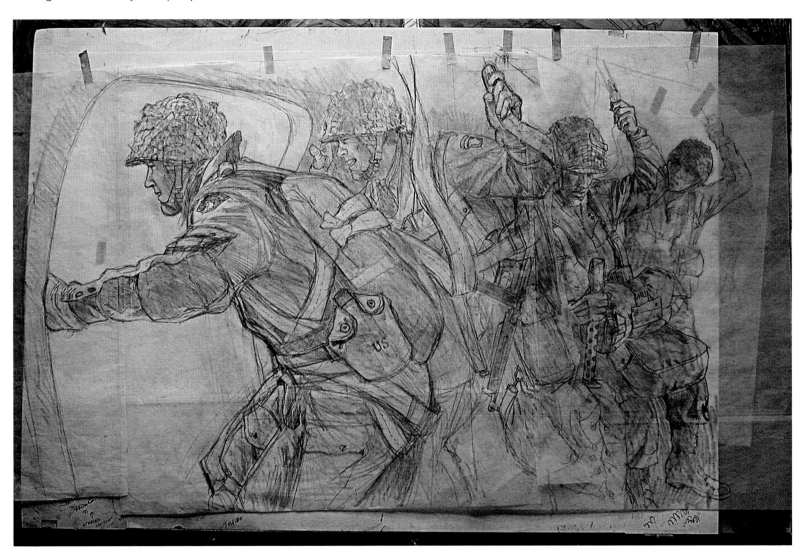

(Left) Partially painted figures and aircraft interior. (Above) Working drawing for Night of Nights.

Eisenhower had a paper distributed to all of the personnel involved in the invasion. It read: "Soldiers, sailors and airmen of the Allied Expeditionary Force! You are about to embark upon a great crusade, toward which we have striven these many months. The eyes of the world are upon you…. Good luck! And let us all beseech the blessing of Almighty God upon this great and noble undertaking." Col. Robert Sink, Commander of the 506th Parachute Infantry Regiment, added this message to the men under his command: "Tonight is the Night of Nights. May God be with each of you fine soldiers."

Many people assisted me in my endeavor to make this depiction of that "Night of Nights" as authentic as possible. Michael Glick and ten members of the 101st Airborne Living History Organization spent a sweltering June day posing for me inside a very hot C-47 while Jack Lefferts and I took reference photos. They wore full paratrooper battle gear (helmet, boots, main and reserve parachutes with harnesses, weapons, ammo, gloves, etc.). Historian Jake Powers is one of the leading authorities on E Company, 506 PIR, 101 Airborne Division. His knowledge of the most minute details proved extremely helpful. As they have done so many times before, Jack Lefferts and Dave Berry offered their assistance and suggestions. I am very grateful to all.

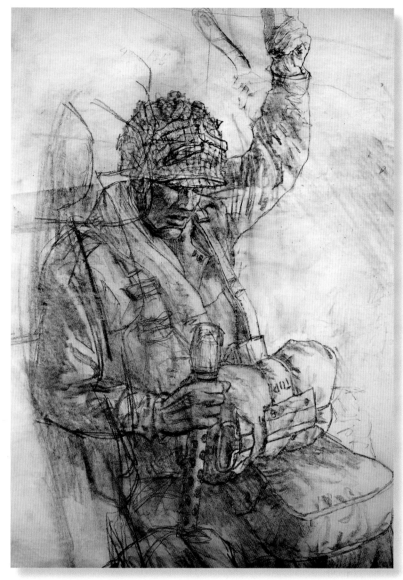

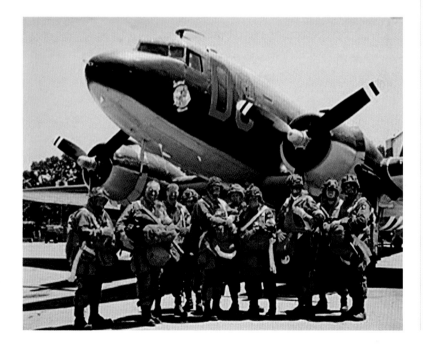

(Above) *Study of third figure in jump stick.*
Note 30-caliber machine-gun barrel sticking out of leg bag.
(Right) *Note progression of equipment details.*

(Left) *Members of the 101 Airborne Living History Organization.*

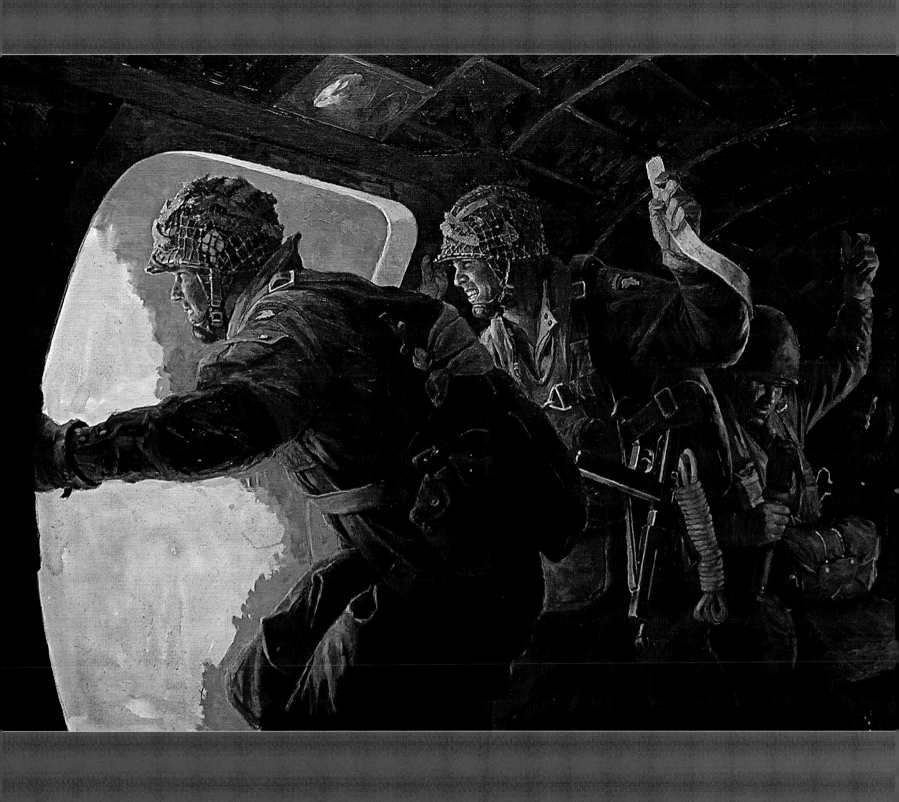

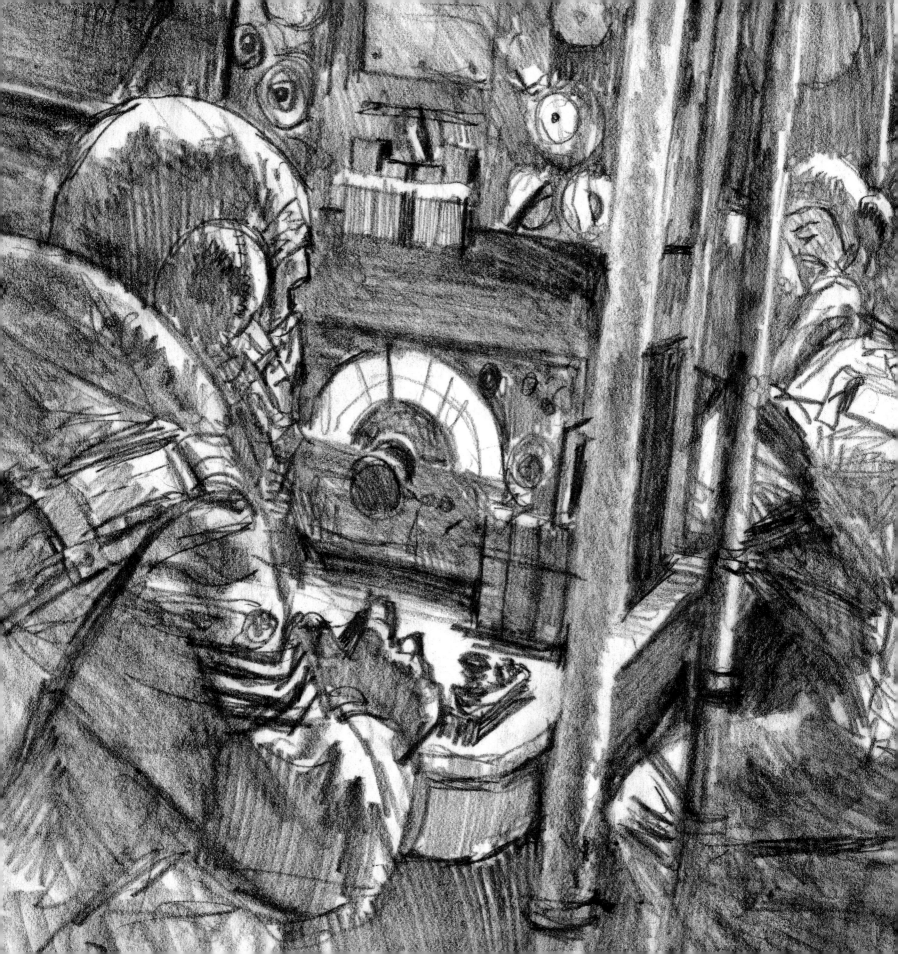

We Guide to Strike

Shortly after I completed *Mission Regensburg*, I had the idea of doing a similar painting depicting the interior of a British Lancaster bomber during a night mission. I set the idea aside for many years until later, Colin Smith, of Vector Fine Art Prints suggested the possibility of a Pathfinder Force theme.

Colin arranged access to the interior of the Lancaster bomber on permanent display at the Imperial War Museum at Duxford, UK, where I was granted permission to take detailed photographs. Fortunately, that aircraft was completely fitted out with its original instrumentation from WWII, missing only the H2S radar, which I was able to incorporate into the painting later. If you look at the painting, you can see the H2S radar just behind the pilot's armored seat.

I chose as my point of view a position looking forward from the wireless operator's station. Comp–ositionally, the viewer's vision flows from the wireless operator's back, then curves around toward the two navigators, past the flight engineer and the pilot, leading to the menacing night sky with its death-dealing flak and stabbing searchlights.

Colin then put me in contact with Jack Watson, a former flight engineer/bomb aimer with 156 Squadron Pathfinder Force. Jack was a great help, illuminating the role of the Pathfinder Force and explaining the jobs of the individual crewmembers.

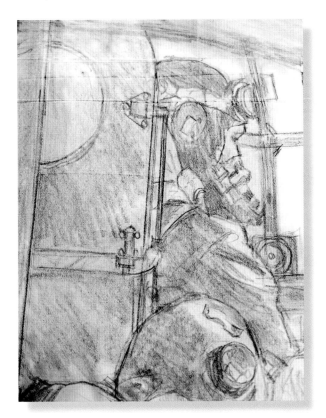

(Above) *A study of the Lancaster pilot.*

(Left) *Extreme close-up detail of preliminary sketch. No models posed at this stage.*

After consulting several more references, I came up with the following scenario: Flying ahead of the main bomber stream, a Lancaster of 156 Squadron Pathfinder Force makes a run over its target in the Ruhr Valley. The Ruhr was wartime Germany's greatest industrial region and perhaps the most heavily defended target in the world. Extreme concentration can be seen in the crew's eyes as they focus on the critical task of marking the target. Because the valley was shrouded in an almost permanent haze of factory smoke, visually pinpointing targets in the towns below was nearly impossible at night. But Pathfinder Force was able to penetrate the pollution using a British aerial blind-bombing system known as Oboe. This technology afforded the ability to seek out targets regardless of weather conditions and to illuminate desired areas with brilliant target markers that reflected back up from the ground through the haze. The crew's precise identification of the target locations enabled trailing bombers to strike to be incisively and accurately, further crippling the German war effort.

I dedicated this painting in honor and memory of the many thousands of crewmen with RAF Bomber Command Pathfinder Squadrons who heroically served their country by performing the extremely dangerous task of nighttime target-marking without fighter escorts or self-protective bomber formations. The painting's title, *We Guide to Strike*, is the motto of 156 Squadron Pathfinder Force.

Later, Jack Watson offered the following praise for this project: "When Vector Fine Arts published the prints of Gil's painting of *One of the Many*, I was invited to join the team who were signing the prints at Duxford. It was then that Colin Smith of Vector Fine Arts told me that he was commissioning a painting from Gil to be a tribute to the Pathfinder Force of Bomber Command. I was honoured by Colin when he asked me to assist Gil as an adviser on the crew positions during his production. Colin explained that the idea was not to produce just another picture of a Lancaster but to show what it was like from the inside of a Pathfinder Lancaster approaching a target. Gil started by emailing me a pencil sketch of the first prototype. This in itself was a masterpiece and I was able to tell Gil what alterations would be needed to the composition concerning the crew positions and I emailed back my observations. After another three sketches the format of the picture was ready. Gil was now able to produce his masterpiece you see today. It says something of what a master Gil Cohen is, that the time between sketches was so quick. I mentioned that the sketches in themselves were brilliant, so much so that I downloaded each one and I have kept them. At the launch at Duxford, during the signing, it was very pleasing when so many ex-Pathfinders and aircrew said how authentic the finished picture was. Gil Cohen has captured the tension and concentration of a crew on their run into the target. Thank you, Gil, for this lasting tribute, not only to Pathfinders but also to all aircrew."

(Left) Detail of a working drawing.
(Right) The same actual size detail as finished painting.

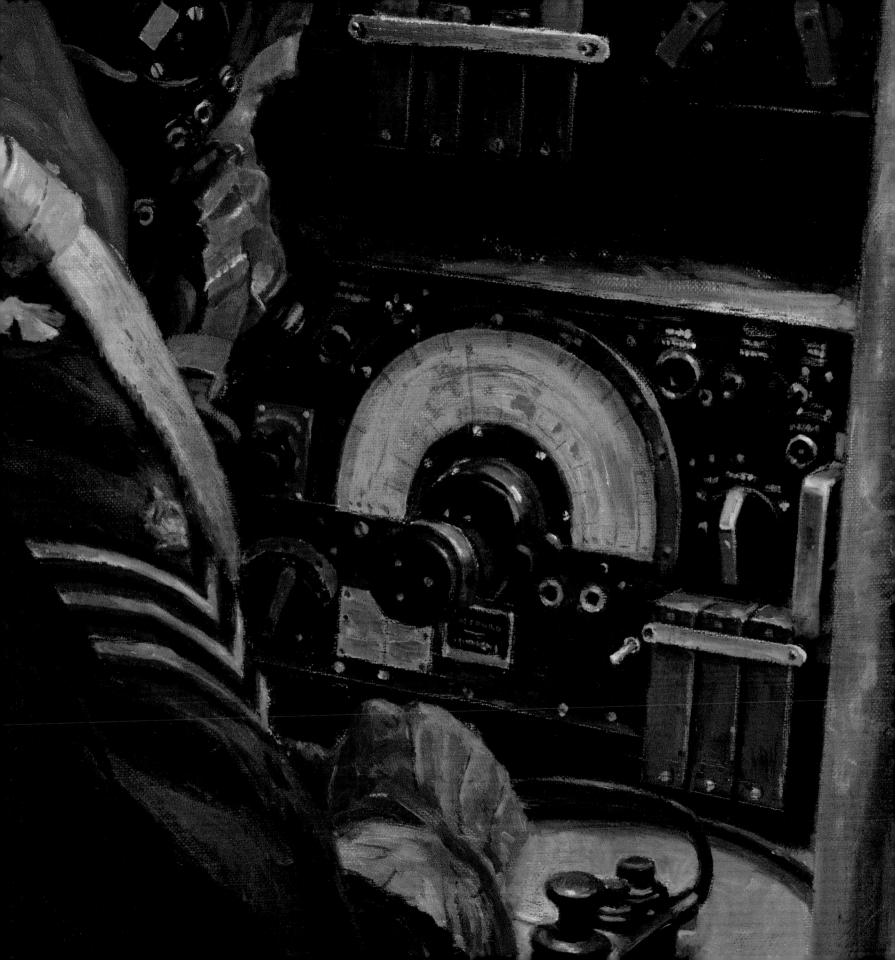

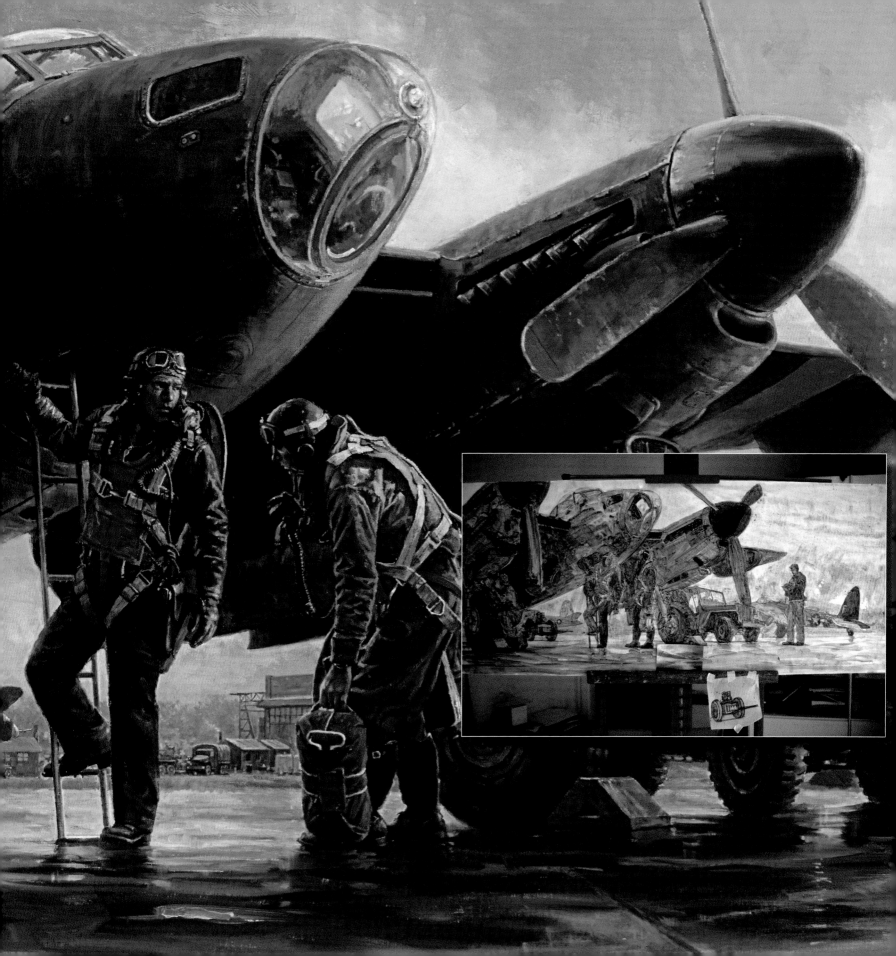

Eyes of the Eighth

The inspiration for the painting *Eyes of the Eighth* came from a communication sent to me by Charles "Chuck" Austin, a veteran of the 25th and a retired motion picture photographer. Chuck suggested that I consider the 25th Bomb Group as a possible subject in my continuing series of Eighth Air Force paintings. After reviewing their exciting exploits and unusual history, I knew that the 25th Bomb Group would be the subject of my next painting. As research, I sought out existing photographs, scrapbooks, 25th Bomb Group newsletters and personal narratives. Much of the material came from Chuck and other former Bomb Group members. A special note of thanks goes to Bob "Paddy" Walker, for his informative description of the operations of the 25th.

I decided on a composition that suggests the anticipation and apprehension of the two airmen as they climb into their aircraft, the dark Mosquito, with its unmistakable silhouette. The Air Force Museum in Dayton, Ohio, gave me access to its Mosquito aircraft, currently on exhibit, and I used live models. One of my models was Jack Lefferts, an expert on the U.S. Army Air Force during the Second World War. He suggested I pose a ground crewman on the starboard side making a last-minute inspection of the landing gear, while the crew chief, on the port side, signs off his aircraft checklist.

Sometime after I had begun the underpainting phase, I began to have a nagging feeling that the painting was lacking something. There is a tendency to lose one's objectivity once you have been intensively focused on the work for a long a period of time. I asked two artist friends to come to the studio and critique the progress of my painting. What they had to say was so visually apparent that I could hardly believe that I had not seen it before.

(Left) Inset shows underpainting stage.
Note changes made to navigator figure and position of far propeller.
This improved the composition dramatically.

The horizontal composition is partially made up of vertical elements. Viewed from left to right, these verticals are: the starboard propeller blade on the nearest Mosquito; the two crewmen; and the bottom blade of the port propeller and the crew chief with his clipboard. Collectively, these vertical elements gave the scene a static look. They stopped the viewer's eye from flowing through the painting.

To correct this problem, I changed the position of the navigator. Instead of him standing upright, I had him bend to pick up his parachute pack. I then turned the port propeller to the right of the navigator figure so that no blade pointed toward the ground. With more diagonals, the scene flowed and provided the intended emotional impact. Once past this difficulty, progress on the painting went relatively smoothly.

This project could not have been completed without the invaluable assistance of Charles Austin, Paddy Walker, Morton Hunt, Willis Locke and Charles Moore, all veterans of the 25th Bomb Group; Jack Lefferts, Joe DiFazio, Dave Berry, Mark LaBella and Rob Millard, who patiently endured my direction in their tireless posing; Major General Charles Cooper, USAF (Ret.), Bob Spalding and others from the U.S. Air Force Museum in Dayton; the accomplished writer and aviator Ann Cooper, who made the initial connection between the 25th Bomb Group veterans and myself; Dan Patterson, for his gifted guidance relating to his photography; and artists Bob Milnazik and the late Isa Barnett, whose timely critiques contributed immensely to the success of the painting.

The Galleries

Return to the Bump / Biggin Hill, Summer 1940

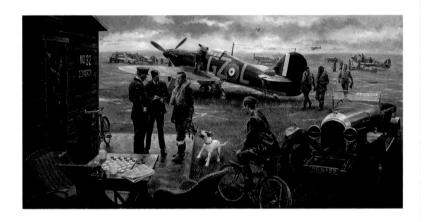

This Battle of Britain theme was suggested to me by Colin Smith of Vector Fine Art Prints, who further recommended that I feature top-scoring British ace Flight Lieutenant Pete Brothers of No. 32 Squadron. I agreed.

Flight Lt. Brothers requested that the painting include his English bull terrier, Merlin (whom he claimed would recognize his returning Hurricane fighter and chase the plane as it taxied down the tarmac), and his old Bentley motorcar with its "Air Defence Priority" windscreen sticker. My initial reaction to the windscreen sticker was that it would distract the eye and clutter the composition, but for Pete, it was an important element. Every morning, while it was still dark, he had driven to Biggin Hill. When the guards at the numerous checkpoints spotted that sticker, they knew that the driver of that vehicle was a fighter pilot defending the British homeland during that crucial time, and they quickly waved Pete through.

Today, Biggin Hill is a busy commercial airport located outside of London, and obviously its configuration has changed over the many decades since the war, but the general landscape remains the same. In preparation, I worked with archival images, augmented by contemporary photos of Biggin Hill supplied by Colin Smith.

In this painting, we see Flight Lt. Brothers being greeted by Merlin upon his return to base at RAF Biggin Hill. The intelligence officer questions him about the intense air battle that has just taken place in the skies high over southern England, while the ground crew work diligently to prepare the Hurricanes of 32 Squadron for the next sortie, later that day. Pete's Bentley can be seen parked in the right foreground with its "Air Defence Priority" windscreen sticker. On the table to the left we see a set of draughts, a folded copy of the *Daily Express* and tea cups — signs of airmen having passed the time while waiting for the signal to "scramble."

The summer of 1940 was one of the most crucial in the history of Great Britain. With the fall of France, Hitler's armies now occupied most of Europe. Germany was poised for the invasion of England, but first it was vital that the Luftwaffe establish dominance in the skies over Britain. The Royal Air Force would not let this happen. It was men such as Pete Brothers and others of the RAF who stopped Hitler in his tracks.

Return to the Bump / Biggin Hill, Summer 1940 is a testament to the enduring courage of the brave men and women who won the Battle of Britain. My friends Jamie Ivers and Scott Rall, along with seven other members of the RAF 601 Squadron Living History Reenactors, were of invaluable assistance with their technical expertise, suggestions and posing. The site of the reference photography was outside the Fighter Factory, a warbirds restoration complex owned by Jerry Yagen. Jerry also loaned me the use of his gorgeously restored Hawker Hurricane. Lastly, thanks to Don Hinmon for the use of his handsome 1923 Bentley.

Gentlemen, As You Were / Dowding at Hornchurch, 1940

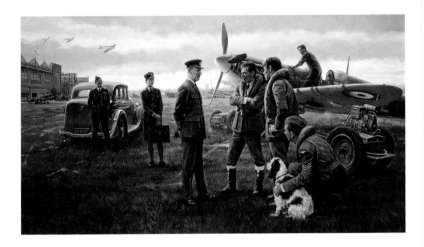

Air Chief Marshal Sir Hugh Dowding, in charge of RAF Fighter Command, chats with recently returned Spitfire pilots during an impromptu visit to RAF Hornchurch in the early stages of the Battle of Britain. Their intense clashes with the Luftwaffe in the skies over southern England still resonate in their minds. Dowding would refer to them as "my fighter boys."

It was to Dowding's "fighter boys" that Prime Minster Winston Churchill expressed the nation's gratitude in his historic speech to the House of Commons on August 20, 1940, when he eloquently said: "Never in the field of human conflict was so much owed by so many to so few. All hearts go out to the fighter pilots, whose brilliant action we see with our own eyes day after day." And it was Dowding himself who had done so much to prepare Britain's defenses against a German invasion years before the start of WWII.

London stockbroker Scott Bryant commissioned this painting. Scott's home, as a boy in the 1970s and '80s, was on a tract of land that was once RAF Hornchurch, a fighter base made famous during the Battle of Britain. Scott, along with Colin Smith of Vector Fine Art Prints, suggested I feature the renowned Sir Hugh Dowding. Reference was supplied by Colin and by Richard Smith (no relation), an expert on the history of Hornchurch.

I began by sketching tiny thumbnails, putting the viewer at various points of view until I arrived at the most effective perspective for conveying the narrative of the story. In the foreground are three Spitfire pilots, two officers and one sergeant-pilot. Their mascot, an English cocker spaniel, greeted them upon their return to Hornchurch, following their battle against German bombers and Messerschmitt fighter planes. The exhausted young pilots discuss the events of that morning and are smoking cigarettes when a staff car pulls up and out of it emerges the big chief — Dowding himself! As "the Old Man" approaches, they quickly put out their "fags" (cigarettes) and snap to attention, saluting Dowding. Dowding responds, "Gentlemen, as you were."

Observe the contrast between Dowding's military bearing, his hands clasped behind him, and the more informal body language of the exhausted young pilots. The sergeant-pilot is kneeling down, affectionately holding the dog. (Another reason for clutching the mascot might be to prevent their friendly pet from jumping on the Air Chief Marshal with muddy paws!) Aesthetically, I wanted to break up the vertical elements of the standing figures. The kneeling figure brings the viewer's eye to Dowding, then to the two pilots, before leading back to the background.

Standing on the wing root of the Spitfire, just behind the pilots, is a mechanic performing maintenance. His task is to make sure that when the bell rings for the next "scramble" that aircraft will perform at its maximum best. On the right sits an omnipresent starter trolley, which was fitted with a battery and connected to the aircraft to fire up the engine. Dowding's driver and assistant, a Women's Auxiliary Air Force (WAAF) officer, stands behind the boss. Next to the staff car, we see the base adjutant. In the morning sky, Spitfires prepare to land. Just to the right of Dowding, along the distant horizon, we can make out the towering chimney of St. George's Hospital, which proved to be a hazard to inexperienced pilots taking off and landing at Hornchurch. It wasn't until after the war that the chimney was shortened considerably.

In Alis Vincimus (On Wings We Conquer)

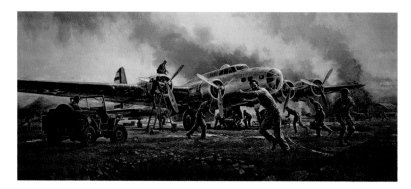

On Sunday afternoon, December 7, 1941, I was at home in Philadelphia listening to the radio when regularly scheduled broadcasts were interrupted by the news flash that Japan had attacked the U.S. fleet at Pearl Harbor. I was a schoolboy, and the excitement from the adults around me made it seem as though the world had changed forever. Looking back on that time, I realize that the world did indeed change forever.

Not long after that cataclysmic event hurled America into the Second World War, I began hearing the name Captain Colin Kelly Jr. on the radio and reading about him in newspaper articles. In those dark, desperate days America needed a hero badly, and Kelly was lauded as the first American hero of WWII. One of the many accounts told how Kelly's B-17 bomber was crippled by Japanese anti-aircraft fire off the coast of the Philippines, so he dove his plane down the smokestack of a Japanese battleship. In gratitude, President Franklin Roosevelt proclaimed that the President of the United States in the year of 1956 was to give an automatic appointment to West Point to Colin Kelly III, the then infant son of Colin Kelly Jr. As it turned out, President Dwight Eisenhower did appoint Colin Kelly III to West Point. However, young Kelly declined any special privileges and passed the exams to enter the academy on his own merit.

Titled for the motto of the 19th Bomb Group, *In Alis Vincimus (On Wings We Conquer)* depicts the morning of December 10, 1941, and the following scenario: Captain Colin Kelly Jr. and his bomber crew flew in from Del Monte Field, Mindanao, the previous evening. Morning finds him in the radio shack of the American airbase at Clark Field, the Philippines. Suddenly, news comes in that a Japanese bomber formation has just crossed the coast of Luzon, presumably on their way to Clark Field for a second attack. The first attack, on December 8, destroyed many aircraft on the ground. Kelly dashes out of the radio shack, jumps into a jeep and races to where his B-17C is being serviced and loaded with gasoline and bombs. In the painting, we see Kelly running, shouting to the mechanics and armorers to stop what they are doing, and summoning his crew to board for take-off before they too are caught on the ground when the Japanese bombers fly over. In the background, we can see evidence of the destruction from the previous raid.

At 0930 Kelly and his crew took off loaded with three 600-pound bombs. Out to sea, they spotted warships bombarding the coast. Bombardier Meyer Levin targeted a light cruiser of the Nagara class and dropped his three bombs. Two missed the target, but the third scored a hit.

As Kelly was returning to Clark Field, his B-17 was attacked by Zeros, led by noted Japanese ace Saburo Sakai. Before Kelly's plane crashed near Clark Field, several men were seen to have bailed out. The true heroism of Colin Kelly Jr. was his attack on the Japanese invasion fleet, without escort, amid swarms of Japanese fighters. In addition, Kelly stayed at the controls of his crippled bomber, allowing most of his crew to parachute to safety.

I was commissioned to create this painting by Eugene Eisenberg of Adventura, Florida, who has the largest private collection of original aviation paintings in the world and who also has a deep interest in the early days of the Pacific theatre of WWII.

In the summer of 1998, the original painting was unveiled at ceremonies in Kelly's hometown of Madison, Florida. I will always have very fond memories of my time spent with Colin Kelly Jr.'s younger sister, Emmy, her daughter, Mary, their extended family, and the citizens of Madison, as well as Bob Altman and Jim Halkyard, veterans of Kelly's aircrew on that fateful day.

We Guide to Strike / The Enemy Above

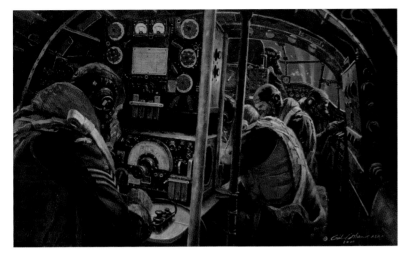

See extended description of We Guide to Strike *beginning on page 53.*

In *The Enemy Above* I sought to convey the tense, dark, damp, almost suffocating atmosphere inside a German U-boat during the deadly games of "cat and mouse" that took place beneath the surface of the Atlantic during the Second World War.

In researching *The Enemy Above*, I traveled to the Chicago Museum of Science and Industry, accompanied by Aaron Hamilton and Frank Schwuchon, two experts on the subject of WWII German U-boats. They were able to guide me as to where controls and machines were located and explained the function of each. I spent three hours in a U-boat control room sketching and taking photographs in order to determine the most effective point of view. For me, putting the viewpoint at the captain's map table seemed to work best.

The reason for traveling to a location site to research a painting isn't just to obtain technical information. Spending over three hours in the control room of U-505 gave me a brief hint as to the claustrophobic dankness a U-boat crew would have felt while being down in the depths of the sea for weeks or months at a time, sometimes exaggerated by the terrifying anticipation of your boat imploding at any moment as depth charges detonate progressively closer and louder. Weeks later, back in my studio, I could still recall the ambience of U-505's interior as I applied each brushstroke to the painting.

The following is the scenario of the painting as described by noted historian Aaron Hamilton: "Detected amidst an Allied convoy at night, the U-boat captain yells, 'Alarm!' as the crew on watch drop into the U-boat and man their stations during the ensuing crash dive. Explosions rock the U-boat as a volley of depth charges are dropped from a pursuing Allied destroyer, defending the wounded convoy. Time stands still in the control room of the Type IXC U-boat as the crew hopes to evade the attacking destroyer. In the foreground, his face heavy with the burden of command, the U-boat's captain leans on the map table while deciding what his next move will be in the prevailing war of nerves with his counterpart onboard the destroyer.

"Bracing himself, the chief engineer eyes the illuminated array of depth gauges, while his presence reinforces the strained nerves of the helmsmen trying to keep the U-boat at a level keel. Forward of the periscope housing, crewmembers tensely listen to the increasing crescendo of sonar pings and propeller wash, knowing that their survival depends upon the decisions made by the captain in the upcoming minutes.

"By late spring of 1943 the German U-boat threat to the vital Allied logistic lifeline in the Atlantic was at its end. No more 'happy times' presented themselves to the U-boat crew, as increased convoy defenses and new technological advances began to take their toll on the feared Wolfpacks. Despite the increasing loses, U-boat crews maintained their morale under conditions that would take the lives of almost three out of four crewmen by war's end."

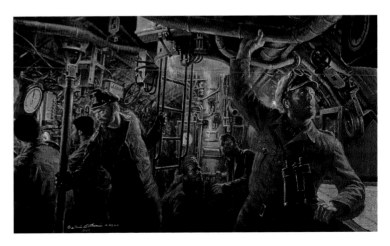

Return to the Bump /
Biggin Hill,
Summer 1940

Oil on linen, 50" x 26", 2005.
Collection of Eugene Eisenberg.

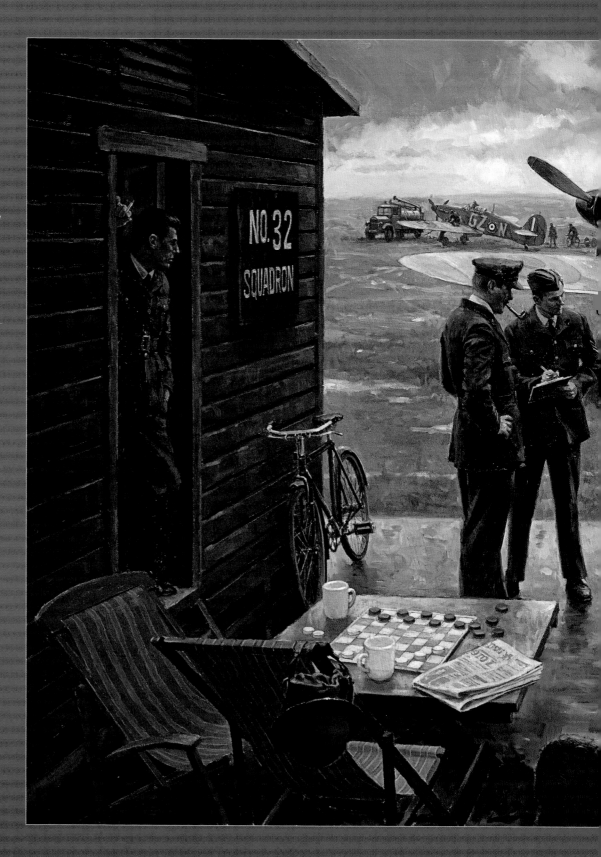

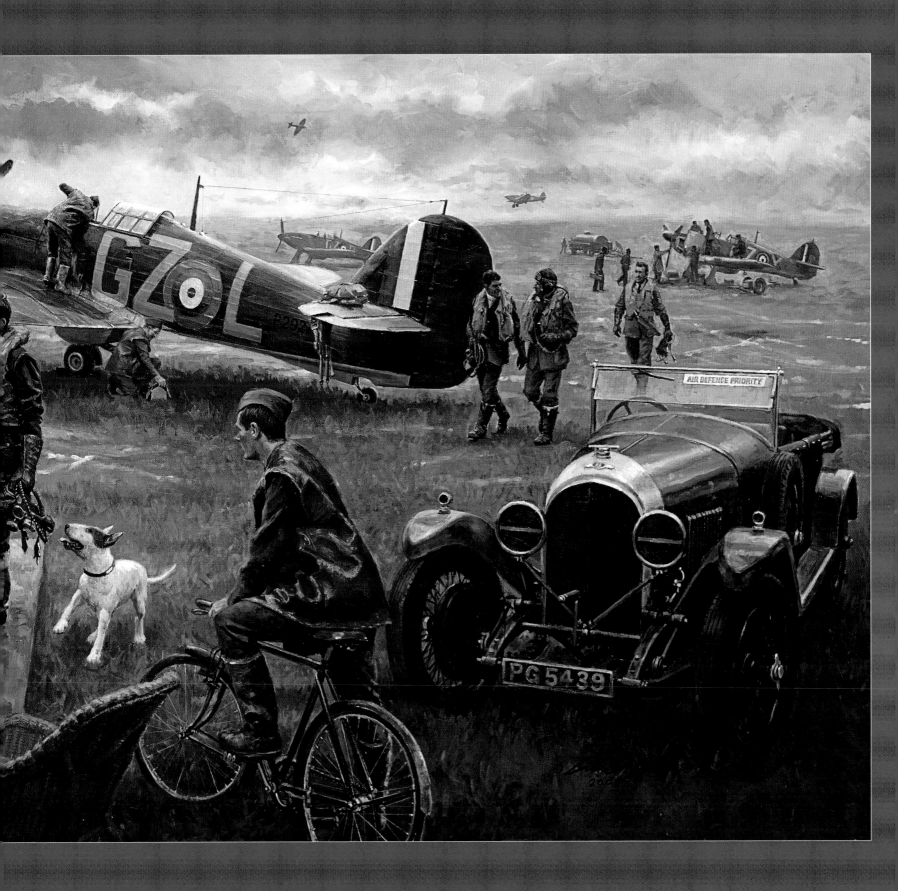

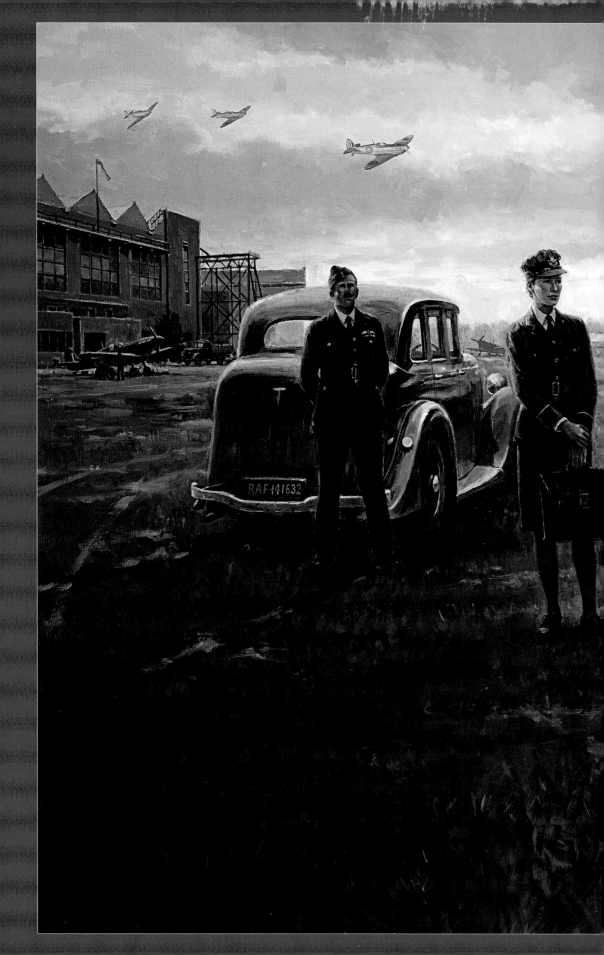

Gentlemen, As You Were / Dowding at Hornchurch, 1940

Oil on linen, 48" x 28", 2006.

Collection of Scott Briant.

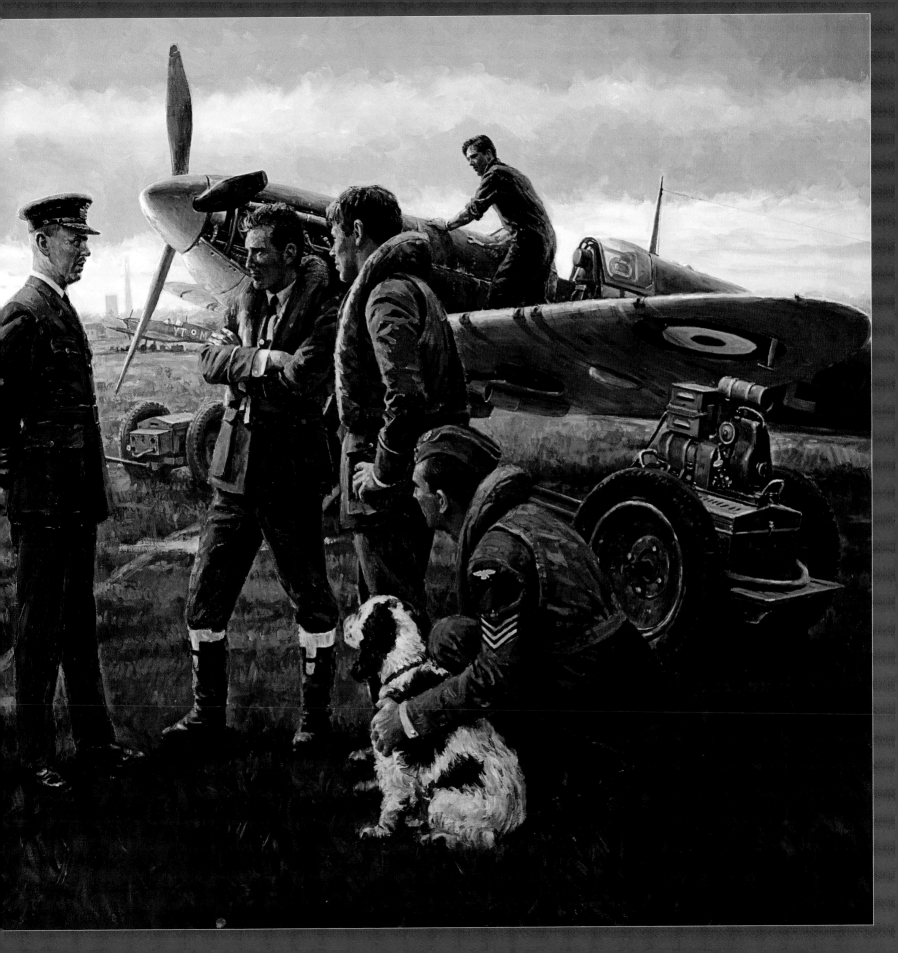

In Alis Vinsimus (On Wings We Conquer)

Oil on linen, 88" x 40", 1998.
Collection of Eugene Eisenberg.

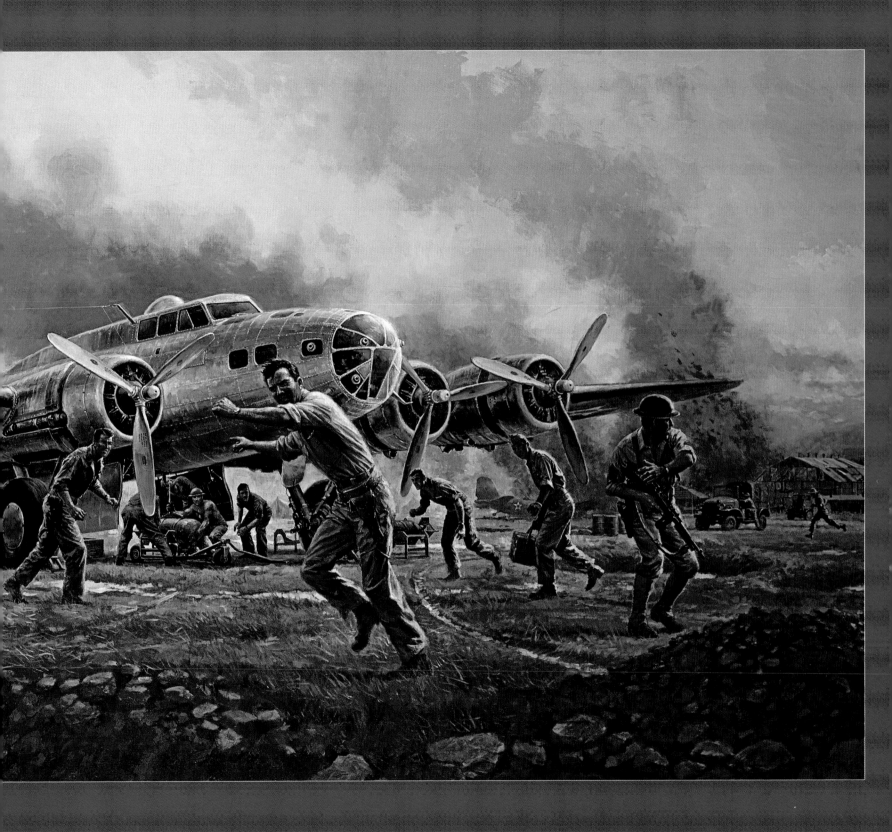

We Guide to Strike

Oil on linen, 38" x 28", 2006.

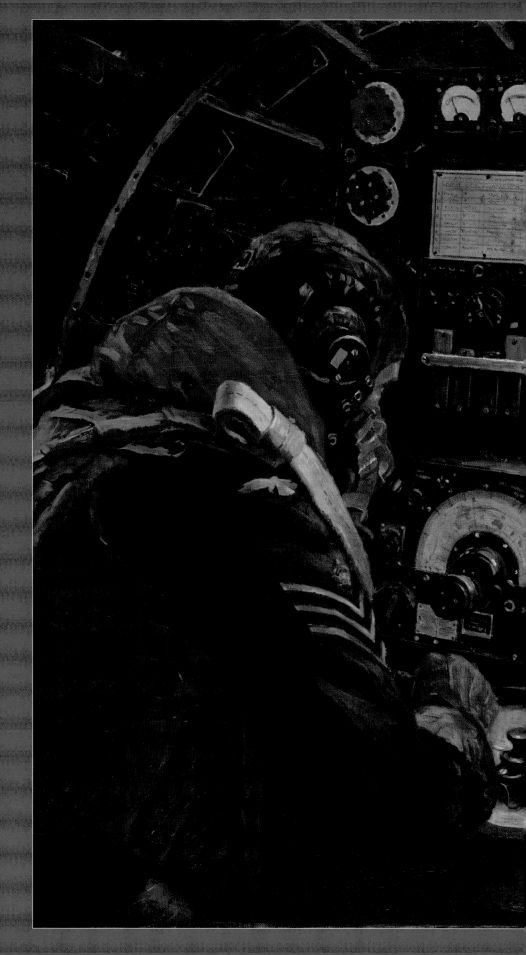

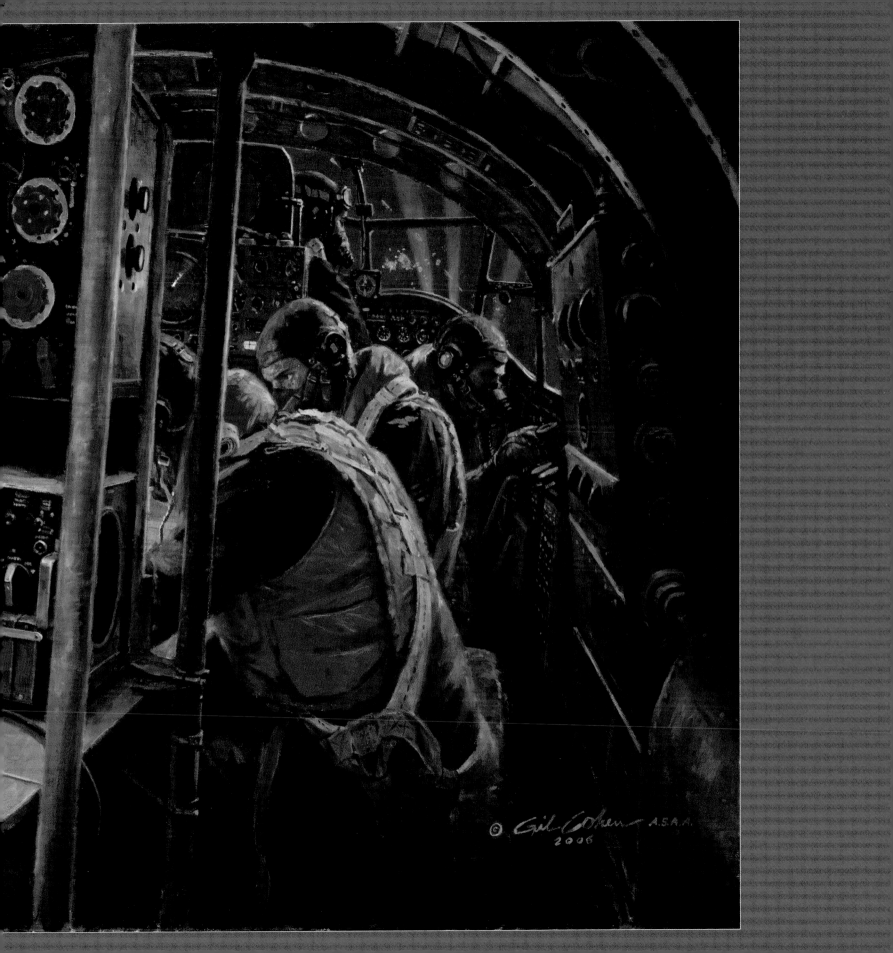

© Gil Cohen A.S.A.A.
2006

The Enemy Above

Oil on linen on board, 42" x 24", 1999.
Collection of Jon Stenberg.

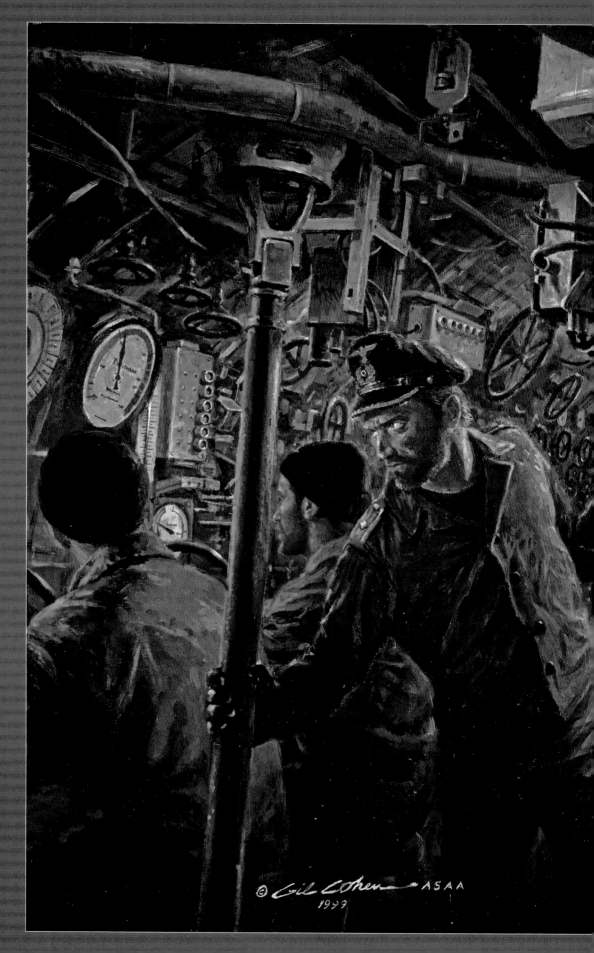

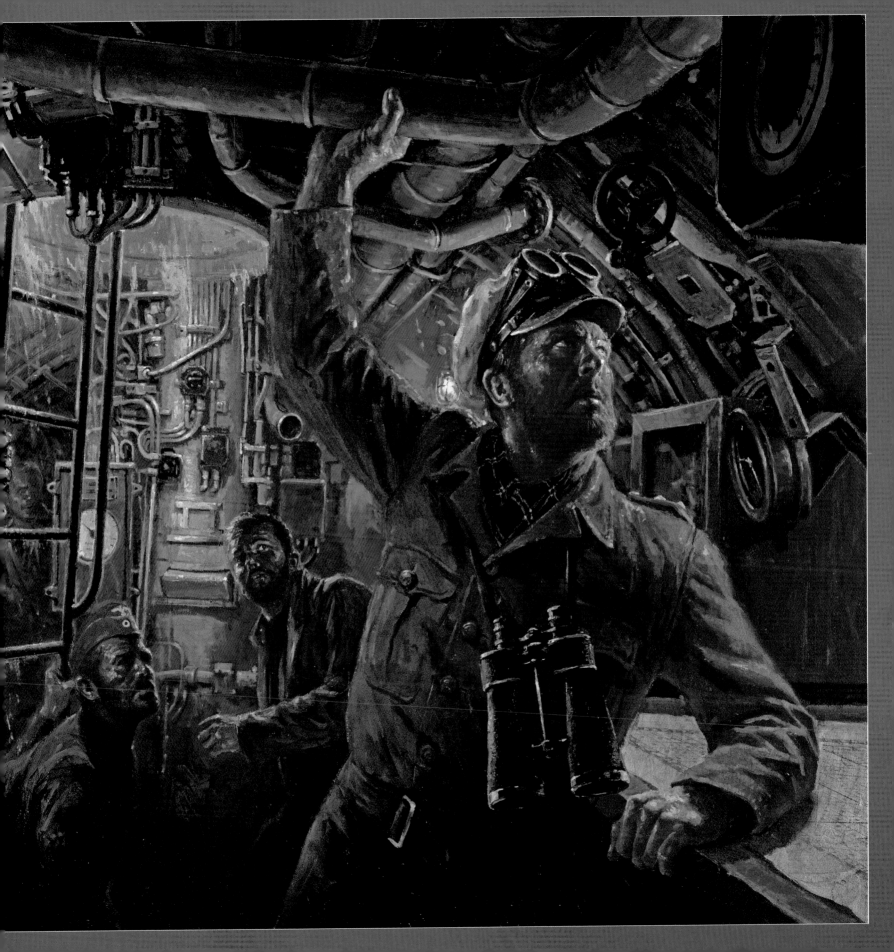

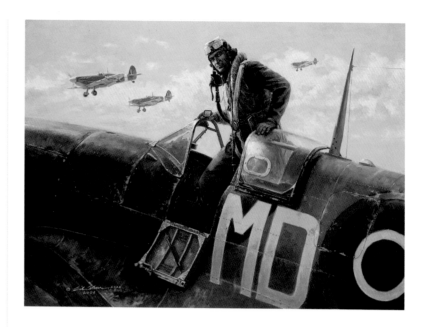

Fourth Mission of the Day

August 19, 1942, will be remembered as the date of the ill-fated "reconnaissance-in-force" known as Operation Jubilee, the joint British-Canadian amphibious assault against German troops in Dieppe harbor on the French coast. Air cover was provided by an unprece-dented assembly of RAF aircraft, and the battle, according to those who were there, was an almost continuous melee of close aerial combat, with damaged aircraft from both sides seen spiraling towards the sea, planes colliding in mid-air, burning ships sinking in the harbor and along the Channel coast, and a pall of smoke covering the entire scene.

Among the many RAF fighter command units that flew that day were three Eagle Squadrons comprised of American airmen flying Mk.Vb Spitfires. Despite heavy Allied losses, the Americans carried out their mission exceptionally well. They were credited with 10 enemy aircraft destroyed, 5 probables and 12 damaged.

The 133 Eagle Squadron was led by Flight Lieutenant Donald J. M. Blakeslee. Blakeslee would be the only Eagle commanding officer to complete all four missions that day and would be credited with shooting down an FW 190 and a DO 217, as well as with two FW 190 probables, in a gallant attempt to protect the Allied troops below.

The following month, in ceremonies at the Debden fighter base, the three RAF Eagle Squadrons were transformed into the newly formed 4th Fighter Group of the U.S. Army Eighth Air Force. Later, under the inspiring command of Col. Don Blakeslee, the 4th Fighter Group went on to achieve great fame for their number of missions successfully completed, enemy aircraft destroyed and unit citations received. Col. Blakeslee, who wrote the foreword for this book, will go down in history as one of the greatest leaders of fighter pilots.

I decided to honor the Eagle Squadron and, to my mind, who better to exemplify the courage and determination of the Eagle Squadron than Blakeslee. The painting's central focus is a close-up of Blakeslee about to climb out of the cockpit of his Spitfire after completing his fourth sortie over Dieppe on that long and harrowing day. He is exhausted after a protracted day of deadly combat. In the background, other Eagles of 133 Squadron are seen coming in to land.

I wish to thank Jerry Yagen of the Fighter Factory Museum, who generously allowed me to photograph the gorgeous Spitfire in his vast aircraft collection. Also, Jamie Ivers, whose thorough knowledge of RAF uniforms and flying gear was a great help in my attempt to authentically depict this scene.

Rosie's Crew / Thorpe Abbotts, 1943

In 1991, then head of the Air Force Art Program Alice Price, artist and engineer Andy Whyte, and I took a motor trip to East Anglia, where most of the Eighth Air Force bases had been located during the Second World War, and while there we visited the former home of the "Bloody" 100th Bomb Group at Thorpe Abbotts, a bucolic farming village about two hours northeast of London, where we were shown many artifacts, including uniforms, photographs and other memorabilia. Having previously read books about the 100th, I quickly recognized the photos of some of the legends in that famous group — Harry Crosby, "Cowboy" Roane, Sam Barr, Jack Kidd, Everett Blakely and Robert "Rosie" Rosenthal. My friends suggested that I feature Rosie in a future painting, but another eight years went by before I acted on that idea.

Robert Rosenthal joined the U.S. Army Air Forces as a recent law school graduate following the attack on Pearl Harbor. After flight school he was assigned to the 100th Bomb Group, Eighth U.S. Army Air Force in England.

On October 10, 1943, not long after joining the 100th, Rosie took part in a particularly perilous, ill-fated mission over Munster, Germany. After dropping their bombs, the crew headed home with two engines out and wounded onboard. Upon returning to their base at Thorpe Abbotts, Rosie and his crew were stunned to discover that they were the only ones from their group who had made it back to base. Thorpe Abbotts was eerily quiet. When Rosie entered the officers' club, there was nobody to be found.

After 25 missions Rosie completed his first tour of duty. Returning from Berlin on March 8, 1944, the crew of Rosie's Riveters wanted to celebrate by buzzing the field, which was strictly against regulations. Normally, Rosie maintained a conservative attitude about such things, but on that festive day, he decided what the heck! Flying extremely low on the deck over Thorpe Abbotts airfield, Rosie headed right for the control tower! Everyone near the control tower ducked and

fell to the ground. Unbeknownst to Rosie, General Huglin, head of the 13th Bomb Wing, was among the dignitaries in the tower that day. Huglin later came up to Rosie and pronounced the prank a "hell of a buzz job!"

Rosie Rosenthal went on to volunteer and complete two tours of duty. As a natural leader, he rose through the ranks rapidly, reaching the rank of major. He was Command Pilot during a mission to Nuremburg when his plane was hit. With three engines out, he crash landed in France. All four officers on board suffered severe injuries. Rosie had multiple head contusions, a fractured right arm and other injuries. The last thing he heard before losing consciousness was the sound of French-speaking voices. When he awoke, he was in a hospital in Oxford, England, where he remained for five weeks. Eventually, he returned to Thorpe Abbotts, where he became commander of the 418th Squadron.

In early 1945, Rosie volunteered for his third tour of duty. While leading the entire Third Air Division of 1,000 bombers on a mission to Berlin, Rosie's plane was hit by flak as they approached the target. Only after completing the target run did Rosie radio the second-in-command and instruct him to take over. With dead and wounded aboard, Rosie's crippled bomber headed east toward Russian lines before entering an uncontrolled spiral descent. At approximately a thousand feet, Rosie finally bailed out. Russian troops found him and took him to a hospital, where his various wounds were treated. Rosie

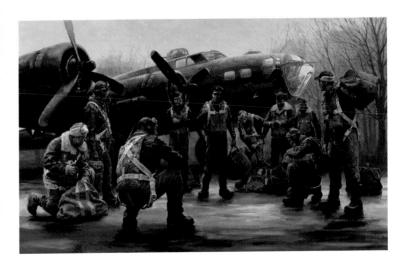

and a few of his men later wound up in Moscow, where they met American Ambassador Averell Harriman and were wined and dined and treated to a performance by the Bolshoi Ballet. At that time, Rosie had completed 52 combat missions, having been shot down and wounded twice.

After Germany's capitulation, Rosie was finally shipped back to the United States and sent to McDill Field to undergo B-29 training. Then news came that Japan had surrendered unconditionally and World War II had come to an end.

Just a few months later, Rosie, now a lawyer with a prestigious New York law firm, learned that Supreme Court Justice Robert Jackson, who had been appointed by President Truman as U.S. prosecutor at the Nazi wartime trials in Nuremburg, needed assistant prosecutors. Rosie volunteered immediately. Onboard the ship that would take him back to Germany, Rosie met and fell in love with Phillis Heller, a Navy WAVE, also on her way to Nuremburg as an assistant prosecutor. Upon arriving in Nuremburg, they were married by a bürgermeister. They would spend over 60 years together, their family would grow to three children and several grandchildren, and Rosie would have a long, successful career in corporate law.

In 2000, nine years after my visit to Thorpe Abbotts, I finally embarked on the painting project depicting Robert Rosenthal. What better way to define Rosie's legendary leadership than to depict him briefing his crew before they board their plane to embark on a bombing mission over Germany. I choose not to represent a specific mission but to depict a typical scene with Rosie's original crew during his first tour of duty. In short, I wanted this one painting to symbolize all of their missions. I spoke with Rosie several times about his exploits and took copious notes. I also contacted a few of the surviving members of his crew. Tail gunner Bill DeBlasio, since deceased, was particularly helpful with his recollections of flight gear, Rosie's reassuring manner, and his fellow crew members' personalities.

My friend Mike Faley, the 100th Bomb Group historian, sent me a diagram of Thorpe Abbotts' airfield. Hardstand 43, where Rosie's Riveters had been parked, was near the perimeter of the airfield, along the edge of the woods. A 100th Bomb Group Museum volunteer who currently lives in the village of Thorpe Abbotts sent me current photos of the treeline where Hardstand 43 would have been located.

The atmosphere that I wanted to create was that of a typical English late autumn morning — chilly, damp and overcast. With this in mind, I began making small, rough thumbnail pencil sketches. I placed Rosie in the center of the composition, in front of Rosie's Riveters, with the crew in a semi-circle around him. Reenactors posed for the painting, including members of the U.S. Army Air Forces Historical Society in New Jersey and people from living history organizations in Ohio. My friend Jack Lefferts, in Pennsylvania, generously supplied a large assortment of authentic WWII flight gear as reference.

Many months later, when the painting was finally completed, my wife, Alice, and I, along with two friends, traveled to the home of Rosie and Phillis in Harrison, New York. Our van contained many limited-edition prints to be signed by Rosie, as well as the original oil painting, which measured 56 inches across. We propped the rather large painting, draped in a white bed sheet, on two chairs at one end of the Rosenthals' living room and had Rosie sit on a sofa at the other end. When we lifted the white sheet to reveal the painting, Rosie sat silently and stared at it for a few moments, then remarked, "It's almost as though I'm back in England, feeling the familiar chill mixed with tension prior to take-off." Then he stood up and walked right up to the painting. Pointing to the kneeling figure on the extreme left foreground, he inquired, almost whispering to himself, "Isn't that C.C.?" I thought, Yes! Sgt. Clarence C. Hall, top turret-flight engineer. Rosie added thoughtfully, "After the war, in the 1950s, C.C. was killed in an industrial accident." When Rosie spotted the countenance of co-pilot 2nd Lt. Winfrey Lewis, he uttered, "You know, he was prematurely bald. He was known as 'The Bald Eagle' and I was 'The Legal Eagle.'" Then his sly humor kicked in. Pointing to his own figure, he asked mischievously, "Who's that handsome guy?" I replied, "That's Gregory Peck!"

After a delicious lunch, we embarked on the task of signing over 1,000 prints. It must have been difficult for Rosie. He had rolled up

his sleeves, and a long scar could be seen on his right arm, where it had been fractured twice during the War. After a while, Rosie observed, "Gil, you are zipping off your signature very quickly, while I'm taking so much time signing Robert Rosenthal. How about if I sign Gil Cohen and you can sign Robert Rosenthal?" After only a few signatures, Robert Rosenthal became simply Rosie Rosenthal.

Rosie maintained a modest and self-deprecating sense of humor. He was not one to readily call attention to himself, and until the end of his life the continued to look after the men who had served under him during the war and their families. During a 100th Bomb Group reunion in Omaha, I observed that Rosie couldn't take three steps before an admirer would approach him and engage him in conversation.

Robert "Rosie" Rosenthal passed away in 2007 at the age of 89. I feel very privileged to have known him. He was undoubtedly one of the great contributors to the success of the U.S. Army Eighth Air Force in the strategic bombing of Nazi-occupied Europe. His much deserved medals were many and included the Distinguished Service Cross, the Silver Star with Cluster, the Distinguished Flying Cross with Cluster, the Purple Heart with Cluster, seven Air Medals, the British Distinguished Flying Cross and the French Crouix de Guerre.

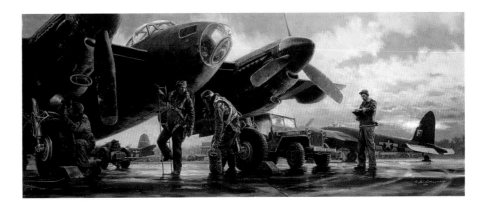

Eyes of the Eighth

It is 1944. The rain ended about an hour earlier, leaving a damp, penetrating chill in the air. Aircraft of the 25th (REC) Bomb Group sit on the wet tarmac of 8th Air Force Station 376, Watton, England. A warm orange glow from the fast-setting autumn sun reflects off the blue-gray surfaces of the Mosquito. The crew chief reviews his preflight checklist, insuring that the PR Mk XVI is in prime operating condition for the long, arduous and extremely dangerous photo-reconnaissance mission that the pilot and navigator are about to make this night. A mechanic uses his flashlight to make a last-minute check of the aircraft's starboard landing gear. A mud-spattered jeep pulls up alongside the "Mossie," its blackout headlights forming dim slits of light. Two shadowy figures emerge from the vehicle. The pilot and his navigator are dressed in full flight gear, including Mae West, parachute harness and flying helmet with oxygen mask. The pilot has put on his seat-chute pack. The navigator carries his chest chute in his left hand so he can more easily enter the cockpit. The briefcase he holds contains maps and navigational aids. Both men are on a voluntary second tour. They are a war-experienced aircrew with many varied secret missions over enemy territory. The pilot starts to enter the aircraft then turns to his navigator to say something

before they both climb into the tiny, cramped Mosquito cockpit. The mission they are about to embark on will be a long one, deep into the heart of Nazi Germany. They will have no armed escort. The aircraft will have no defensive armament except the .45s that the crew carry on their belts. They will fly alone, stealth and speed their only protection. For this nighttime recon mission, their aircraft is equipped with aerial cameras and million-candlepower photoflash bombs. Flying at dangerously low altitudes, the photoflash bombs will detonate at about 2,000 feet, illuminating the enemy target with daylight effect while special cameras record images of potential strategic targets.

The 25th Bomb Group consisted of three squadrons: the 652nd, the 653rd, and the 654th. They conducted a wide range of unique, highly specialized and even experimental operations. They flew some of the most dangerous missions of WWII.

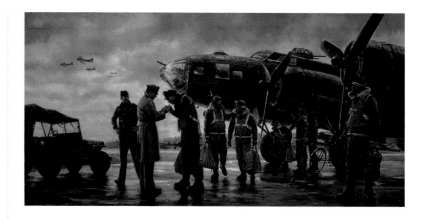

Coming Home / England, 1943

The U.S. Army Eighth Air Force, based in England during World War II, has held a special fascination for me since my youth. In 1989, Bob Westervelt of Aeroprint/Spofford House, publishers and dealers in aviation art, and I decided that the first subject in my series of limited-edition prints would indeed be the Eighth Air Force. This painting would convey the emotions of an aircrew upon returning to their base somewhere in England after a harrowing bombing mission over Nazi Germany.

After sketching a number of thumbnail roughs, a workable composition began to solidify. A group of living history reenactors whom I had met previously at the Geneseo, New York, air show agreed to pose for me at the Air Force Museum in Dayton, Ohio. I shot reference photos using the reenactors and, back at my studio, chose poses that seemed to best represent my theme.

Based on these poses, I produced more careful pencil drawings and added the details of the B-17 and the generic background with its hangars, parked aircraft and huts. These drawings were enlarged and transferred to the canvas. As is my usual working procedure, I laid down an acrylic underpainting. I try to keep the consistency of the underpainting a very loose, transparent wash. This technique allows the linear structure of the composition to show through the completed underpainting. The painting executed in oil took approximately seven to eight weeks to complete.

To many, my identity as an aviation artist is still best represented by *Coming Home / England, 1943*. Some have suggested that this image is reminiscent of the Gregory Peck movie *Twelve O'Clock High*. Certainly that motion picture inspired me when I saw it during my teenage years, and it may have influenced me subconsciously later in life. In any case, this painting was to be the first of many with the Eighth Air Force as the theme.

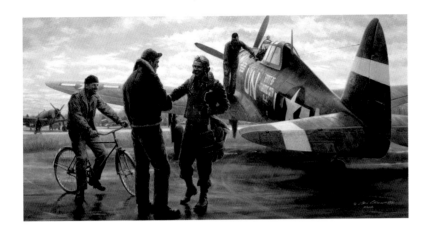

Return to Halesworth

As a child during World War II, I was an avid collector of aviation magazines. One day while leafing through a copy of *Flying* magazine, I came across a photo of a young fighter pilot sitting in the cockpit of a P-47 Thunderbolt fighter plane. He bore an all-American grin and was shaking hands with a ground crewman. This pilot, Walker M. (Bud) Mahurin, seemed to me to represent the quintessential young American fighter pilot of that time. I clipped the picture from the magazine and filed it away. Decades later, as a follow-up to my painting *Coming Home / England, 1943*, I decided that my second painting with an Eighth Air Force theme would be of Fighter Command. I pulled that old magazine clipping of Mahurin from my file, and it became the inspiration for my painting *Return to Halesworth*.

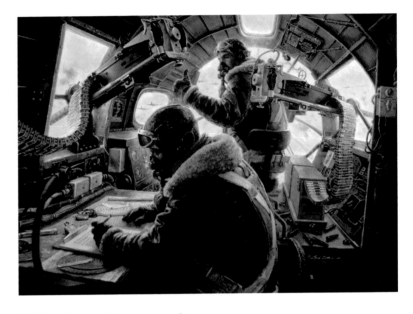

Mission Regensburg

See extended description of Mission Regensburg *beginning on Page 45.*

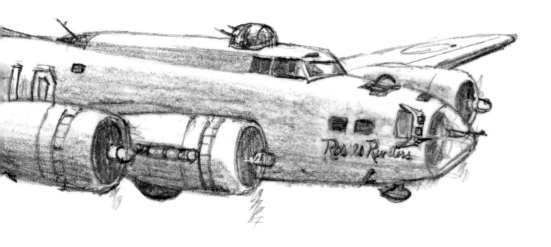

Fourth Mission of the Day

Oil on linen, 36" x 26", 2006.

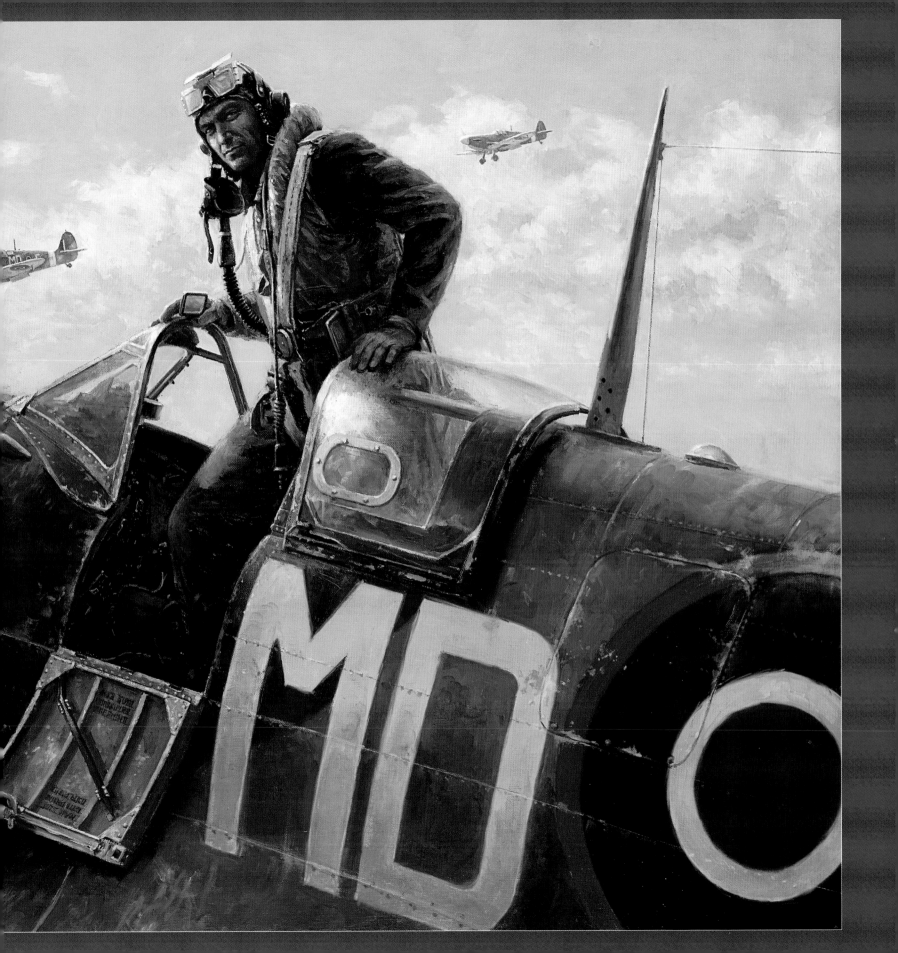

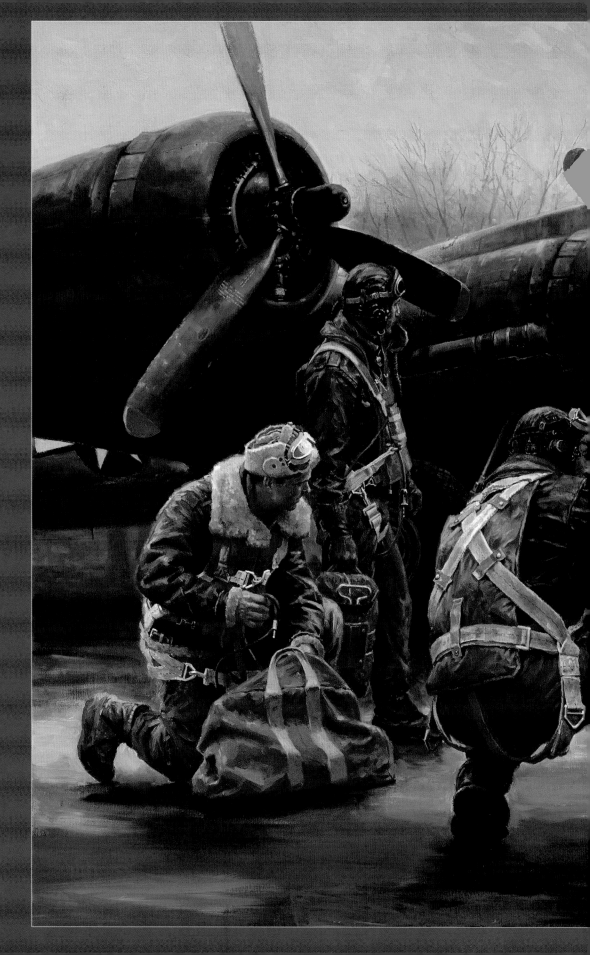

Rosie's Crew /
Thorpe Abbotts, 1943

Oil on linen, 56" x 34", 2001.
Collection of Eugene Eisenberg.

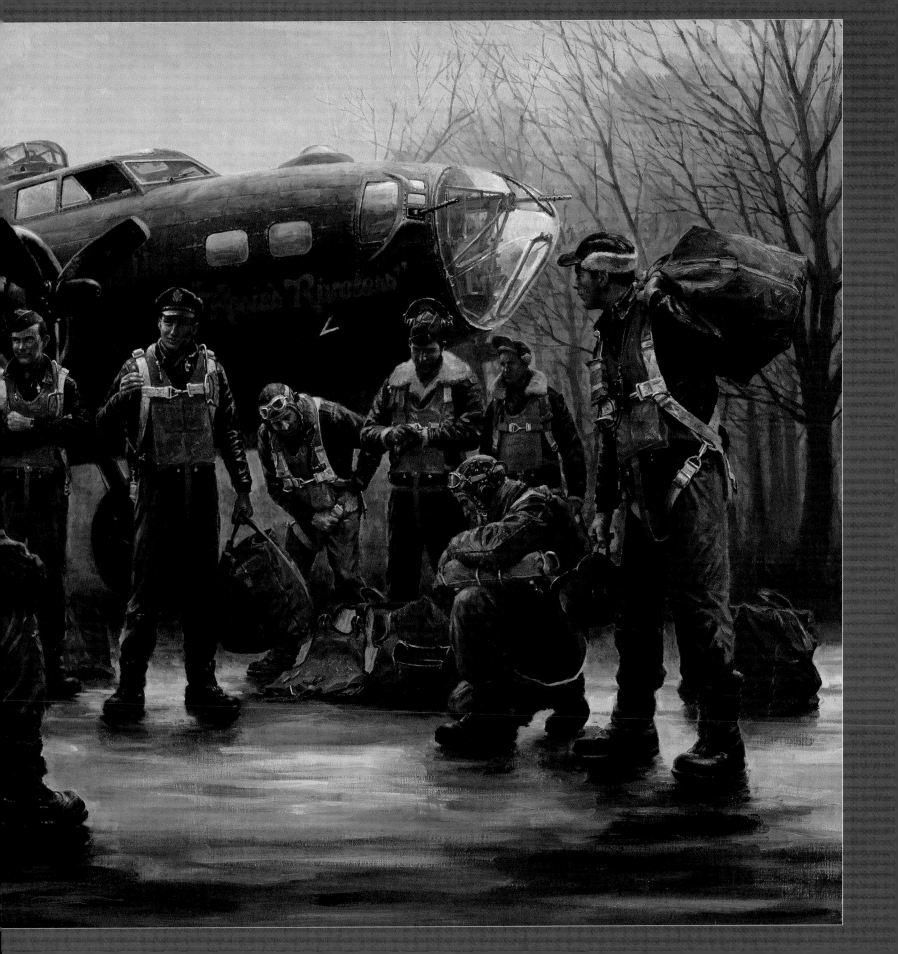

Eyes of the Eighth

Oil on linen on board, 56" x 23", 1996.
Collection of Paul Wong.

Coming Home / England, 1943

Oil on linen on board, 44" x 22", 1990.
Collection of Dr. Harry Friedman.

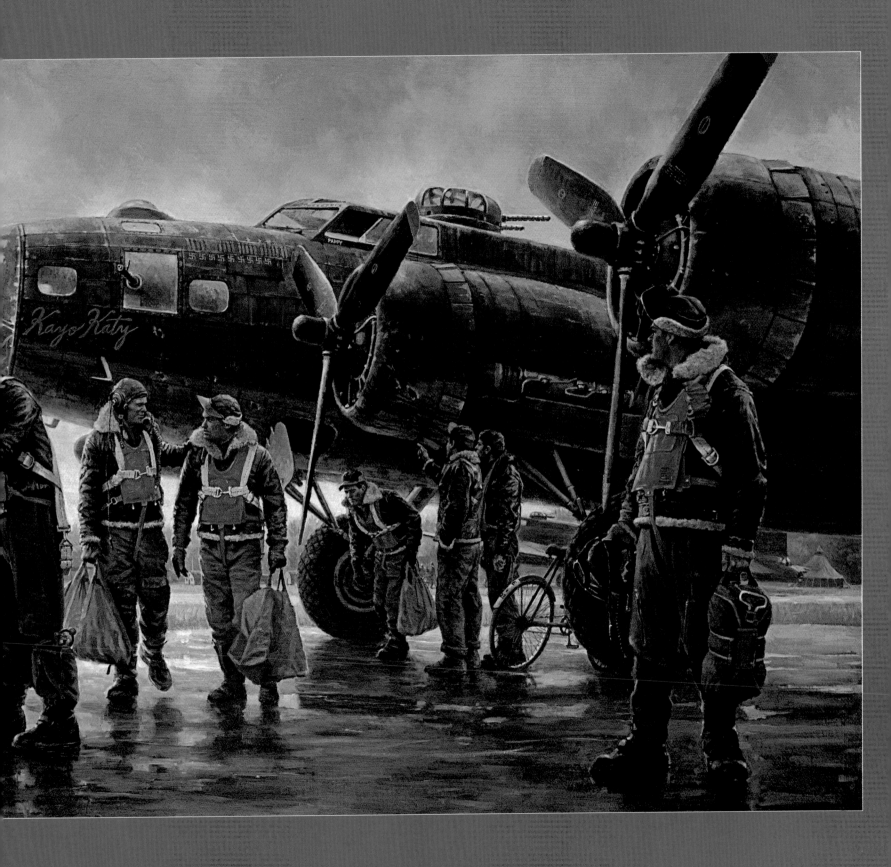

Return to Halesworth

Oil on linen on board, 42" x 28", 1991.
Collection of Dr. & Mrs. Charles Burnett.

Mission Regensburg

Oil on linen on board, 44" x 32", 1994.
Collection of Dr. Harry Friedman.

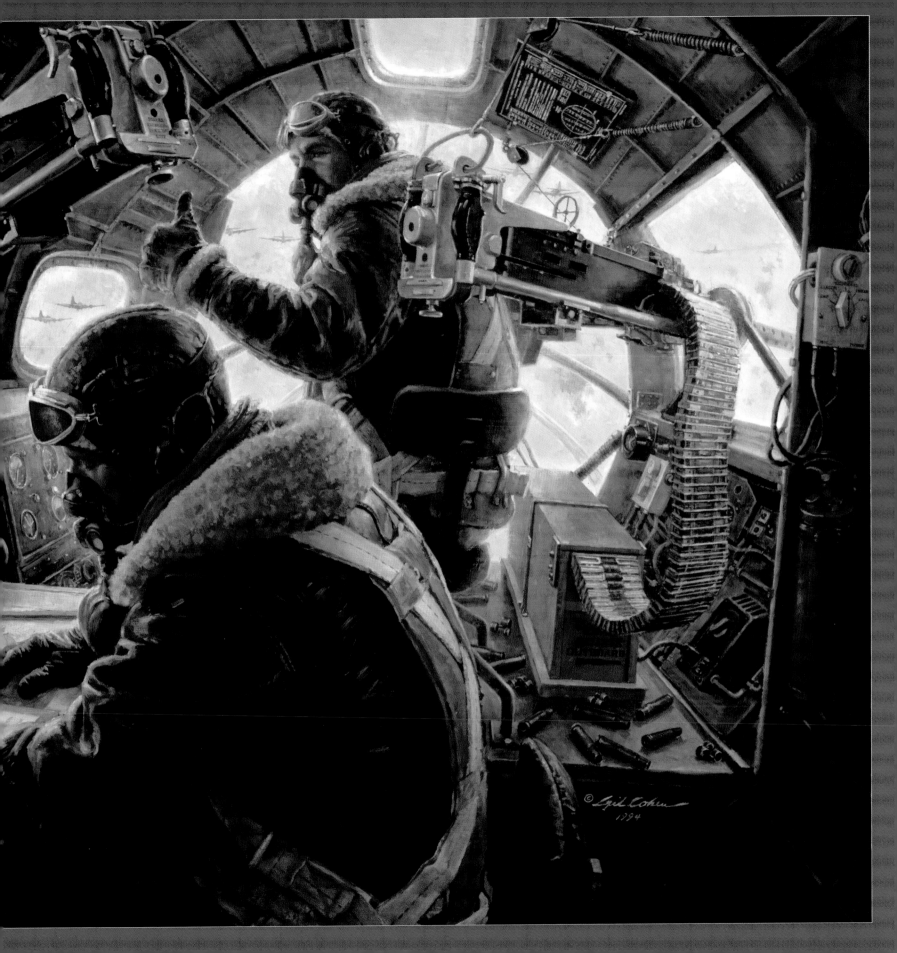

Ploesti: The Odyssey of Utah Man — North Africa, 1943

It was early in the evening on August 1, 1943. The personnel at the temporary base of the 93rd Bomb Group, located in Benghazi, Libya, had virtually given up any hope of *Utah Man* returning after the disastrous mission to the Ploesti oil refinery complex. Then, at about 1900 hours, the unmistakable form of a B-24 Liberator was seen approaching over the distant horizon. *Utah Man* had returned!

As the pilot, Walt Stewart, described the scene to me sixty years later: "When I climbed out of the shell-riddled plane, I was greeted by the most beautiful sight in the world, a real live American woman. I couldn't believe my eyes — a volunteer Red Cross worker, not a nurse. She and the other women offered us chocolate bars, donuts and coffee." I was very surprised to hear about a civilian American Red Cross volunteer, a woman who was not a nurse, in that God-forsaken place. Benghazi wasn't exactly the French Riviera. Deadly scorpions and sand flies abounded, and the temperature reached 130 degrees Fahrenheit. I remained somewhat skeptical for a while until I received a phone call from my friend Dale Burrier, who has helped me with past research projects. He told me about an article that he had come across in a 1944 copy of *National Geographic Magazine*. The article was written by a woman who was part of a group of female Red Cross volunteers who toured North Africa, and later Italy, in a 1941 Ford station wagon, dispensing coffee, donuts, chocolate and conviviality to American fighting troops. After reading this fascinating

article and viewing the many photographs that accompanied it, I chose to honor these women by placing them prominently in the foreground of this painting.

Research consisted of "live" sketching and photographing the B-24D *Strawberry Bitch* housed at the Air Force Museum in Dayton. A cautionary note to aviation artists: An aircraft that has been on static display for decades will likely have a lower "sit" due to the fact that the landing gear hydraulic fluid has dried out, causing the landing gear cylinder to be compressed into the oleo strut. I took measurements of the B-24, paying particular attention to its height to the ground at various points. Sometime later, I measured the same reference points on a B-24H, an actively flying aircraft belonging to the non-profit educational Collings Foundation. The measurements of this flying B-24 were very different indeed. The rear end of the Collings Foundation plane sat at least six inches higher than the Air Force Museum B-24! Of course, this was also true of the landing gear height and other parts of the "living" Collings plane. Another factor to consider is the weight distribution within the aircraft, especially one with a tricycle landing gear such as that of the B-24. How much cargo, personnel, ordnance and other equipment were in the plane and where was this equipment located?

This painting was one of the most complex compositions I had yet produced. My desire was to depict the many and varied emotional exchanges taking place all at the same time. In the right foreground, an exhausted airman is accepting coffee from a Red Cross volunteer. The woman is wearing the usual apparel of the desert climate, khaki shirt and pants. She is perspiring from the oppressive heat. However, if you look closely, you will notice a small preservation of her femininity, a tiny pearl earring. On the left, we observe a 1941 Ford station wagon, its tailgate open, revealing a large GI coffee urn and a tray of donuts. A fatigued airman rests on the edge of the tailgate, talking with the volunteer who is dispensing coffee from the urn. Equipment and supplies, pulled from the bomber, lie on the ground. The pilot, Lieutenant Walter T. Stewart, seen to the left of the bomber's star, is describing his harrowing mission to

Operations Officer Major Ramsay D. Potts, who had returned from the mission earlier that day. Mechanics, standing on the port wing, are conducting a thorough inspection. The battle damage report for *Utah Man* that day included destruction to the port vertical stabilizer, the forward bomb bay doors and left aileron, as well as over 200 holes in the fuselage and wings from ground fire. Miraculously, not one crewmember was even scratched!

After *Utah Man* and the surviving 93rd Bomb Group planes returned to their home base in England, Walt Stewart, whose tour of duty was now over, went back to the USA to embark on a War Bond tour. *Utah Man*, now piloted by Walt's former co-pilot, remained in England to resume bombing missions over Germany. A few weeks later, in the middle of his War Bond tour, Walt received the tragic news that *Utah Man* was shot down over Germany. The only survivor of his original crew was the badly wounded tail gunner.

One of my most cherished memories of this project is my opportunity to meet Walt Stewart and his lovely wife, Ruth, and the fascinating time we shared together.

The Ditching

To Allied aircrews returning from bombing missions over Germany, the sight of the North Sea below assured them that home and safety were near. It was the last milestone after many hours of flak and battle with enemy fighters. But to the crews of aircraft low on fuel, with wounded aboard and/or extensive damage, the need to "ditch" in that cold body of water could mean instant death from the crash or slow death in the icy waves.

On September 26, 1944, Heavenly Body, a B-17 of the 385th Bomb Group on a mission to bomb Bremen, Germany, was hit by flak, disabling number four engine and forcing the plane to return to England. As navigator Herbert R. Greider described it: "The returning head wind at mission altitude was over 100 mph. As we returned over the North Sea, the bombardier, Roy Buck, dropped the bomb load as we headed west into the high winds toward England. The pilot, Charles Lamont, radioed the British Air/Sea Rescue as a precaution. The way the British Air/Sea Rescue worked with the 8th Air Force was that the Air Force would notify the British that the U.S. mission was proceeding up the North Sea in time for the British boats to go out along the flight path ahead of the bomber formation. In addition, a P-47 was sent out to follow us."

The B-17 lost two more engines. Greider described the events that followed: "With only one engine, ditching was assured. We had talked to a crew that had previously ditched — 'No problem. Just like throwing a flat stone over smooth water.' But our problem was the high winds and huge waves. We, the crew, got into the radio room, which was the normal ditching procedure. The pilots did a wheels-up ditching. What was not expected was the effect of the very high waves — 15 to 20 feet, according to the British Air/Sea Rescue. It was almost like hitting a wall. The plane broke open at the radio room. I was lying on the floor and found myself immediately underwater. Instead of crawling out of the overhead hatch, we walked along the wing. The plane hit so hard that the pilots never had a chance."

The Ditching was commissioned by Dr. Thomas Greider, the son of navigator Herb Greider, who survived the ordeal of nearly drowning in the icy waters of the North Sea. Herb Greider has since told me that he felt as though he was reborn and is having a very long second life that started on September 26, 1944.

With the help of surviving crew members Herb Greider, Al Detert, Roy Buck and Gil Woerner, I was able to reconstruct those harrowing moments on that fateful day.

After the Mission

This painting shows a scene familiar to all who were fortunate enough to survive the deadly war of attrition in the skies over Europe during the Second World War. Members of a bomber crew are being debriefed by an intelligence officer, whose job it is to collect — while memories are still fresh — vital information on the day's mission. In front of us is a table laden with aerial maps and strike photos, along with coffee mugs, cigarette packs and ashtrays. We are close enough to the crew, standing and sitting around the table, to perceive their mood and character after having just completed another hazardous mission over enemy territory. The American intelligence officer is taking notes, while looking over his shoulder is his British counterpart. The pilot points to a section of the map, indicating where enemy fighters were first encountered. The waist gunner, standing second from the left, stares pensively toward the viewer. His expression suggests emotional trauma from the recent stress he has endured. His right hand is bandaged, perhaps as a result of the bolt of his .50-caliber machine-gun repeatedly slamming into it. As yet, he has not thought to remove his parachute harness. The tail gunner, a young man still in his teens, glances out the window, wondering whether his buddy in another aircraft has yet returned. Even though the people depicted in this scene are fictitious, I have done my best to make everything authentic and to convey a feeling of realism, a "you are there" quality, no less than if I were presenting an actual crew being debriefed.

The Mighty Eighth / The Russian Shuttle

In December 1991, I received a phone call from England. On the other end of the line was the legendary RAF hero J.E. (Johnnie) Johnson. He had an idea for a painting featuring his friend Don Blakeslee, leader of the U.S. 4th Fighter Group. Johnson went on to describe the unusual operation that became known as the "The Russian Shuttle Mission."

President Roosevelt and Prime Minister Churchill had agreed on a coordinated bombing strategy for Nazi-occupied Europe. Allied airbases could be established in vast areas recently liberated by Russian troops as they fought their way westward. The idea was to bomb German targets not only from the west (England) and the south (Italy), but also from the east (Soviet Union). Stalin balked when informed of the plan. He did not relish the idea of an American military presence on Soviet soil. However, realizing that lend-lease aid might be cut off if the USSR declined, he reluctantly agreed to the strategy.

The first shuttle mission to the Soviet Union took place on June 21, 1944, when at 0728 hours P-51s of the 4th Fighter Group took off from Debden, England. They were augmented with one squadron from the 352nd Fighter Group and led by the charismatic Colonel Donald J. M. Blakeslee. Over Poland, they rendezvoused with B-17s of the 3rd Air Division, which they escorted the rest of the way to Russia. After crossing the Russian front lines, they left the bombers and headed to the fighter base at Piryatin in the Ukraine. After 7½ exhausting hours of flying by dead-reckoning, using what Blakeslee described as "lousy maps and my wristwatch," they finally reached the spot where the airfield was supposed to be located. This is how Don described that event to me: "As I flew my men to the point where my maps indicated that the airfield was located, I looked down and all I saw were barren plains. Then suddenly, I received a radio call from the ground telling me that I was already flying directly over the airfield!"

In my depiction of the event, I show Don climbing out of his

plane at Piryatin and pointing to his watch, indicating that he had landed within a minute of their scheduled time of arrival. Before Don climbed out of his cockpit, he made sure that he looked presentable for his Russian hosts, replacing his leather flight helmet, goggles and oxygen mask with a garrison cap displaying the silver

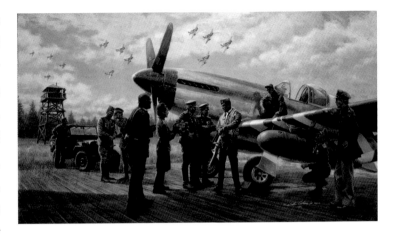

eagle that indicated his rank of full colonel. He was already wearing class A dress shoes for the occasion. It is also interesting to note that he still wore his RAF-style Mae West, a holdover from his days of flying with the British.

As was the Russian custom, a young lady in the uniform of the Soviet Air Force greets Don with a bouquet of roses. A Russian Air Force officer wastes no time kneeling under the wing of the Mustang to examine American aircraft construction methods. To the right stands the American liaison officer, who speaks fluent Russian and acts as interpreter. An American crew chief kneels on the wing next to the cockpit. Another American, a sergeant, waits by his jeep, ready to chauffeur Don to a hut for a well-deserved rest ("I was so drained that all I could think of at the time was getting a good stiff drink and hitting the sack!"). In the sky above, we see other 4th Fighter Group aircraft, along with a few "blue-noses," circling and preparing to land. It was a time of great transition in the development of the P-51. Mustangs on that mission were a mixture of earlier and later models. Some had birdcage cockpit canopies, Malcolm hoods, and some had the newest "teardrop" canopies. All were equipped with Rolls-Royce Merlin engines.

As Don looked around the airfield, he found it to be very crude compared to Allied bases. The control tower was made of logs and resembled a POW watchtower. Tall grass was growing everywhere, even through the holes in the pierced steel planking that made up the tarmac and runway. I'm sure that this was done purposely so it would

be more difficult to recognize as a military airbase from the air. Much of the preparation and construction had been done by Americans and Russians working together in the weeks before the arrival of Blakeslee's Mustangs.

When Don first saw the finished painting, he enthusiastically praised its accuracy in capturing that moment in history. As he studied the details more closely, he began to examine the two Russian figures on the left, toward the rear. "What are those two guys whispering about?" he asked. "How should I know? You were there, Don, I wasn't," I replied. He broke out in great laughter.

I first got to know Don Blakeslee at the print launch for *The Mighty Eighth/The Russian Shuttle* in Tampa, Florida, in early 1993. After the reception that evening, Don and I had dinner at our hotel, where he regaled me with stories of his many adventures during the War. It started when he left his home in Ohio in 1940 and traveled north to Canada to join the Royal Canadian Air Force. As the oldest Dominion in the British Commonwealth, Canada was already at war with Germany — long before Pearl Harbor. Don took his flight training in Winnipeg, and one day he and two fellow cadets went into town and wound up at a tearoom where a woman read tea leaves. After peering into the three cups, she looked up at the men and asked gravely, "Do you really want to know the truth about your futures?" They nodded in the affirmative. She told Don's two buddies, "You will not live to see the end of the war." Then she turned to Don and said, "You will live until age 96." Subsequently, all three men were shipped to England in 1941. One man was killed only a month after he arrived, when his Wellington bomber exploded in mid-air as he was on final approach to land. The other man drowned in the North Sea after bailing out of his disabled plane. As for Blakeslee, I recently received word of Don's death just before his 91st birthday. The tea-leaf reader was off by only five years!

Blakeslee was one of the greatest leaders of combat pilots in the history of the Air Force, yet he eschewed self-adulation and shunned publicity. His aircraft were not festooned with crosses indicating enemy kills or with decorative nose art, but his wife's name, Leola, was painted in small white letters just below the cockpit of his Spitfire. Blakeslee did not suffer fools gladly, and he occasionally displayed this attitude even toward his superior officers when ordered to lead his men on missions that he considered ill-planned and likely to cause needless deaths. The men he led loved and respected him.

Under Colonel Blakeslee's command, the 4th Fighter Group became the highest scoring group in the entire Air Force. Here are his own words to his men as he took over command of that group:

"The 4th FG is going to be the top fighter group in the Eighth Air Force. We are here to fight. To those who don't believe me, I would suggest transferring to another group. I'm going to fly the arse off each one of you. Those who keep up with me, good; those who don't, I don't want them anyway."

When Blakeslee was finally sent home, he had flown a record 1,200 combat hours. He remained in the Air Force long after the war, finally retiring in 1965, and lived the next 45 years in relative obscurity. I am very fortunate to have known this gallant man. I hope that my two paintings depicting Blakeslee will, in their small way, help to convey his noble legacy to this and future generations.

Night of Nights

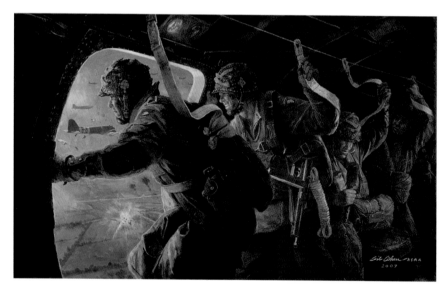

See extended description of *Night of Nights* beginning on Page 51.

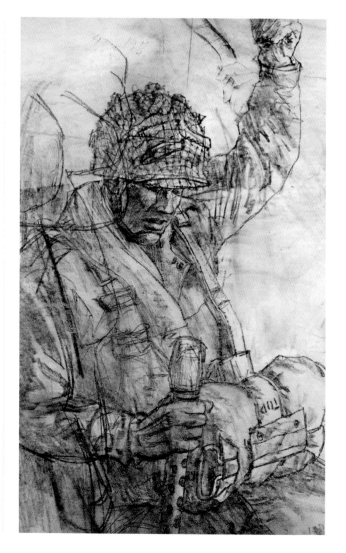

Almost Home

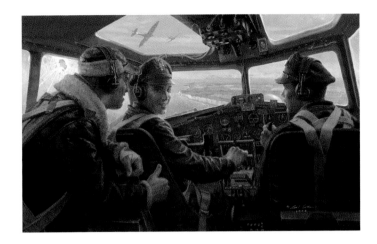

The Boeing B-17 Flying Fortress was the most desirable American heavy bomber in World War II, especially with the U.S. Army Eighth Air Force based in England. This, in spite of the fact that a third of all of the Eighth's "heavies" were B-24 Liberators. The "Lib" had a greater range and could carry a larger payload, but it is the B-17 that most readily comes to mind when picturing bombers of that period. It sure was gorgeous! Perhaps that is why Bryan and Adam Makos of Valor Studios commissioned me to create this painting depicting the B-17.

What Bryan and Adam had in mind was a work reminiscent of my previous painting, *Mission Regensburg*. For that painting I had chosen to portray the navigator and bombardier at their stations in the Fortress nose section. This time, Bryan and Adam suggested a view inside the cockpit, just behind the pilot and co-pilot. After reviewing several possible scenarios, here is the narrative that we settled upon: A straggler B-17, its number-three engine knocked out, is limping home after the infamous second Schweinfurt mission of October 14, 1943, also known as Black Thursday. Although damage inflicted on the Schweinfurt ball-bearing works proved more extensive than on the previous mission to that target, the cost was heavy, with 60 bombers failing to return.

After endless hours spent attempting to evade pursuing German fighters, the Fortress crew finally crosses the English Channel and is met by two British Spitfires, who will escort them the rest of the way across the Channel into England. When the crew spots the familiar White Cliffs of Dover, the pilot smiles and glances back fleetingly at the flight engineer, who gives a reassuring thumbs-up. They are "Almost Home."

Because it was felt that the crew's countenance of expression was crucial to the emotion of the scene, I decided to eliminate the top-turret mechanism, much in the same way that I had eliminated the bulkhead (wall) that would have obscured the point of view chosen for the nose section of the painting *Mission Regensburg*. Pilots and engineers may discern details such as the approximate positions of the dials on the instrument panel and throttle quadrant positions indicating the disabling of number-three engine and the feathering of its prop. Those not so technically oriented will still see evidence of the hell the crew has recently been through, including the window shattered by a 30mm shell and the bandaged left hand of the top-turret flight engineer.

As I've mentioned before, I usually try to get the technical details correct, but these details are not the most important aspects of my work. Instead, it is my hope that they will help to draw viewers into my paintings, where they may experience the atmosphere of that moment in history and derive a sense of the emotions lived by the individuals whom I have portrayed in oil.

Ploesti:
The Odyssey
of Utah Man —
North Africa, 1943

Oil on linen, 60" x 28", 2002.
Collection of Eugene Eisenberg.

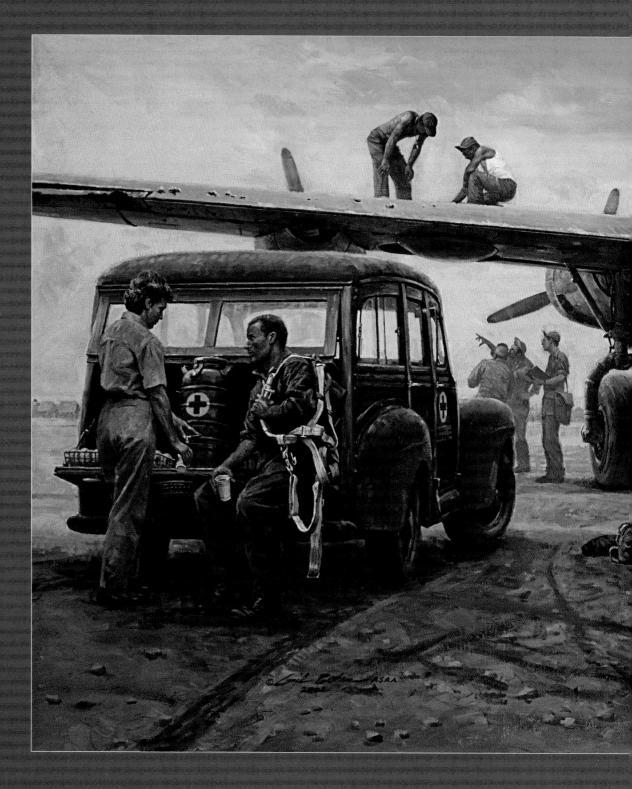

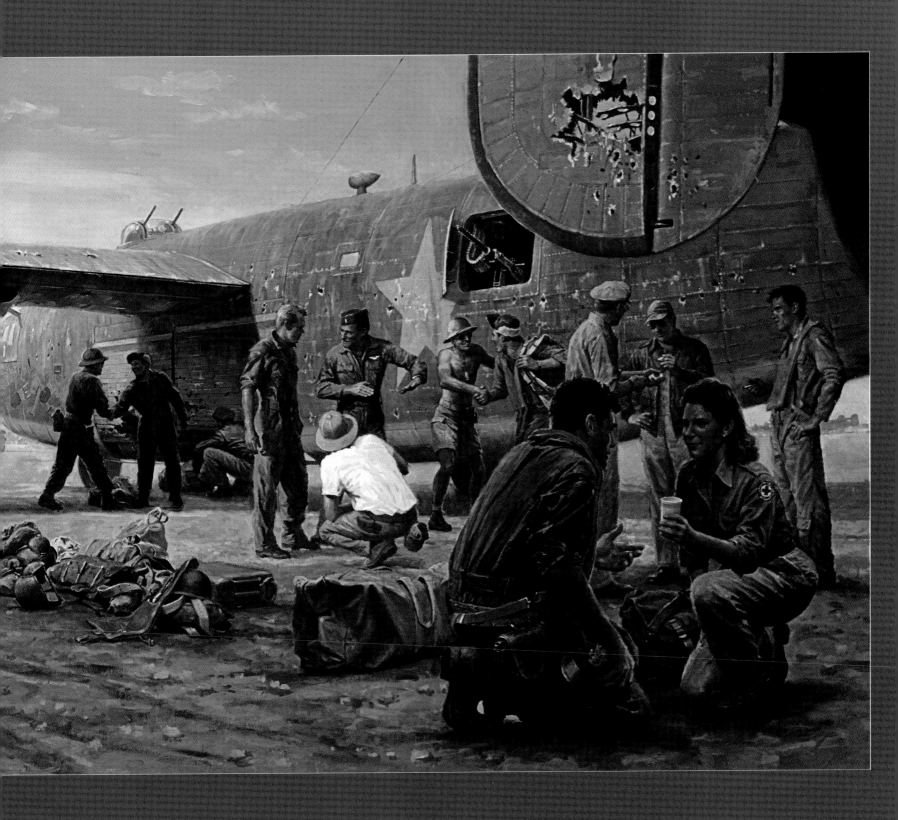

The Ditching

Oil on linen on board, 48" x 30", 2000.

Collection of Dr. Tom Greider.

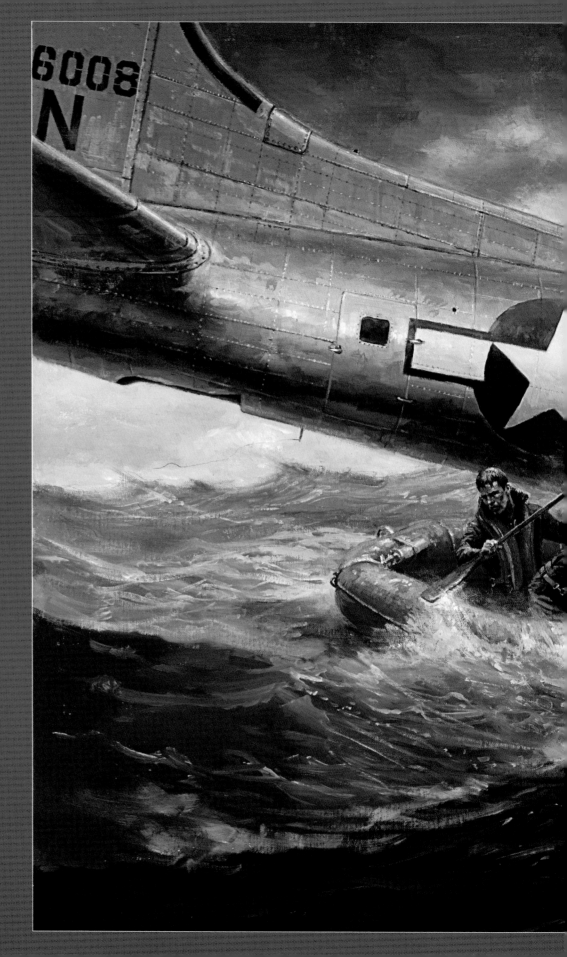

After the Mission

Oil on linen on board, 48" x 32", 1993.
Collection of Dr. & Mrs. Charles Burnett.

How To Bail Out of the Fly...

Procedure When Wearing

Procedure When W

© Gil Cohen ASAA
1993

Night of Nights

Oil on linen, 46" x 28", 2007.
Collection of Valor Studios.

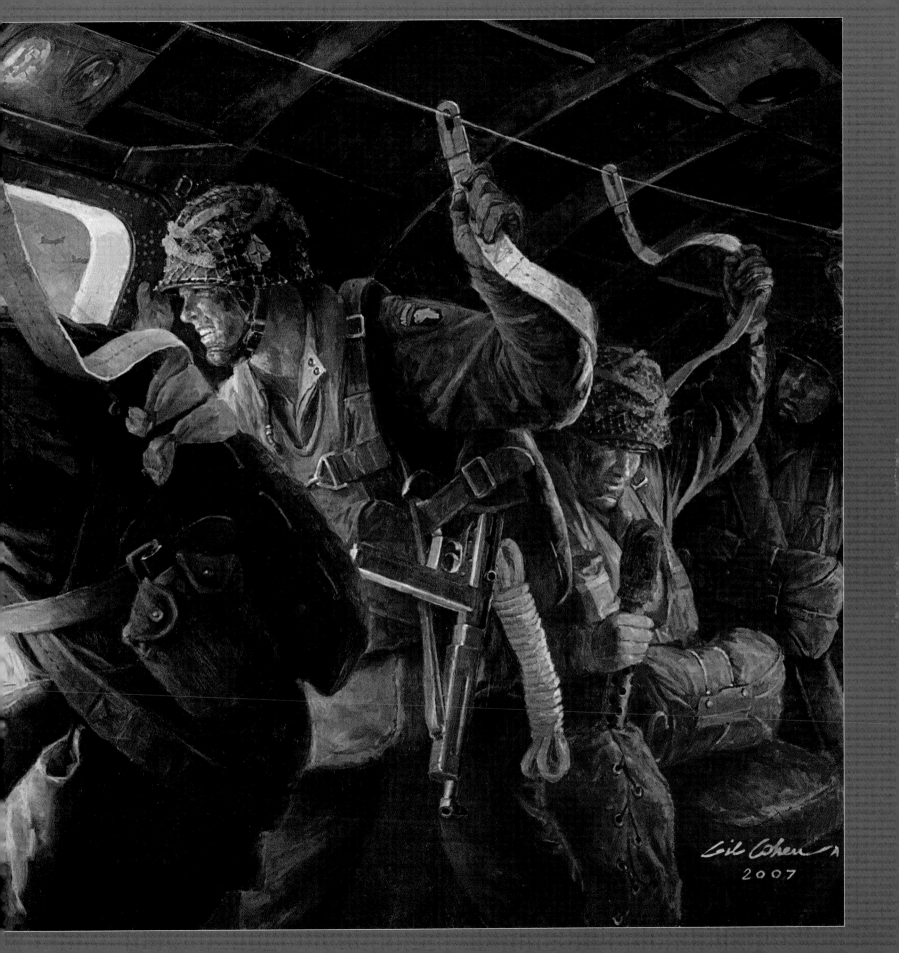

Gil Cohen
2007

The Mighty Eighth /
The Russian Shuttle

Oil on linen on board, 48" x 38", 1993.
U.S. Air Force Art Collection.

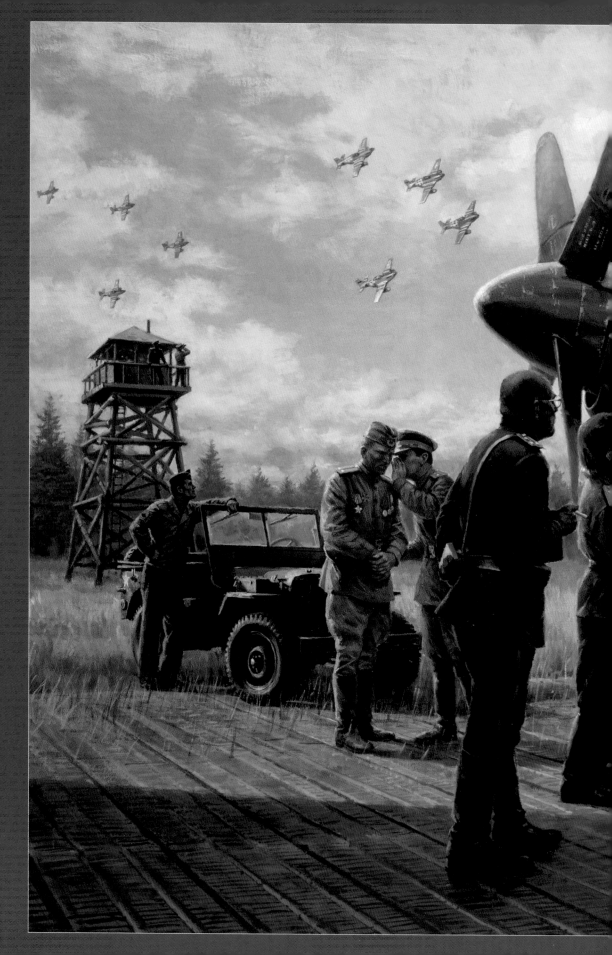

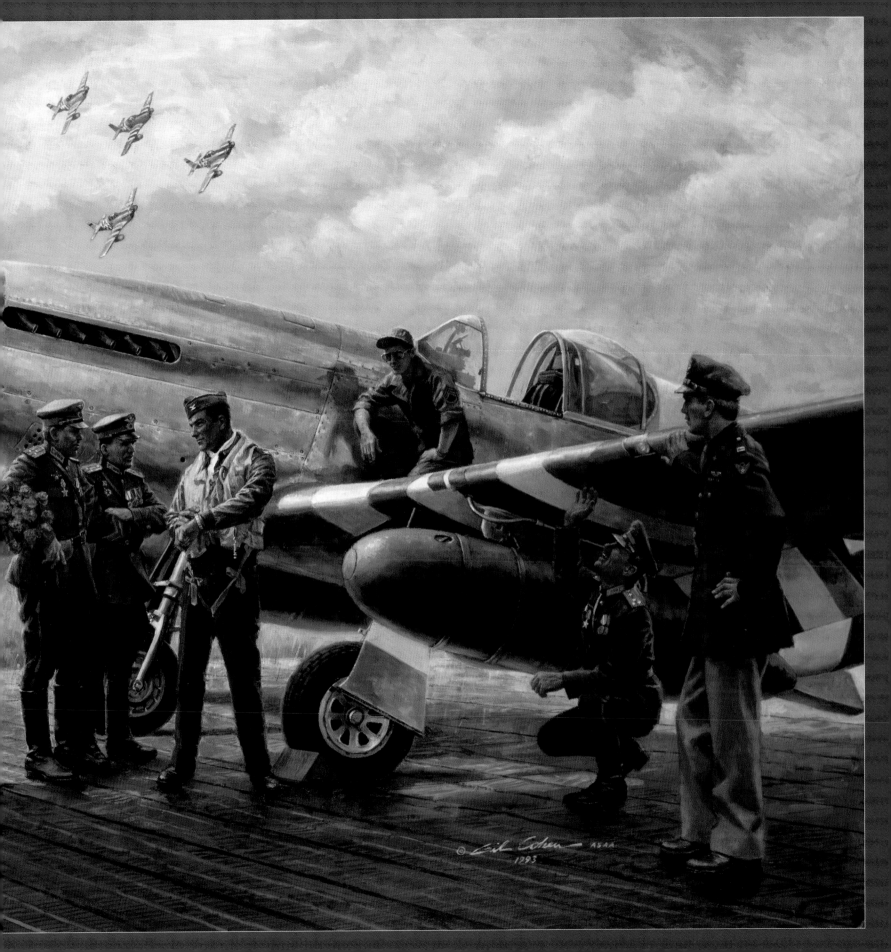

Almost Home

Oil on linen, 46" x 28", 2008.
Collection of Valor Studios.

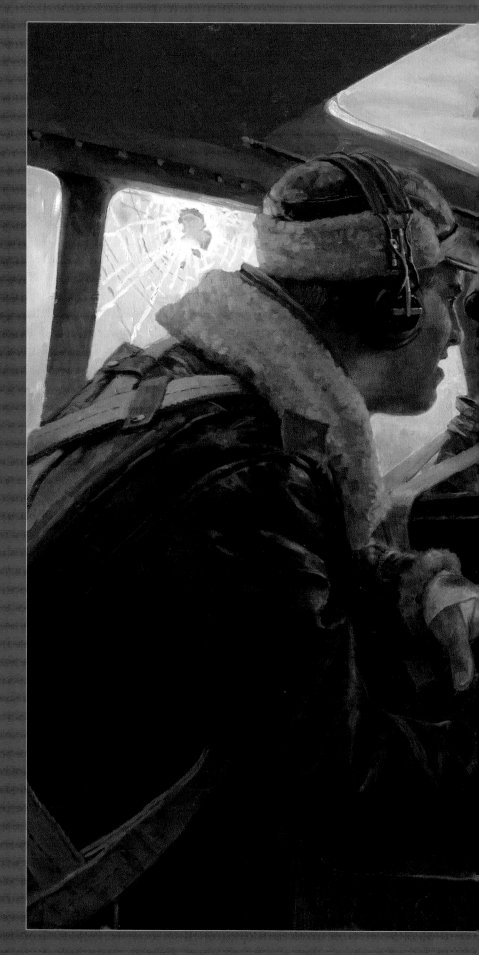

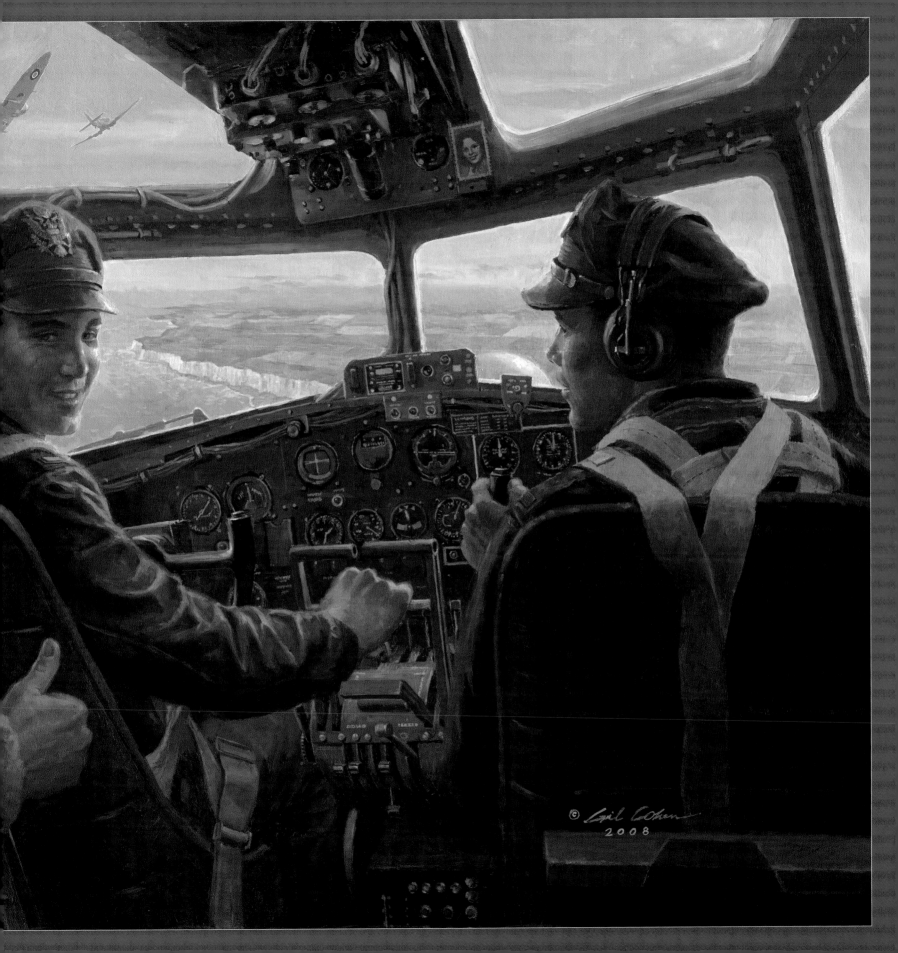

© Cecil Cohen
2008

Requiem for Torpedo Eight

I t is 0700, June 4, 1942. We are on the deck of the carrier *Hornet* (CV-8). This is the carrier made famous two months prior when B-25s led by Jimmy Doolittle were launched from her deck in the first surprise bombing raid on Japan. The atmosphere is tense as Douglas TBD Devastator torpedo bombers of Torpedo Squadron Eight are poised for take-off. The pilots' orders are to attack the entire might of the Japanese fleet off Midway Island. Squadron leader Lieutenant Commander John C. Waldron and his aircrews are well aware that their chances of survival on this fateful mission are minimal.

At the time of its introduction to the Navy in 1937, the Devastator was in the technological forefront of aircraft design, but five short years later, it was hopelessly obsolete against a formidable enemy with more advanced weaponry.

All fifteen Torpedo Squadron bombers were shot out of the sky that day while flying low and slow against the Japanese armada, but not before forcing defending Zero fighters down to wave-top level, where they exhausted much of their fuel while leaving their carriers virtually unprotected. Soon after, SBD *Dauntless* dive-bombers hit and sank three carriers — *Akagi, Kaga* and *Soryu* — the pride of the Japanese fleet, and later, the *Hiryu*. This action was the turning point of World War II in the Pacific. From this point on, Japan would fight a defensive war against increasingly powerful American forces.

In my depiction of this momentous event, I chose to place the viewer on the deck of the USS *Hornet* as the Devastators of Torpedo Squadron Eight take off. In the foreground, a deck-crew airplane handler motions the pilot of aircraft T-2 forward toward the center of the deck, ready for launch, as aircraft T-14, piloted by Ensign George Gay, starts its take-off run down the Hornet's flight deck. Ensign Gay would be the only survivor among the crews of the 15 Torpedo Squadron Eight aircraft to engage the Japanese that day.

This was a period of transition in the national insignia emblazoned on American aircraft. Because of the danger of confusing the American and Japanese insignias at a distance, the red disk in the center of the white star was oversprayed with white paint. Also, notice that some of the plane handlers on the deck are wearing the brand-new M-1 steel helmets, while others still don the WWI-style shallow helmets.

A lot of my references for this painting came from former Petty Officer 2nd Class Bill Tunstall, who served as a Devastator crew chief aboard the Hornet during the Battle of Midway. Bill's help in conveying the feeling of that crucial time was invaluable. He also provided me with important technical details such as the configuration of the *Hornet*'s "island" and the color and markings of the aircraft.

This painting is dedicated to the brave men of Torpedo Squadron Eight, who sacrificed their lives and, in so doing, enabled America to pursue Allied victory in the Second World War.

Staying Power — Berlin 1948 – 49

In 1948, during the early stages of the Cold War, the Soviets cut off all land routes into Berlin from West Germany. Supplies — coal, clothing, food, medicines, etc. — could not get through. The Allied Forces decided that the only means of delivering these life-sustaining supplies to the people of West Berlin would be by airlift. The deployment of such an operation during peacetime was unprecedented in history; thus began the Berlin Airlift.

Berlin airfields, such as Tempelhof, took a beating from the tonnage of constantly landing airplanes. What interested me was the fact that the airfields were being maintained and repaired by many German civilian women. I created the painting *Staying Power — Berlin 1948-49* to honor the arduous, largely unrecognized contribution of countless female West Berliners.

The woman in the right foreground is glancing up at the C-54 coming in on final approach. Perhaps she is thinking that this plane contains items much needed by her family and many others.

Colonel Gail Halverson, a C-54 pilot who participated in the Berlin Airlift, recalled that children would line the airfields, waiting for the airplanes to land. Col. Halverson would attach small parachutes to parcels containing candy and release them as his plane circled the airfields. He soon became known as the "Candy Bomber." Many other aircrews subsequently followed suit. Col. Halverson countersigned the limited edition prints of *Staying Power — Berlin 1948-49*.

In 1949, Stalin finally gave in and allowed supplies to be delivered to West Berlin via land routes.

Taegu Air Base, Korea — December 1951

A pilot with the 158th Fighter Bomber Squadron of the Georgia Air National Guard reviews the maintenance checklist of his F-84E with his crew chief before taking off on a dangerous ground-attack mission against enemy troops and supply lines.

In the background, ground-crew personnel load bombs under the wings of the Thunderjet while other men make last-minute adjustments to the Allison J35-A-29 Turbojet engine.

Numerous interdictions were conducted from Taegu Air Base, an austere forward base located in a desolate part of the Republic of Korea.

Operation Nickel Grass

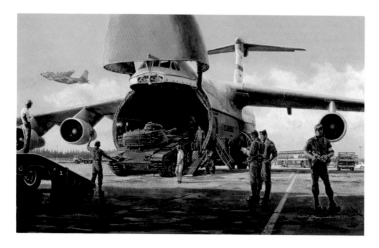

On October 6, 1973, during the solemn holy holiday of Yom Kippur, Egypt and Syria launched a devastating surprise attack on Israel, catching Israeli intelligence completely off guard. By October 9, the Arabs had gained substantial ground from the Golan Heights in the north and across the Suez Canal into Sinai in the south.

When Israeli Prime Minister Golda Meir informed the United States that supplies and ammunition were running out, President Nixon ordered the USAF's Military Airlift Command to depart immediately with supplies for Israel — "Send everything that can fly." The U.S. then negotiated with Portugal to obtain landing rights for refueling at Lejes Field in the Azores. On October 14, the first giant C-5 aircraft landed at Lod International Airport near Tel Aviv carrying 97 tons of ammunition. By October 20, the Israeli Army and Air Force were on the offensive, routing Arab forces from the Syrian and Egyptian fronts. A ceasefire soon followed. The massive USAF (MAC) airlift known as Operation Nickel Grass ended on November 14. A total of 567 missions had delivered more than 22,000 tons of war supplies to Israel.

Early in 1998, I was approached by historian Ken Robertson of the Nickel Grass 25 Committee of Dover, Delaware, to create a painting to commemorate the 25th anniversary of Operation Nickel Grass. That summer, I accompanied USAF Vice Chief of

Staff General David Vesley, his entourage and artist Rick Herter to Israel, where I interviewed several historians and witnesses to the airlift activities that had taken place a quarter-century ago. Back home, both Ken Robertson and Michael Leister, director of the Air Mobility Command Museum at Dover Air Force Base, supplied me with reference material and put me in touch with Colonel Ron Love (USAF, Ret.). Love had been in Israel during Operation Nickel Grass and was able to supply me with photographs that he had taken. I also traveled to the Ordnance Museum at the Aberdeen Proving Grounds in Maryland, where I met the museum's director, Dr. William Atwater. He provided me with indispensable information pertaining to the M-60 heavy tank that is shown being unloaded from a C-5 transport plane at Lod Airport.

On October 13 and 14, 1998, a gala 25th Anniversary Commemoration Ceremony was held at Dover AFB. The VIP list of guests included former Israeli commanders during the Yom Kippur War, Americans who had taken part in the airlift operation, Delaware Senators Biden and Roth, and the Portuguese Ambassador to the U.S. During those ceremonies, the painting Operation Nickel Grass was unveiled and dedicated to the Air Mobility Command Museum at Dover Air Force Base.

This assignment gave me the opportunity to go to Israel for the first time. I was fascinated with the Holy Land, its history and its people, and I shall be forever grateful for the experience.

Operation Provide Hope: Somalia, 1993

In December 1993, artist Keith Ferris and I accompanied General Ronald Fogelman, then head of Air Mobility Command, on a whirlwind mission to many countries, including war-torn Bosnia and Somalia. Our C-5 flight from Cairo, Egypt, to Mogadishu, Somalia, lasted five and a half hours. Upon landing, we donned helmets and flak jackets before being whisked into waiting Blackhawk helicopters, their rotor blades already spinning. The machine-guns aboard were manned by soldiers in desert camouflage.

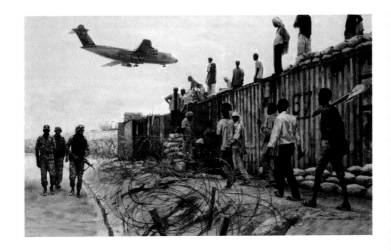

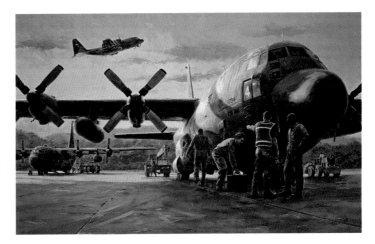

On our military-escorted walking tour of sun-parched Mogadishu, I observed many things that seemed incongruous in this poor, war-ravaged region of southeast Africa — including cheerful Christmas decorations. Many natives showed signs of their recent starvation, but their garb was a mixture of fezzes, turbans and other traditional clothing, and western-style shirts, jeans and cheap, plastic factory-made sandals.

In my painting, we observe a work detail walking past rusted and worn containers festooned with graffiti. More Somalis are moving sandbags on the roofs of the containers. Barbed concertina wire and sandbags were everywhere. On the left, we see three American soldiers, part of the UN Peacekeeping Forces, their guns at the ready. In the background is an Air Force C-5 on its final approach into Mogadishu Airport.

Operation Coronet Oak

Operation Coronet Oak was the Air National Guard's longest-running mission, beginning in October 1977 at Howard Air Force Base, Panama, and ending in 1999 as part of a series of events that turned over control of the Panama Canal and military bases to the Republic of Panama. It rotated portions of the Air National Guard and Air Force Reserve C-130 units on short tours of active duty to meet theater airlift requirements of the U.S. Southern Command in Latin America. Coronet Oak also marked the growing participation of women and minority personnel.

This painting depicts members from the 179th Airlift Wing, Ohio, and the 130th Airlift Wing, West Virginia, preparing for additional missions while a C-130 from Rhode Island's 143rd Wing takes off from Howard Air Force Base, Panama.

On the Deck Over Scotland

In the summer of 1996, I accompanied members of the Maryland Air National Guard on exhilarating low-altitude exercises over England and Scotland. Even as we flew our C-130 aircraft over a cluster of drop zones, we were dazzled by the spectacular beauty just ahead — the cliffs of Mallaig, the west coast of the Scottish Highlands, just south of the Isle of Skye.

Requiem for Torpedo Eight

Oil on linen, 50" x 24", 2004.
Collection of Eugene Eisenberg.

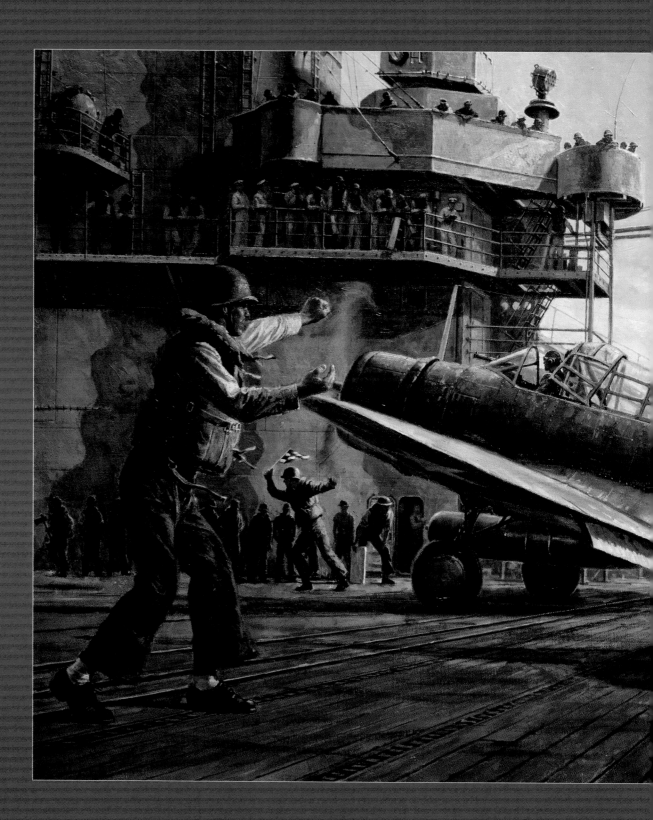

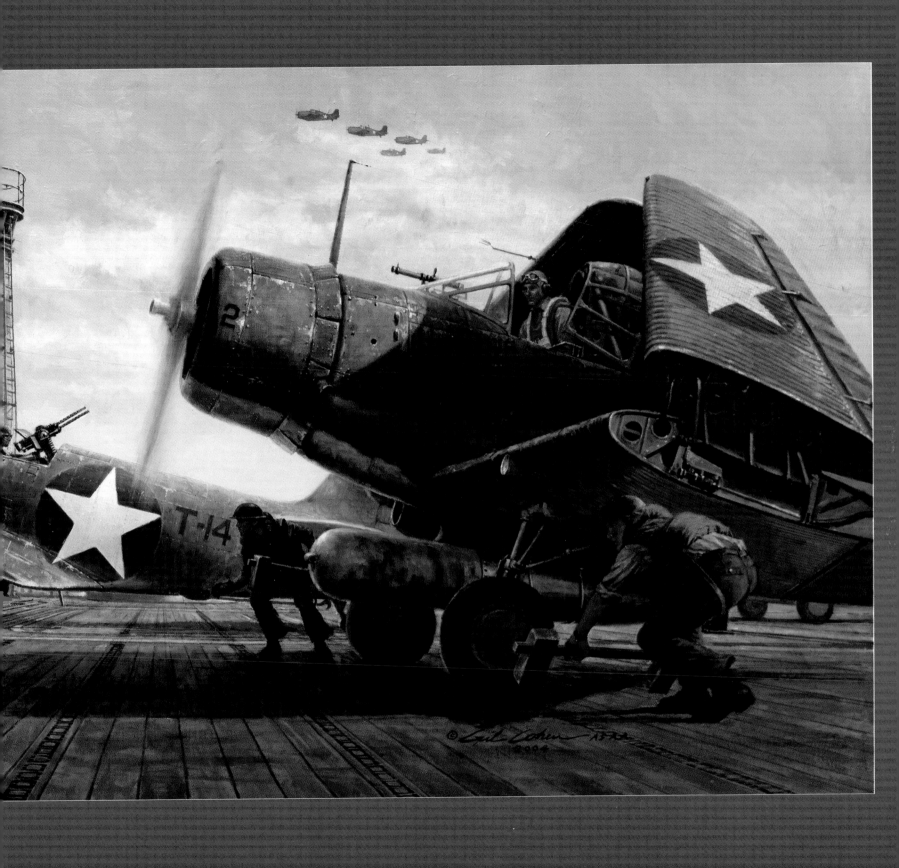

Staying Power — Berlin 1948–49

Oil on linen, 44" x 26", 1997.
U.S. Air Force Art Collection.

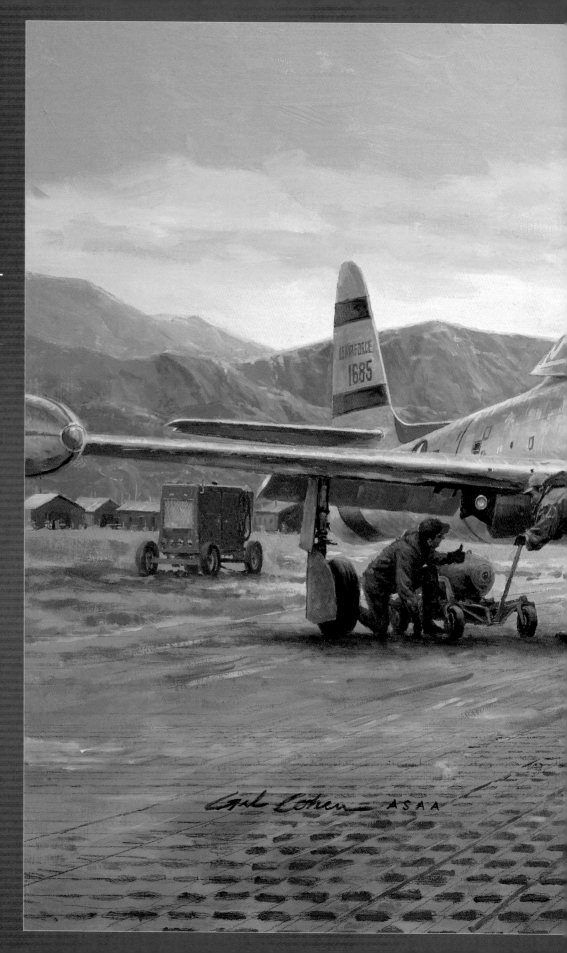

Taegu Air Base, Korea — December 1951

Oil on linen, 36" x 24", 2000.
National Guard Bureau Art Collection.

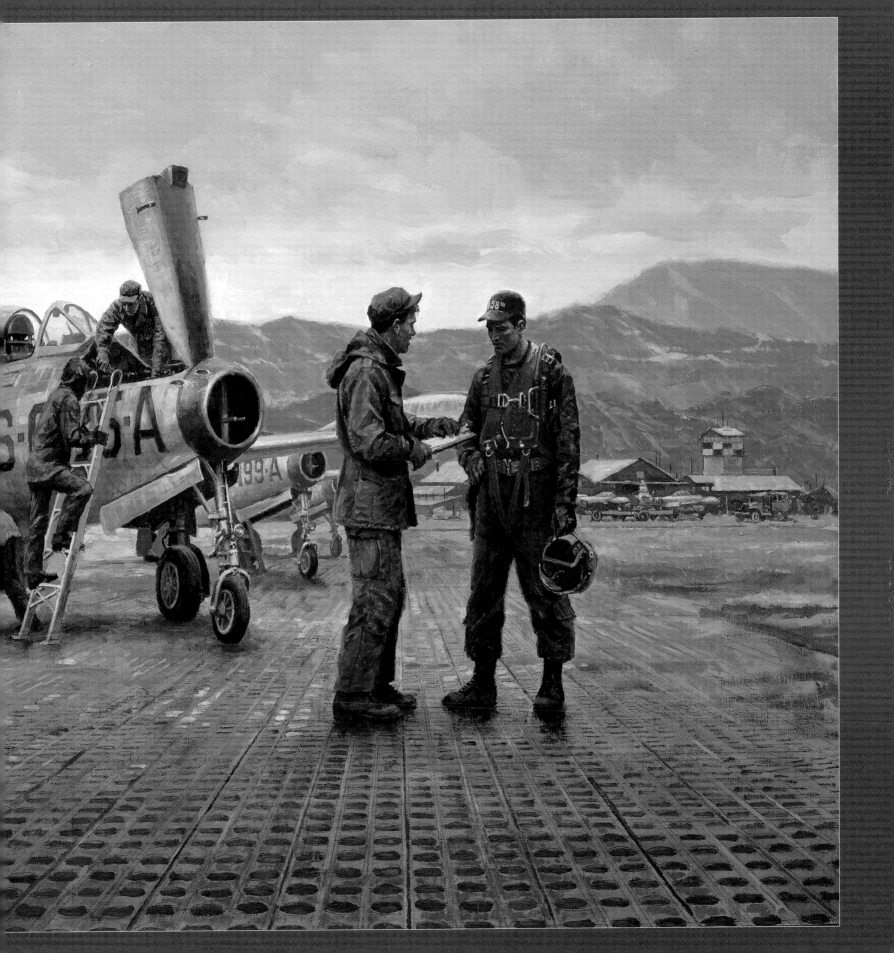

Operation
Nickel Grass

Oil on linen, 48" x 28", 1998.
U.S. Air Force Art Collection.

Operation
Provide Hope:
Somalia, 1993

Oil on linen on board, 48" x 30", 1994.
U.S. Air Force Art Collection.

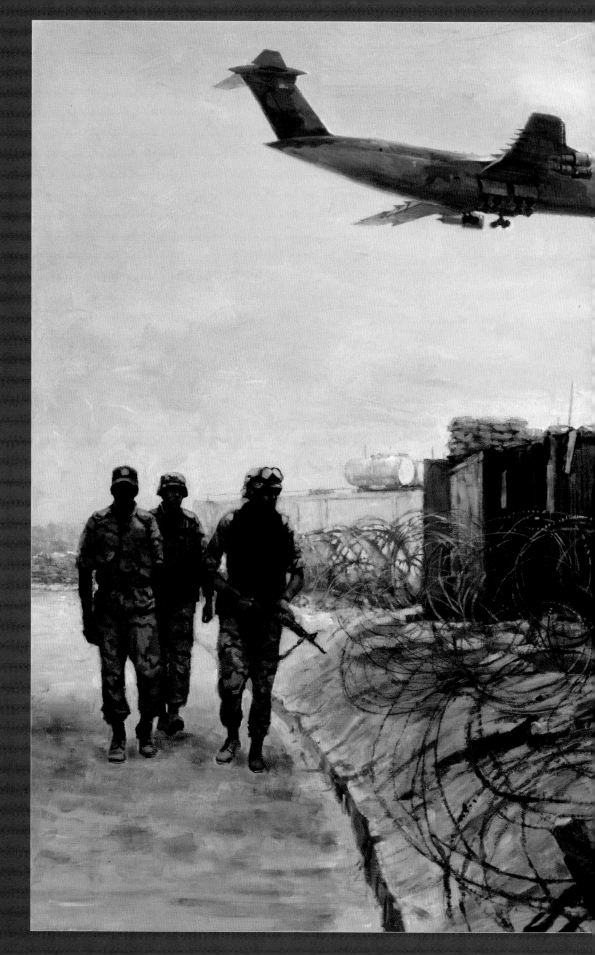

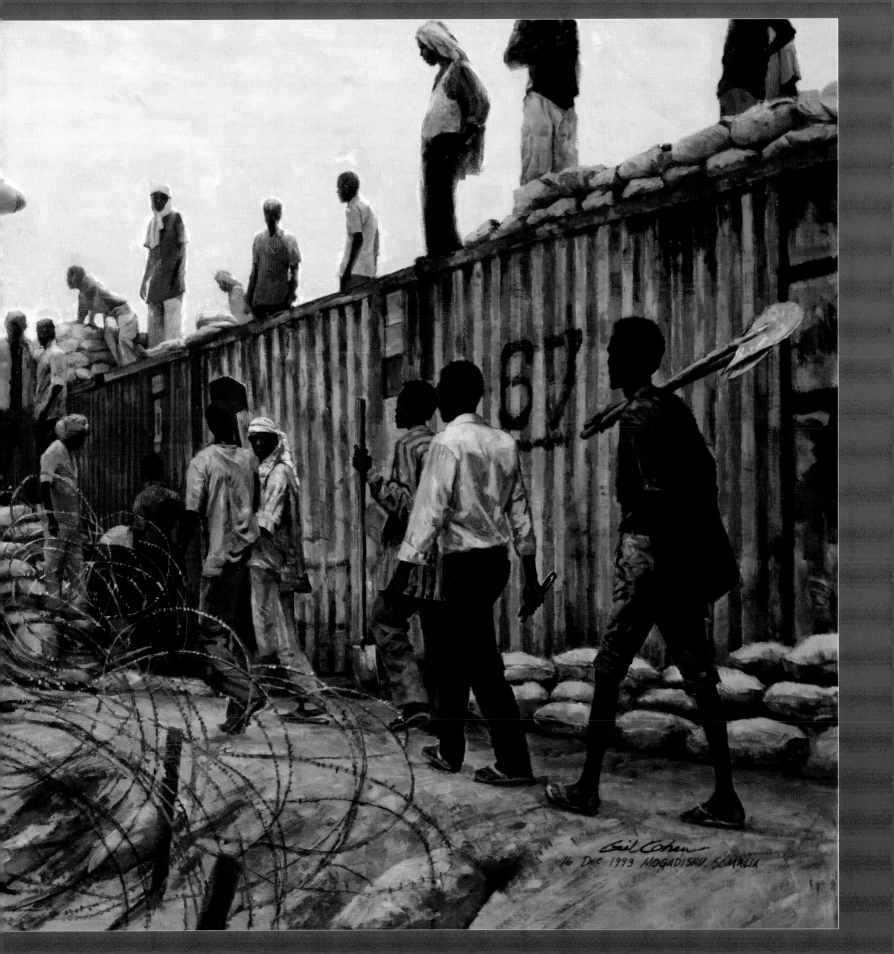

Gail Cohen
16 Dec 1993 Mogadishu, Somalia

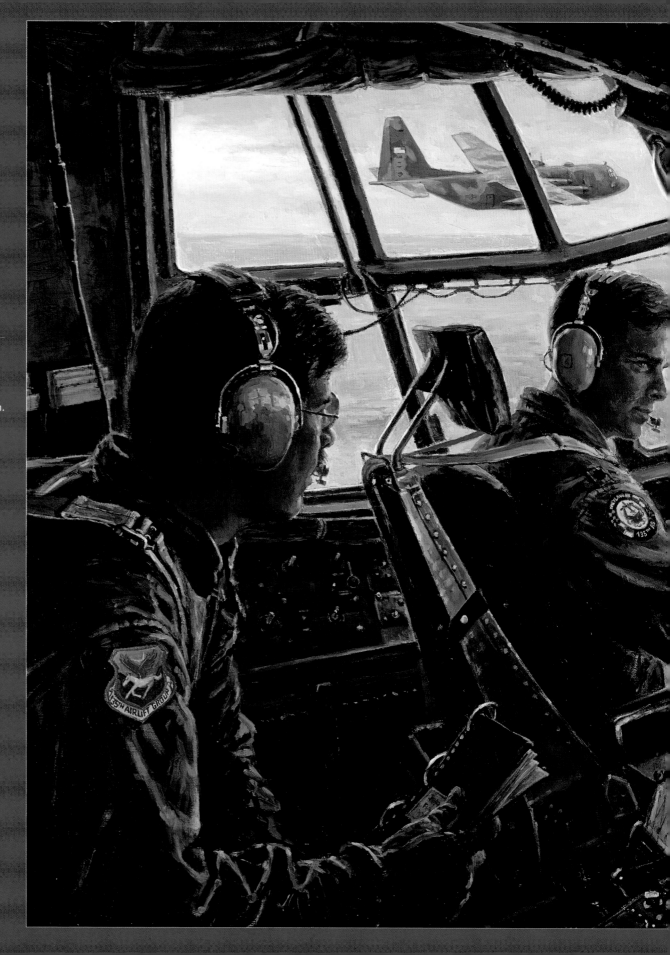

On the Deck Over Scotland

Oil on linen on board,
48" x 28", 1997.
National Guard Bureau Art Collection.

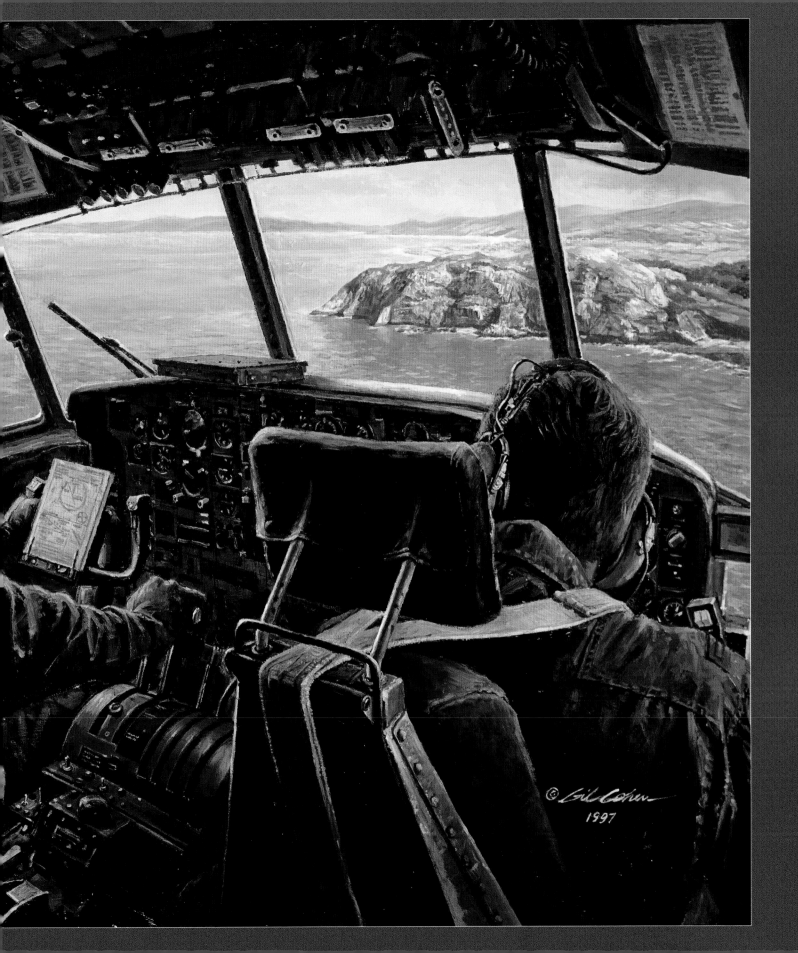

Operation Coronet Oak

Oil on linen on board, 36" x 24", 2001.
National Guard Bureau Art Collection.

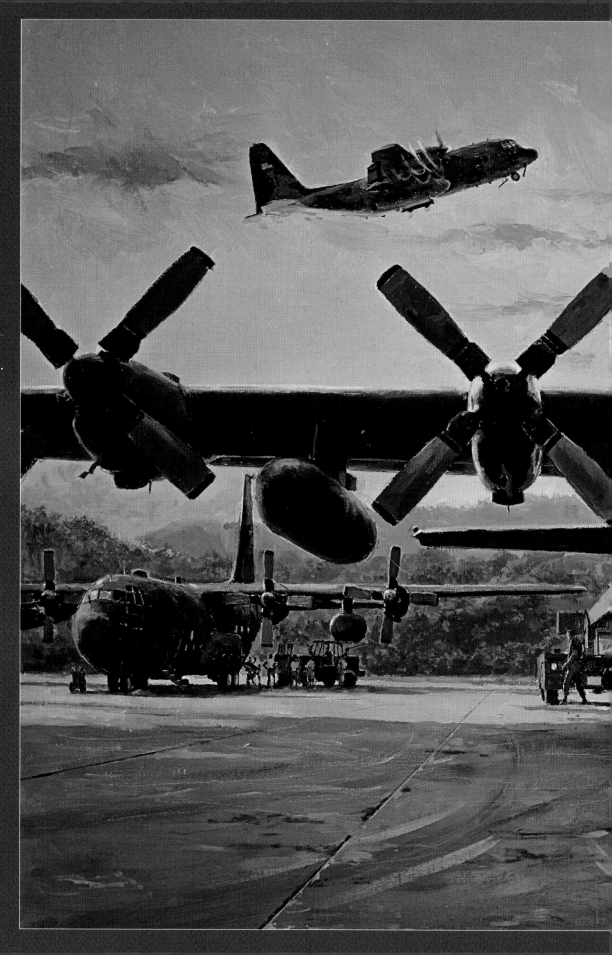

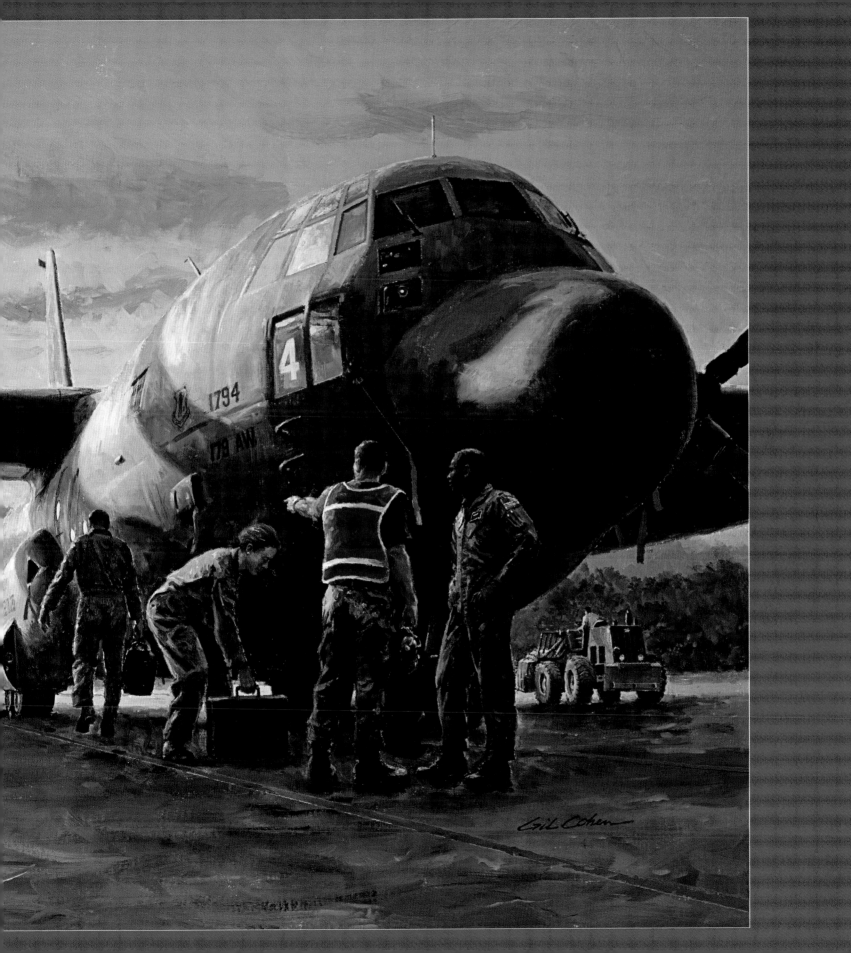

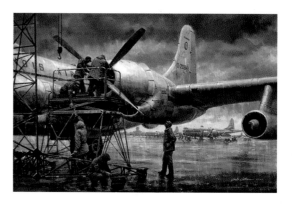

Mac Security Police

To witness the series of joint Air Force and Army exercises called Airlift Rodeo, I accompanied members of the Military Airlift Security Police on a war games patrol. The security police were to capture and secure the perimeter around the airfield in order to allow the safe flow of Air Force traffic and prevent the interference of enemy forces.

In this painting, the troops on patrol wear face camouflage and carry full battle gear, including M-16 rifles with MILES (Multi-Integrated Laser Engagement System) attachments. Their helmets are equipped with sensor bands.

I was captivated by the play of light and shadow on the figures, as well as the dappling effect of the sun filtered through the trees and other foliage.

Operation Creek Party

Mechanics from the 126th Air Refueling Wing, Illinois Air National Guard, prepare a KC-97L tanker for a mission at Rhein–Main Air Base in Germany during Operation Creek Party. Creek Party provided in-flight refueling services for fighter aircraft assigned to the U.S. Air Forces in Europe for ten consecutive years. Enlisted Guardsmen, working under austere conditions, usually outdoors at Rhein–Main, played a vital role in sustaining their aging KC-97L aircraft.

This painting is a good example of how I use certain components in my work. Mechanical objects often encompass the human element, usually within a dark atmosphere. In this example, a cross is formed by the giant propeller of the KC-97 engine, providing the center of interest. Starting from the ground, the viewer's eye is led upwards to this focal point by the action of the mechanics passing tools up to the men on the platform, where they are performing maintenance on the engine. The crew chief, seen on the right looking up at this center of activity, contributes to the dramatic effect of the composition, as does the ambience of the rain-swept tarmac of Rhein–Main Air Base.

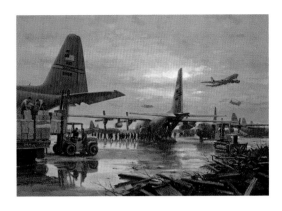

In Katrina's Wake

Hurricane Katrina made landfall in Louisiana and Mississippi on August 29, 2005, causing one of the worst natural disasters in the history of the United States. Air and National Guardsmen from across the country, along with state and local emergency responders and active-duty Armed Forces members, poured into the Gulf Coast region to participate in a massive humanitarian relief effort. The entry point for much of the National Guard's relief operations in Louisiana was the New Orleans Naval Air Station, located immediately south of New Orleans in the suburb of Belle Chasse. On September 1, 2005, Air National Guard C-130s and KC-135s commenced airlifting equipment, supplies, food and military personnel into the airfield and began evacuating sick and injured civilians.

In depicting the bustling activity of National Guard units from all over the United States landing at the Naval Air Station, I decided to focus on significant elements in the foreground. On the left, a forklift truck transfers much-needed food supplies from a C-130 onto a flatbed truck for delivery to victims of Katrina in New Orleans. On the right side of the painting, debris from the storm is still being cleared from the tarmac. In the background, troops and supplies are being disembarked from their cargo planes. In the sky overhead, various support aircraft take off and land.

Zero Gravity in ISS

The Zvezda Service Module was the first fully Russian contribution to the international Space Station. Launched and docked in July 2000, it provided living quarters and became the main control system, with communications and command capabilities from ground controllers.

Sometime in 2001, I was contacted by NASA, who requested a painting of the interior of the Zvezda Service Module featuring astronauts performing their tasks. After spending a fascinating day gathering reference material at the Johnson Space Center outside Houston, I worked up some pencil roughs and sent them to NASA for approval. While there I had an enlightening conversation with an astronaut who had served aboard the ISS (International Space Station). He went into great detail about what zero gravity felt like. For instance, he reminded me that if I show cables or cords extended, they would not droop down. They would "float" just as everything else does, including the human figures.

In preparing for the finished painting, I tried posing people in the role of the astronauts. This proved very difficult due to the obvious intrusion of Newton's Law of Gravity! Even the clothes we wear are affected by gravity. People posing in Earth's gravity would be of very limited use. Therefore, I had to largely invent the figure drawings. In the end, I thoroughly enjoyed executing this painting and being challenged to viscerally create the ambience of zero gravity inside the Zvezda Space Module.

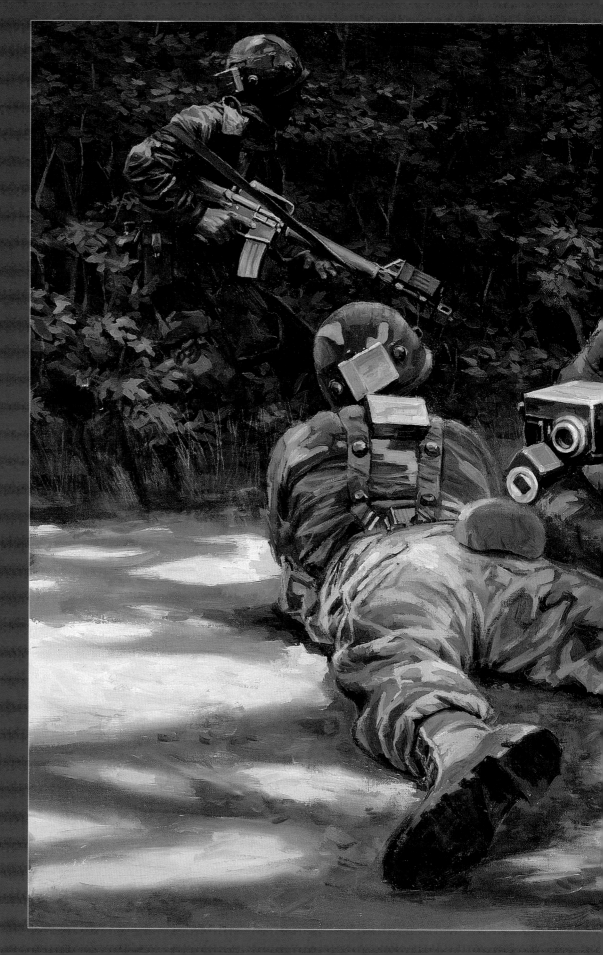

MAC Security
Police Patrol

Oil on linen on board, 44" x 28", 1988.

U.S. Air Force Art Collection.

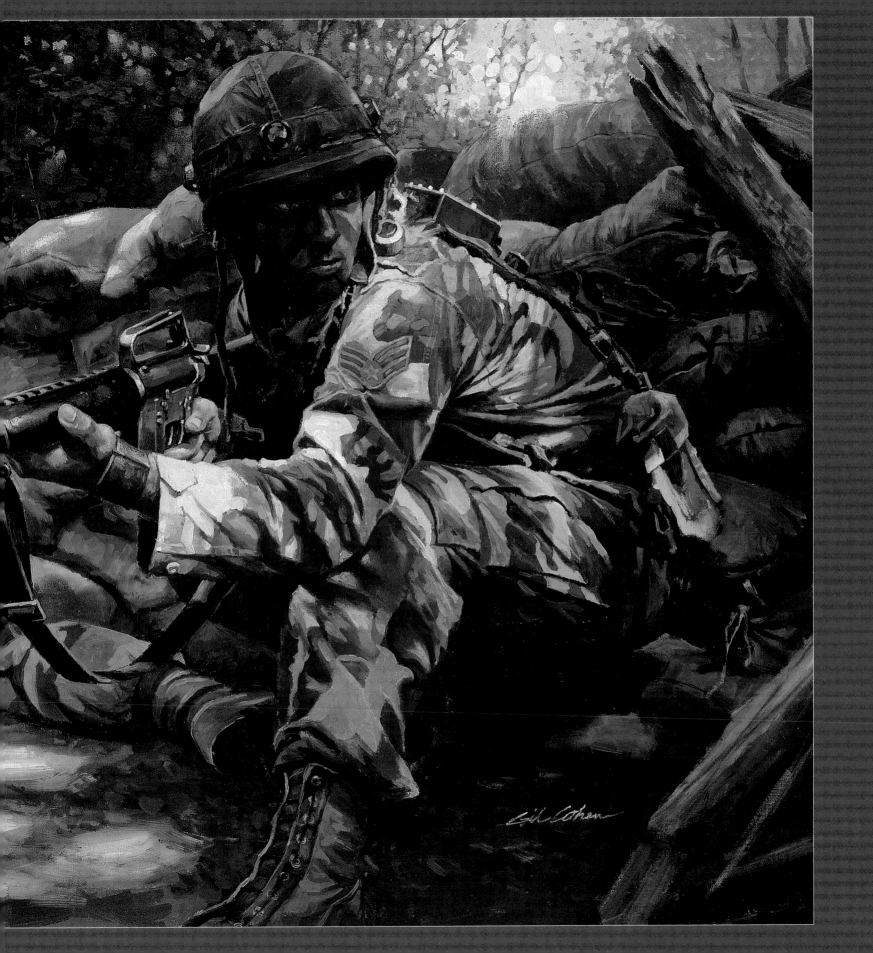

Operation Creek Party

Oil on linen on board, 36" x 24", 1997.
National Guard Bureau Art Collection.

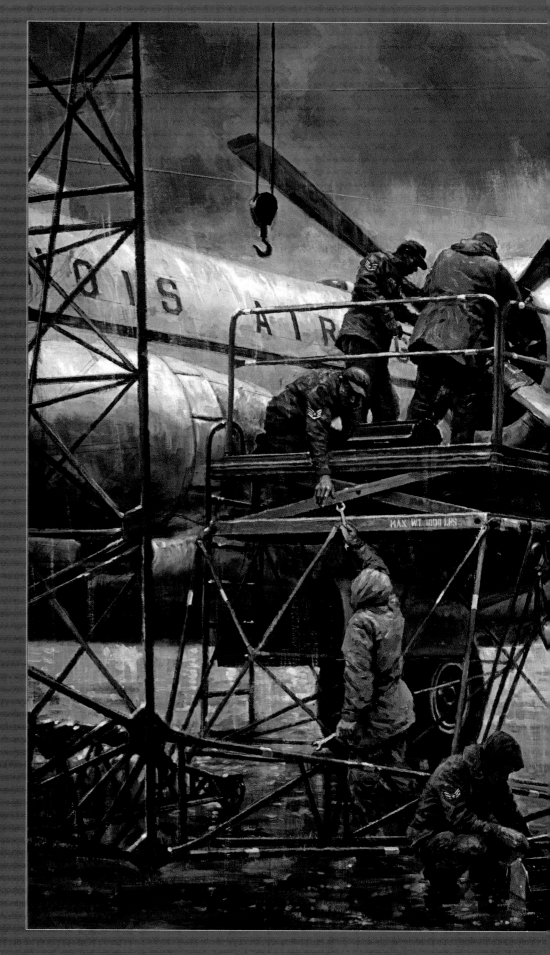

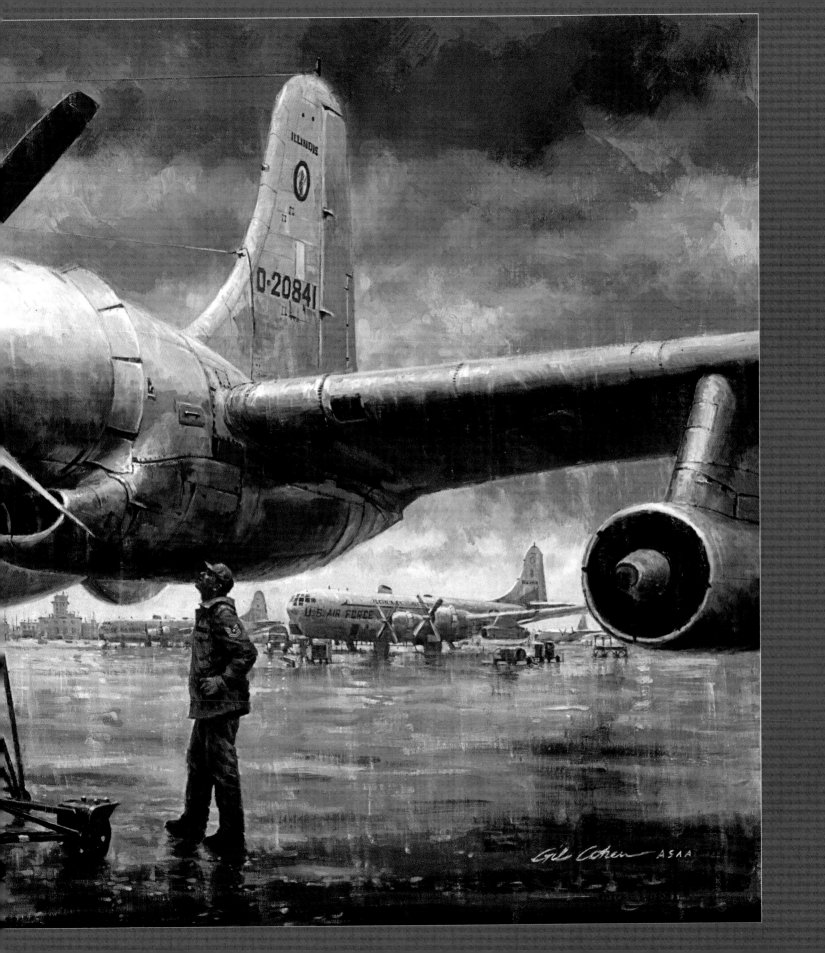

In Katrina's Wake

Oil on linen on board, 36" x 24", 2006.
National Guard Bureau Art Collection.

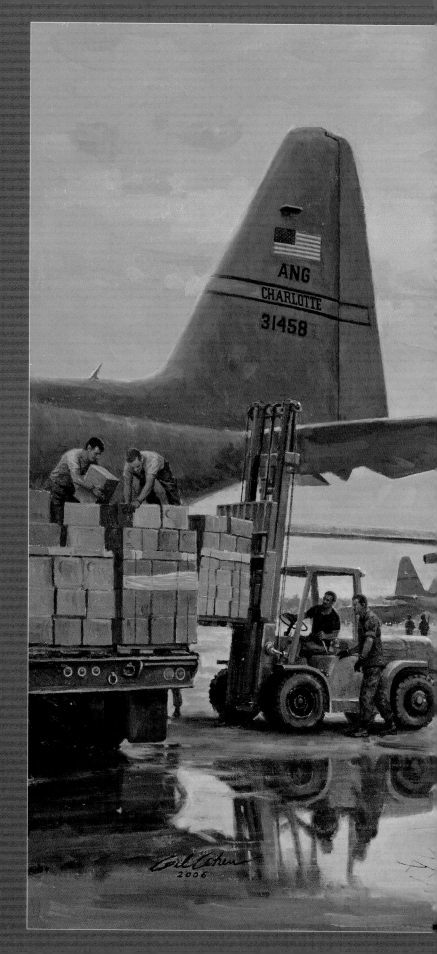

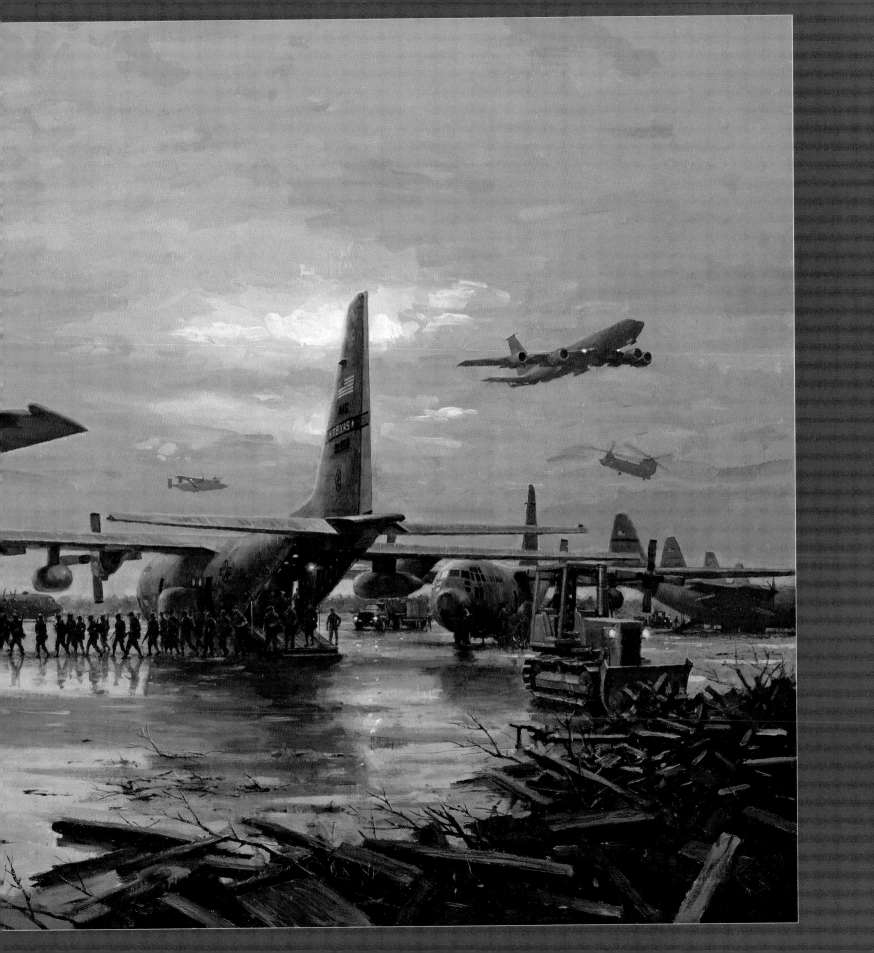

Zero Gravity on ISS

Oil on linen on board, 48" x 28", 2001.
NASA Art Collection.

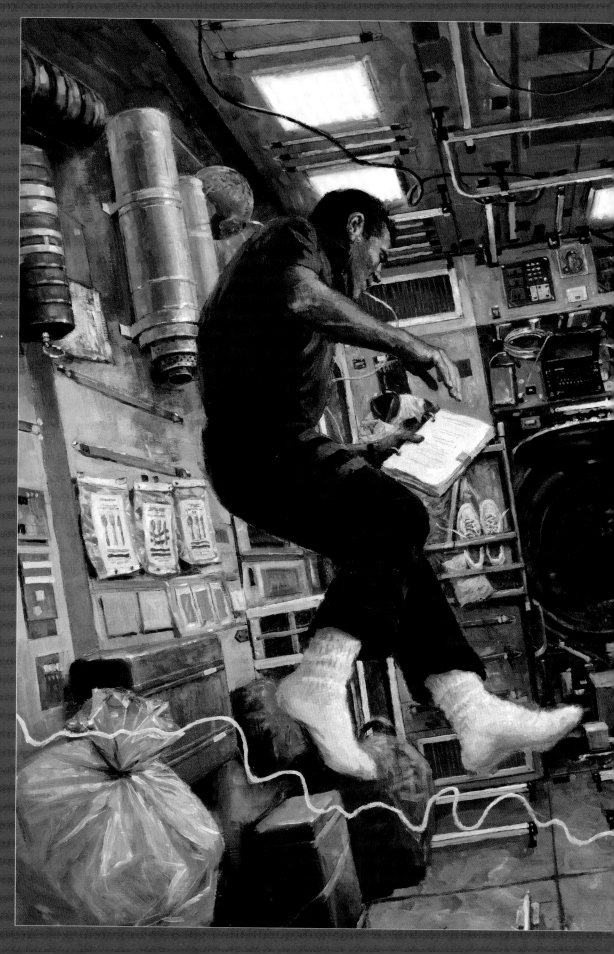

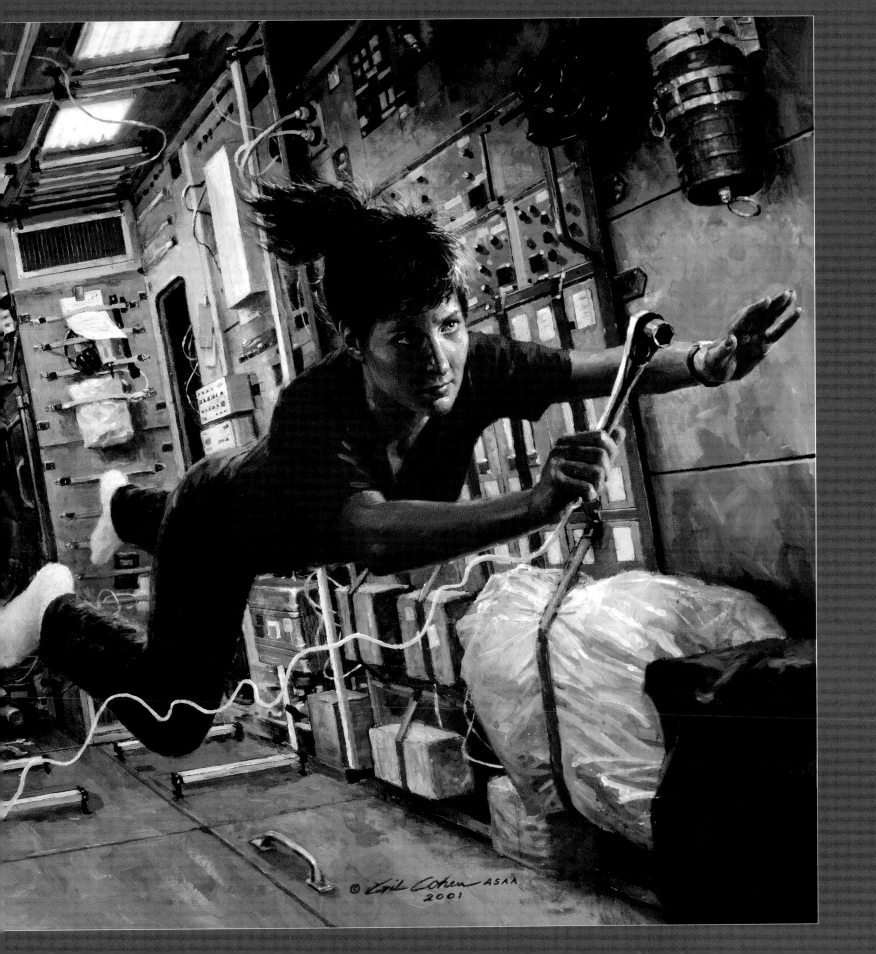

ISODOCK

Back in 1986, I visited the BISODOCK (Isochronal Docks) hangar at McGuire Air Force Base, New Jersey, where thorough inspections of multiple C-141 air-craft systems were performed following every 20,000 hours of flight time. Inside the enormous hangar was this

incredible sight — a huge C-141 Starlifter transport, partially dissected and surrounded by a complex network of metal scaffolding. Looking over the wing and out beyond the open hangar doors into the bright sunshine, I thought, *What a painting this could make!*

Howard Air Force Base, Panama: December 1989

In December 1989, American forces invaded Panama to bring down the Noriega regime. A few days later, the Air Force sent me down to Howard Air Force Base along with members of the media to cover the event. The result is this charcoal-and-pastel rendering of troops of the 82nd Airborne Division boarding a C-141 transport aircraft for their return to Fort Bragg, North Carolina, their job of securing Panama City having been accomplished.

The Wrights at Huffman Prairie — 1905

It was at Huffman Prairie farmland on the outskirts of Dayton, Ohio, in the year 1905 that the Wright brothers conducted test flights with their *Wright Flyer* III, leading to some of their most significant advances in aircraft design. During September and October of that year, the Wrights were able to separate, for the first time, the joint control of pitch, roll and yaw.

The painting *The Wrights at Huffman Prairie — 1905* depicts the peaceful atmosphere of Huffman Prairie on a balmy September day in 1905. In the background, cows graze lazily. Orville and Wilbur are just finishing some last-minute maintenance on their *Wright Flyer* III. Mechanic Charlie Taylor makes adjustments on the port propeller. A passing cloud momentarily casts shade on the foreground. Into this bucolic scene walks Orville and Wilbur's younger sister, Katharine, with a picnic basket containing a lunchtime meal for her brothers and Charlie. She has arrived by interurban trolley, disembarking at nearby Simms Station and continuing across the pasture, strolling through autumn wildflowers. Orville briefly interrupts his stitching task to look up and greet Katharine.

Katharine Wright played a significant role in her older brothers' achievements. She provided moral encouragement in every way. She also accompanied her brothers on trips around the United States and Europe as they conducted flights demonstrating the effectiveness and practical viability of their aeronautical designs. Long after Wilbur's death in 1912, Katharine continued to support and care for Orville.

This painting affords the viewer an opportunity to go back in time and be an intimate participant in this familial moment in history.

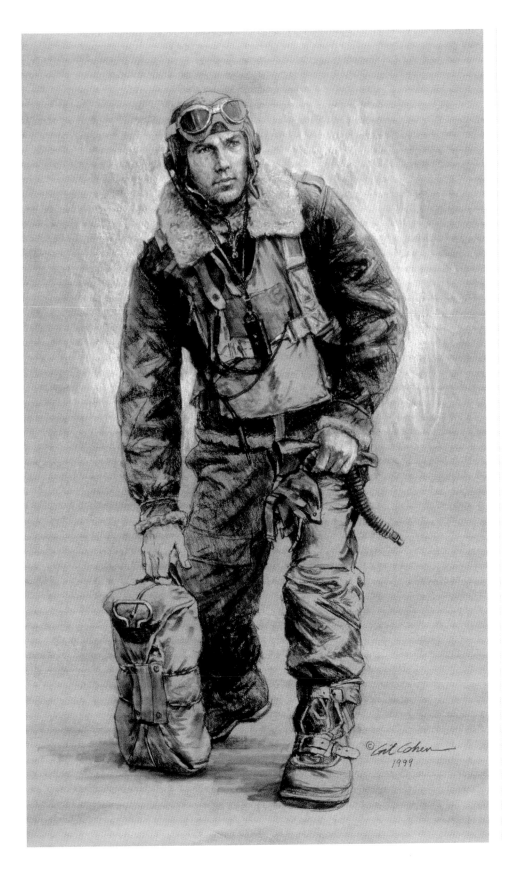

The Crewman

In June 1999, when a one-man exhibition of my paintings at the Mighty Eighth Air Force Heritage Museum ended and my work was to be taken down and shipped to its respective owners, I decided to render a drawing that would honor all of the airmen of "The Eighth." I donated this charcoal-and-pastel drawing to the museum for their permanent collection.

The drawing inspired my friend Michael Faley, historian of the 100th Bomb Group, to write the following:

"The Eighth Air Force crewman was the final link in a complex chain of command that enabled the 'Mighty Eighth' to accomplish thousands of combat missions. All the planning and preparation of hundreds of personnel rested in the hands of the combat crews. Each flyer handled his individual feelings and emotions in his own personal way as he went out to his respective hardstand to proceed to the target for today.

"This drawing depicts an American crewman preparing himself to fly another mission against enemy forces."

Carbon pencil and pastel on toned paper, 24" x 36", 1999.
The Mighty Eighth Heritage Museum Collection.

ISODOCK

Oil on linen on board,
40" x 28", 1987.
U.S. Air Force Art Collection.

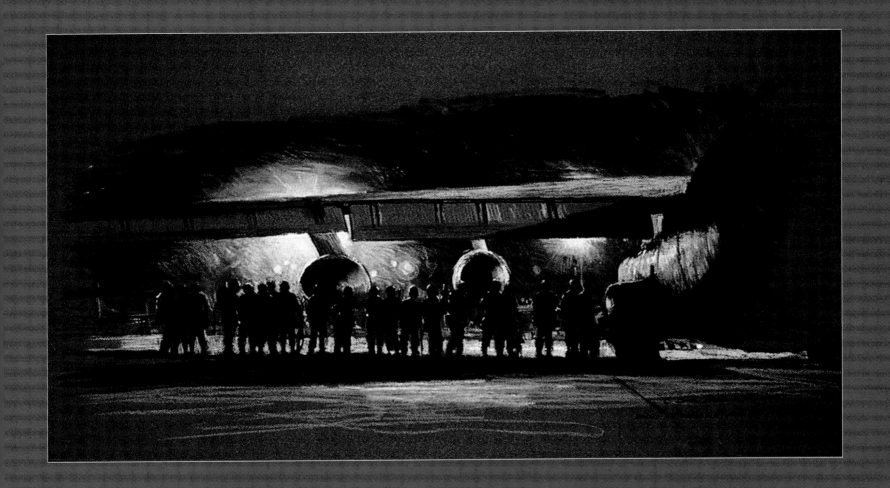

Howard Air Force Base, Panama: December 1989

Pastel and charcoal on toned paper, 30" x 16", 2006.

U.S. Air Force Art Collection.

The Wrights
at Huffman Prairie
— 1905

Oil on linen, 48" x 28", 2003.
Collection of Eugene Eisenberg.

Bibliography

Barker, Ralph. *The RAF at War*. Time-Life Books, 1981.

Crosby, Harry H. *A Wing and a Prayer*. Harper Collins Publishers, 1993.

Davis, Larry. *Fourth Fighter Group in World War II*. Squadron-Signal Publications, 2007.

Holmes, Tony. *American Eagles: American Volunteers in the RAF 1937-1943*. Classic Publications, 2001.

Freeman, Roger A. *The Mighty Eighth*. Crown Publishers, 1989.

Freeman, Roger A. *The Mighty Eighth in Art*. Arms & Armour Press, 1996.

Hawkins, Ian L. *The Munster Raid: Before and After*. FNP Military Division, 1999.

Jablonski, Edward. *Flying Fortress*. Doubleday & Co., 1965.

Kaplan, Philip and Richard Collier. *Their Finest Hour: The Battle of Britain Remembered*. Abbeville Press, 1989.

McCormick, Ken. *Images of War: The Artist's Vision of World War II*. Crown Publishers, 1990.

Miller, Donald L. *Masters of the Air*. Simon & Schuster, 2006.

Nicolaides, Kimon. *The Natural Way to Draw*. Houghton Mifflin Co., 1941.

Ogley, Bob. *Biggin on the Bump*. Froglets Publications, Ltd., 1990.

Orbere, Rich. *Men's Adventure Magazines*. Taschen Publications, 2008.

Ratcliffe, Carter, *John Signer Sargent*. Abbeville Press, 1982.

Robertson, Kenneth. *Operation Nickel Grass: The US Air Force's 1973 Yom Kippur War Airlift to Israel*. Air Mobility Command Museum, 2007.

Sewell, Darrel. *Thomas Eakins*. Philadelphia Museum of Art, 2002.

Smith, Richard C. *Second to None: A Pictorial History of Hornchurch Aerodrome Through Two World Wars and Beyond, 1915-1962*. Grub Street, 2004.

Tillman, Barrett. *TBD Devastator Units of the US Navy*. Osprey Publishing, 2000.

Thorne, Alex. *Lancaster at War 4: Pathfinder Squadron*. Ian Allen Ltd, 1990.

Watson, Ernest. *Forty Illustrators and How They Work*. Watson-Guptill Publications, 1946.

Wheelock, Arthur. *Johannes Vermeer*. National Gallery of Art, 1995.

Acknowledgments

Self-portrait, 2007

As I have alluded to earlier, there are many people I wish to thank for their assistance in researching, supplying uniforms and equipment, posing, and of course insightfully critiquing my efforts.

Above all, I am indebted to my wife, Alice, whose love and support have inspired me.

I would also like to express my deep gratitude to the historians, living history reenactors, veterans and friends who have generously given their time and expertise:

James Adams; Jack Agnew; members of the American Society of Aviation Artists; Dr. William Atwater, curator, U.S. Army Ordnance Museum; Charles Austin, USAAF (Ret.); Virginia Bader, Virginia Bader Fine Art Gallery; Isa Barnett; Donna Berger; David Berry; Bill Bielauskas; Dale Biever; Col. Donald J.E. Blakeslee, USAAF (Ret.); Mary Blackmon; Scott Briant; Air Commodore Peter Brothers, RAF (Ret.); Rick Brown; Dr. Charles Burnett; Dale Burrier; Ed Campion, NASA; John Castronovo, TPI; William Cathers; Brian D. Cohen; Daniel Cole; Jeffrey Cole; Charles and Ann Cooper; Mark Copeland, president and chief historian, the Eighth Air Force Historical Society; Harry Crosby, USAAF (Ret.); Donna Cusano; Ken Dages; Susan M. Dahms; Sgt. Loren Darling, USAAF (Ret.); Betty Darst; Sgt. William DeBlasio, USAAF (Ret.); M. Sgt. Joseph DeFazio, USAF; Air Vice-Marshal Ron Dick, RAF (Ret.); Blaine Duxbury; Wilson (Bill) Edwards, USAAF (Ret.); Eugene Eisenberg; Lt. Col. Chris Inglis, Maryland ANG; Jeffrey Ethell; Michael Faley, historian, 100th BG; Keith Ferris; Dr. Roger A. Freeman; Dr. Harry Friedman; Lorraine Gabriele; Tony Garrick; Kevin Gately; Gary Gault; Jim Gintner; Mike Glick and the 101st Airborne Living History Group; Albert Gold; Eric Goldstein; Rich Greene; Herbert Greider; Dr. Thomas Greider; Dr. Charles Gross, chief historian, U.S. Air National Guard; Aaron Hamilton; Jonathan and Meena Hendrixson; Ellen Hill; Robert Hill (B-17 Guy); Don Hinmom; Judy Hopkin; Keith Horne; Tom Horton; Emy Howerton; Scott Ibbison; Jaimie Ivers; Robert Jackson; Roslin Johannesdottir; Chris Johnson; Air Vice Marshal J.E. (Johnnie) Johnson, RAF (Ret.); Lew Johnston, USAAF (Ret.); Tom Kosicki; Ted Koslosky; Michael Krauss; Mark LaBella; Margot Latimer; Donna Lefferts; Jack Lefferts; Michael Leister, AMC Museum, Dover AFB; Ron Love; Tom Lowery; Col. Walker (Bud) Mahurin, USAF (Ret.); Adam, Bryan, Erika and Robert Makos, Valor Studios; Kathleen McNally; Nicholas Medaglio; David Menegaux; Rob Millard; Robert Milnazik; Theresa Montgomery, U.S. Air Force Museum; Troy Mulvaine; Michael Nice; Mike Noonan; Ron Northrup; Jim O'Neal; Michael Olenick; Mike Olenick; David Orphanides; Al Parisi; Dan and Cheryl Patterson; Wayne Placek; Col. Ramsay D. Potts, USAAF (Ret.); Jake Powers; Richard Radigonda; Scott Rall; Susan Rall; Lt. Col. David Rein, Maryland ANG; Ken Robertson; Greg Roos; Lt. Col. Robert "Rosie" Rosenthal, USAAF (Ret.); Buddy Rudolph; Dorinda Rumbold; Mark Rutch; Carolyn Sadowski; Sandreena; Greg Schott; Frank Schwuchon; Louis Sliazis; Colin and Rose Smith, Vector Fine Art Prints; Lez Smith; Richard Smith; Robert C. Smith; Bob Spaulding, U.S. Air Force Museum; Michelle Speckler; Col. Walter T. Stewart, USAAF (Ret.); Tom Stavropoulos; Bill Tunstall, USN (Ret.); The U.S. Air Force Art Program; The U.S. Coast Guard Art Program; Philip Veloric; Robert (Paddy) Walker, USAAF (Ret.); Ed and Cindy Walsh; RAF Warrant Officer Jack Watson; Curt Weidner; Sgt. Bing Wood, USAAF (Ret.); Robert and Hindy Westervelt; David Woosley; Gerald Yagen; Mitch Zetlin, National Park Service; and Bruce Zigler.

Preliminary pencil study for One of the Few. Note the leather Irvin jacket.

One of the Few

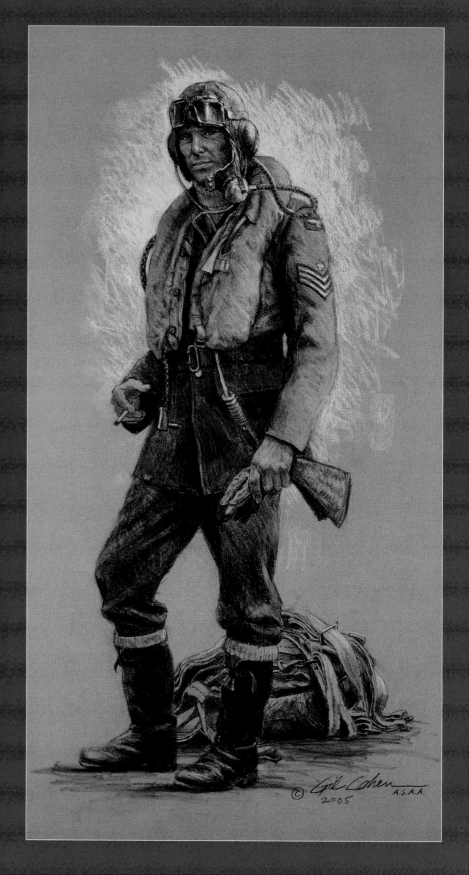

During the dark days of 1940, when Hitler's armies were poised for the invasion of Great Britain, it was the fighter pilots of the Royal Air Force who prevented the German Luftwaffe from accomplishing their mission of gaining supremacy in the skies. In Winston Churchill's words, "Never in the field of human conflict was so much owed by so many to so few."

To me, this drawing represents the archetypal Royal Air Force fighter pilot during the Battle of Britain. His posture and countenance suggest a man who is exhausted after many sorties spent intercepting German aircraft, yet there is an air of resolve about him. He is very much aware that the freedom of England, his beloved homeland, will depend upon his efforts and those of his fellow pilots.

Final rendering in carbon pencil and pastel on toned paper, 16" x 30". The pilot's RAF tunic indicates his rank as sergeant pilot.